A
SOUTHERN SPY
IN NORTHERN
VIRGINIA

D1444047

A SOUTHERN SPY

IN NORTHERN

VIRGINIA

THE CIVIL WAR ALBUM OF
LAURA RATCLIFFE

CHARLES V. MAURO

Charleston London

THE
History
PRESS

Published by The History Press
Charleston, SC 29403
www.historypress.net

Copyright © 2009 by Charles V. Mauro
All rights reserved

First published 2009

Manufactured in the United States

ISBN 978.1.59629.743.2

Library of Congress Cataloging-in-Publication Data

Mauro, Charles V.
A southern spy in Northern Virginia : the Civil War album of Laura Ratcliffe / Charles
V. Mauro.
p. cm.
Includes bibliographical references and index.
ISBN 978-1-59629-743-2 (alk. paper)
1. Ratcliffe, Laura. 2. Women spies--Virginia--Fairfax County--Biography. 3. Spies-
-Virginia--Fairfax County--Biography. 4. United States--History--Civil War, 1861-
1865--Secret service. 5. United States--History--Civil War, 1861-1865--Underground
movements. 6. United States--History--Civil War, 1861-1865--Women. 7. Stuart, Jeb,
1833-1864--Friends and associates. 8. Mosby, John Singleton, 1833-1916--Friends and
associates. 9. Fairfax County (Va.)--Biography. I. Title.
E608.R38M38 2009
973.7092--dc22
[B]
2009017628

Notice: The information in this book is true and complete to the best of our knowledge. It
is offered without guarantee on the part of the author or The History Press. The author
and The History Press disclaim all liability in connection with the use of this book.

All rights reserved. No part of this book may be reproduced or transmitted in any form
whatsoever without prior written permission from the publisher except in the case of
brief quotations embodied in critical articles and reviews.

CONTENTS

ACKNOWLEDGEMENTS

T his book would not have been possible without the permission of Lewis Leigh Jr., who allowed me to photograph the album of Laura Ratcliffe.

Tom Evans provided the interview on John Singleton Mosby and his interaction with civilians. Don Hakenson provided a plethora of photographs and information on the men who served under John S. Mosby. Both Tom and Don accompanied me on two all-day road trips throughout Mosby's Confederacy and on a third trip to Richmond. They both reviewed my manuscript, providing many needed edits and suggestions.

Ed Trexler Jr., a Civil War Fairfax Court House expert, provided information on the possible residential locations of Laura Ratcliffe in 1860. Ed, Lee Hubbard, Charles Gailey and Katrina Krempasky provided input on the map of Fairfax Court House. Susan Inskeep Gray, curator of the Fairfax Museum and Visitor Center, allowed me to photograph Laura's Bible, prayer book and calling card.

Susan Hellman, historian I of the County of Fairfax Department of Planning and Zoning and Virginia specialist at the City of Fairfax Regional Library, provided the title information for Laura's possible houses along Centreville Road in Frying Pan, Virginia.

Daniel Shaner, the owner of Bloomfield II, gave me permission to take pictures of Kate Carper's house. Thanks also to my next-door neighbor Dan Woolley for holding the ladder while I climbed it and photographed the 1858 brick. Richard Hammond, the great-grandson of Kate Carper, provided the story and location of where Kate's brother, Philip, hid in the attic of Bloomfield II during the war. R.P. MacWelsh, the owner of Edgehill, allowed me to take pictures of his property.

Cordelia Sansone provided an interview on Kate Carper and Bloomfield II. Gladys Utterback provided an interview on Laura Ratcliffe and Merrybrook, as did Win Meiselman, the owner of the Ratcliffe-Hanna house. Margaret

Peck provided an interview on the Peck House and the letter from Cora Ratcliffe. Stevan Meserve provided an interview on the whereabouts of E.V. White in Fairfax County during the war.

Deanna Marshall provided a Cambridge, Maryland census. Earl Brannock of the Brannock Maritime Museum provided a guided tour around Cambridge. Robin Abbot, the manager of Christ Church Cambridge, provided access to the church records. Melanie Ayres Merryweather, graveyard chair at Christ Church, provided information on the grave sites there.

A number of people in Cambridge also provided information on the possible connection between Laura and the women of Cambridge. They are Alan Dixon, John Drury, Don Miller, George Radcliffe, Dave Singelstad, David Orem, Sylvia Garrett and Deborah Cox. Thanks also to the *Star Democrat* of Easton for running an article on my search for the connection.

George Combs, archivist/reference librarian at the Alexandria Library, provided information on William H.P. Berkeley. Tom Ryan provided guidance on the *Official Records*. Mary Fishback, of the Balch Library in Leesburg, Virginia, provided information on Catherine Coleman. Deanne Blanton, archivist at the National Archives and Records Administration, got me started looking up information on the Civil War civilian files and on the Army of Northern Virginia. Suzanne Levy, librarian of the Virginia Room, continues to patiently answer all of my questions.

Patrick O'Neill took his time to take me to the Ratcliffe cemetery and the location of Mount Vineyard. Steve Wolfsberger provided his expertise in creating all of the maps.

Sharon Hodges, genealogist, tracked down much of the information on the family relationships of the civilians. Joe McKinney and Bob Luddy responded to my request on the location of W.D. Farley's monument. Hugh Keen, coauthor of *43rd Battalion, Virginia Cavalry, Mosby's Command*, graciously shared his current database on Mosby's men covered in this book. Sandy Anderson provided a copy of *Dear Sister, Civil War Letters to a Sister in Alabama*.

It was a great, great pleasure working with Tricia Petitt, the great-great-granddaughter of Mollie Millan.

And finally, as always, thanks to my wife, Nancy, who put up with me as I put this book together. And thanks also for jumping on the genealogical research and helping interpret the handwriting of over 140 years ago.

INTRODUCTION

An *album* is defined as "a bound or loose-leaf book with blank pages for mounting pictures, stamps, etc., or for collecting autographs." A *spy* is "a person who, in the time of war, acts clandestinely and while not in military uniform to get information for the enemy." A *mystery* is "something unexplained, unknown, or kept secret."[1]

The album given to Laura Ratcliffe by then Confederate brigadier general J.E.B. Stuart in the early part of the Civil War encompasses all three of these definitions. The album contains four poems—two written by Stuart and two that he copied to a young Miss Laura to solicit her favor in gathering information about the enemy. It also contains a total of forty signatures—twenty-six of Confederate soldiers and fourteen of civilians. It is not my intent to chronicle the lives and total operations of these soldiers during the war, as that information has been published in numerous other works. It is my intent, however, to try to clear away the mystery of who these soldiers and civilians were and uncover their relationships to Laura.

None other than Confederate colonel John Singleton Mosby documented Laura, in addition to other Confederate and Union soldiers, as a spy for the Confederate States of America. The album is a bit of a mystery as there are no dates of when these forty individuals signed it, nor is there any indication of where the album was signed.

It is my assumption that the album was kept hidden at the house where Laura lived during the war. To take the album out of the house among the numerous local Union pickets would have been too dangerous if she were caught. Laura was never arrested for spying, although the Union soldiers in the Frying Pan area knew that she was "a very active and cunning rebel."[2]

It is also an assumption that the album was signed during the war. For example, Confederate major John Scott signed the album as "John Scott of

Fauquier." After the war, he signed his name as "John Scott of Fauquier, late C.S.A."[3] Other Confederate officers followed this practice as well.

Indisputable documentation of exactly where Laura lived before and during the war is unavailable. It is believed, however, that she was born in Fairfax Court House and lived there until she moved with her family to Frying Pan, along Centreville Road, in 1861. There are numerous references to both J.E.B. Stuart and John S. Mosby visiting Laura in Frying Pan. It is known that Laura did indeed live along Centreville Road in a subsequent location after the war. The album was passed on to relatives after Laura died, eventually passing into the hands of private collectors.

Laura's lineage was from a prominent family, as she was the great-granddaughter of Richard Ratcliffe, founder of the town of Providence, which was known as Fairfax Court House during the war and, later, as the town of Fairfax and then the city of Fairfax. She was four days short of her twenty-fifth birthday when, on May 24, 1861, President Abraham Lincoln sent troops to invade both Fairfax and Alexandria Counties, just west and south of the city of Washington, one day after Virginia voted to secede.

Unfortunately, Laura did not have children or leave a diary, and no letters have been found to pass down the details of her life during the war. Thus, the only information about her life is provided by others, who only offer a glimpse of her secret activities.

We do, however, have solid information on life in Fairfax County and the lives of Confederate women during the war. The album tells us that Laura interacted with both soldiers and civilians for the Confederate cause. Without the album, information about Laura would be limited to no more than a few paragraphs in the pages of books written by those who interacted with her and chose to write about her.

Some of the mystery can be cleared as we track who the signers were and when they most likely stopped by to gather intelligence on Union activities or to use her home as a "safe house." The album provides us with a heretofore unknown and totally fascinating glimpse of the covert lives of both civilians and soldiers during the war. We know the end point—the fun is figuring out how everybody got there.

THE RATCLIFFES AND
FAIRFAX COURT HOUSE

When Fairfax County was established in colonial Virginia in 1742, the county government was the "basic unit of local government."[4] The county was required to build a courthouse and offices for the justices, clerk and lawyers.[5] Accordingly, a courthouse was erected at Freedom Hill,[6] just south and west of today's Tysons Corner,[7] conveniently located along the Alexandria–Leesburg Road,[8] today's Leesburg Turnpike or Route 7.

However, as the population of Alexandria grew more rapidly than the population in the central and western portions of Fairfax County, the courthouse was moved to Alexandria by order of the governor in 1752.[9] The courthouse remained in Alexandria until 1798, when, due to neglect and lack of maintenance, the Virginia General Assembly ordered a search for a new location, this time back toward the center of the county.[10] In 1800, a new courthouse was opened for business in the town of Providence. Drawn by the new center of activity, and aided by the construction of new roads to the courthouse, a new community developed in Providence, which became known as Fairfax Court House during the Civil War[11] until it was incorporated into the town of Fairfax in 1875.

Richard Ratcliffe masterminded the establishment of the town of Providence and Fairfax Court House. Born in 1752, Ratcliffe became a planter and a lawyer, using both skills as he developed into a successful businessman.[12] In 1786, he began buying land up to three thousand acres in what would become the town of Providence.[13]

In 1794, Richard was established as a justice of the Fairfax County Court. To protect his interests, he offered to sell four of his acres to the Virginia Assembly for the sum of one dollar to build the new courthouse to replace the decaying structure in Alexandria. Located for favorable transportation at the crossroads of the Little River Turnpike (Route 236) and the Ox Road (Route 123), the offer was accepted in 1798, and the red

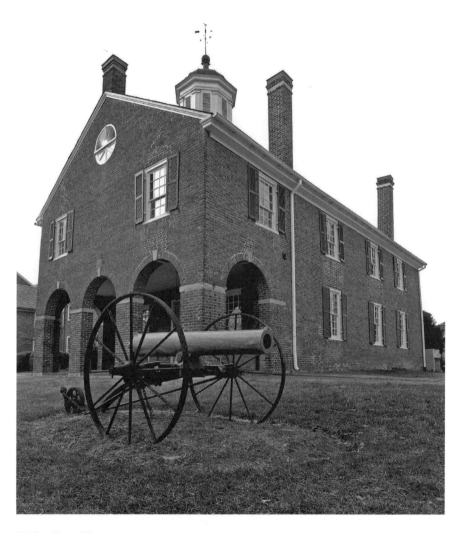

Fairfax Court House.

brick courthouse building that survived the Civil War and still stands today was opened in 1800.[14]

As the town grew, Ratcliffe prospered along with it. He built a large mansion for his family west of town on a plot of two thousand acres that was noted as the Mount Vineyard Plantation in the property tax records in 1816. The house was built on a hill, on the northwest corner of today's Oak and Main Streets, facing east toward the town Ratcliffe helped create.[15]

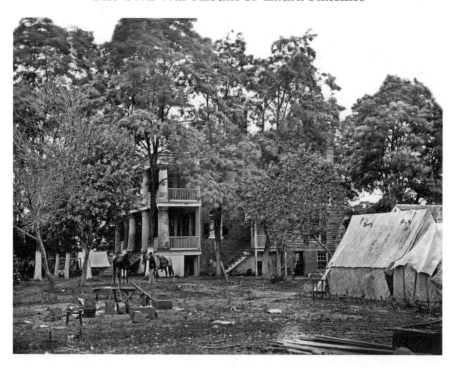

The Mount Vineyard Plantation house, built by Richard Ratcliffe, served as the headquarters of Confederate general P.G.T. Beauregard at Fairfax Court House and, later, as the headquarters of Union general George B. McClellan. *Courtesy of the Fairfax County Public Library, Photographic Archives.*

Ratcliffe, the father of eight children, lived there until he died at the age of seventy-four on September 20, 1825. He was likely buried with other family members in the southeast corner of the two-acre family cemetery on his property, along today's Moore Street.[16] By the time of his death, he had forty grandchildren and five great-grandchildren. One of his great-grandchildren, born just over a decade later, was Laura Ratcliffe.

Laura Francis Ratcliffe was born to Francis Fitzhugh Ratcliffe and Ann McCarty Lee on May 28, 1836. Fairfax Court House was the governmental, commercial and social center of Fairfax County, and its location just outside the city of Washington made it a highly visible and important crossroads during the war. Laura, who grew up in the town that her great-grandfather founded, attained a level of importance during the war for her covert and well-hidden activities and associations, in direct contrast to her great-grandfather's more decidedly public accomplishments.

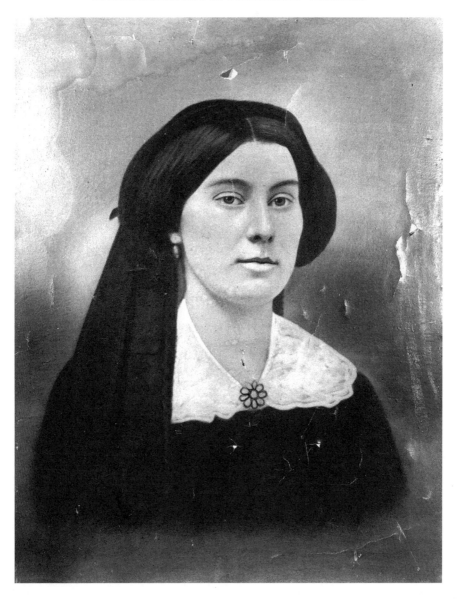

Miss Laura Ratcliffe, circa 1860.

WOMEN OF THE CIVIL WAR

Southerners held strong beliefs and opinions about the South's relationship to the North before the outbreak of the war. They felt that every Southerner's allegiance was to his state. They felt that they had a constitutional right to secede if they found the government to be oppressive and believed that it was their absolute duty to throw out that oppressive government and establish a new one. Southerners were as patriotic to their states as Northerners were to theirs.[17] Should the majority vote to secede, their allegiance was naturally and solely to their home state, the definition of their country.

When President Lincoln called for Virginians to furnish troops to put down the rebellion, Virginians felt that the United States government had no right to do so and that this act was an outrage on the rights of the commonwealth.[18] Once the fighting began, Southern men and women felt extremely optimistic about their chances for military success.[19]

The war, however, sparked fundamental changes in the lives of women in the antebellum South. Before the war, women remained in the sphere of the home and family, and only the men voted and spoke in public. The excitement of secession changed all of that as women became engrossed in politics. Not only would they speak of politics in private, but they also spoke publicly as they began to espouse their views in letters to local newspapers.[20]

In the very beginning, women were afraid that they would simply be left out of the war effort since the conflict seemed to belong to the men. This inaction drove many to seek "something to do to live to some purpose to be in the heat and turmoil of it all."[21] This desire to participate was indeed fulfilled in ways that changed the notion of womanhood in the South.

One fundamental change was the way that women defined themselves in relation to men. Before the war, they had defined themselves

first as daughters and sisters, then as wives and mothers. But the carnage of civil war suddenly forced women across the south to contemplate spending not just the duration of the conflict but perhaps the whole of their lives outside the protections and intimacies of marriage—to be women without men. In the new world in which they found themselves, "it will be no disgrace to be an old maid."[22]

While the men prepared for war, the women sent them off with enthusiasm, as there was little need to explain one's ambitions to join the war effort.[23] Whether there was a victory or loss in each battle, the women were left in anxiety and suspense, waiting for the list of wounded or killed, not wanting to see the names of those they had sent to the war.[24] Though the loss of their brothers, sons, beaus, neighbors or fathers to the war left women in poverty, with burdens to which they were certainly not accustomed, they still believed that it was the duty of every fit man to serve the Southern cause. The death of one of their relatives made women even more devoted to the cause.[25]

This spirit of resistance burned brightest among women. The vast majority suffered strain and hardship, fear and loneliness, hardship and privation rather than experiencing glamour and excitement.[26] A few did serve as spies, nurses or government clerks. The majority stayed at home in a house or cabin and did what they had to do to survive.[27] Few women became known during or after the war.

Once the battles began, many women in the area did more than just sit idly by. Women provided what care they could for the sick and wounded in whatever space was available in railway stations, schools, hotels, churches and even their homes. They provided food, blankets and bandages and offered the best support they could. It was difficult to break out of the prejudice of the time to practice as nurses in military hospitals, although a few women were able to do so.[28]

Still more women who did not live close to battlefields provided support by making clothing and knitting socks for their Southern troops.[29] Early in the war, they provided what food they could to the Southern camps, including chicken, ham, cakes, pies and pickles. As the war wore on, some of the women who lived in towns and cities worked for the Confederate government in ordinance plants, textile mills and garment factories.[30] Some women took to smuggling medicines, pistols and other scarcities under their hoop skirts and in their luggage.[31]

Women in the rural areas naturally assumed the responsibility for running their homes, farms and plantations. As fewer than a quarter of Southern whites owned slaves, few women had slaves or even children to do the

A Night on the Battlefield, Women's Devotion. Miss Tillie Russell holds Lieutenant Randolph Ridgely's head on her lap near the Rutherford Farmhouse on the Martinsburg Pike, near Winchester, circa 1909. *Courtesy of the Mary Custis Lee–17ᵗʰ Virginia Regiment, Chapter #7, United Daughters of the Confederacy.*

work of planting, plowing, harvesting, killing hogs, curing meat, cutting firewood and other farm chores.[32] Often their hardships were increased by Union soldiers in the area taking whatever they wanted from the houses or farms, and additional suffering was compounded in some cases by hungry Confederate soldiers taking whatever they needed as well. Women of all classes suffered—the poor worse than the privileged.[33] Deprivation, hunger, fear and danger affected all.

The behavior of Southern women toward the Yankees was based on the affront to their gender and status as white women by the invaders. Some responded to this outrage with the use of "words, gestures, chamber pots, and even on occasion pistols." One journalist noted, "By all odds, they were far worse rebels than the men."[34] Most Northern soldiers did indeed shy away from harming white women, especially those of the upper class. Many white women, however, used discretion to their advantage by manipulating the offending soldiers to what protection and advantage they could. Some women convinced Union officers to allow them to nurse wounded Confederates while smuggling clothing, boots and supplies to the needy soldiers.[35]

One way to smuggle goods was under one's hoop skirt, which came into fashion in the early 1850s and remained in fashion at the beginning of the war. Tied at the waist, and worn under a dress, these hoops, made of an intricate construction of steel, could have a circumference of over five feet in diameter. As inefficient as they made movement, they represented the Victorian culture that covered a women's anatomy while at the same time representing her "private space."[36] They also provided an opportunity to hide supplies by sewing them into the fabric, as no Yankee soldier dared to invade the women's privacy by breaching the shield provided by such a skirt.

Religion offered both consolation and justification for Southerners. The Confederate legislature adopted the motto *Deo Vindice*, or "Defended by God," to combine nationalism and religious fervor for its country. Religion, which was considered the sphere of women, provided them entrance into the male world of politics. It also provided them the context for dealing with the ordeals of the war. One Southern woman wrote, "It matters not how weak our cause, if but God and justice is on our side, we will at last triumph." And it was clear that "the Lord is on our side."[37]

For those who could still afford it, women traveled to visit relatives or friends in the service. Due to the lack of males to act as traditional escorts, women were beginning to travel more by themselves than before. Also, for those who had the means, reading was a popular pastime, escape and source of enjoyment. The Bible was widely read, along with fiction and whatever news was available of friends, relatives and the war itself.[38]

As the war wore on, however, the emotional and physical sacrifices started to take a psychological toll on women. The strain could become unbearable. One woman from Winchester in western Virginia declared herself "completely broken down mentally" by the end of the war. She also noted that there were a number of new patients in Virginia's Insane Asylum in Staunton, "made insane by the War—all women." Other women wrote, "I think my trials are more than I can bear" and "I have no time to grieve. Life is not desirable for life's sake. I could almost feel the wrinkles coming on my face and my hair turn gray on my head."[39]

As "sufferings and trials petrified," some women felt their feelings turn to stone. "I care very little for anybody or anything. I enjoy nothing, am neither sorry nor glad." One woman wanted to know, "For what am I living? Why is it I am spared, from day to day with no happiness myself? I am wearing a way."[40]

As hard as the war was, the aftermath proved just as difficult. The South had to adapt to the free labor system. With their husbands' incomes not enough or incompetent to support their family, women turned to work

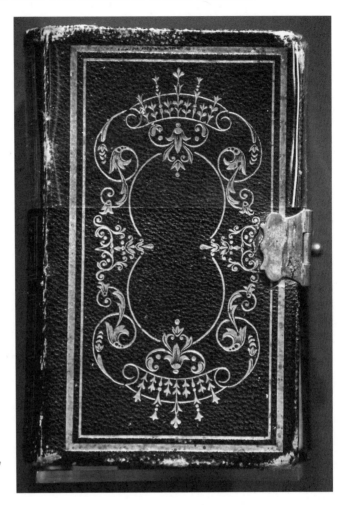

The cover of Laura Ratcliffe's 1850 *Book of Common Prayer*. D. Appleton and Company published the prayer book in Pennsylvania. *Courtesy of the City of Fairfax Historic Collections.*

outside the house, such as teaching, to bring in an income. Some found household work difficult. "Sometimes I cook and sometimes I don't and everything I do is done by guesswork. My ignorance and inexperience is a great trial."[41]

This fundamental change in Southern womanhood caused women to develop a new interest in themselves. New associations arose throughout the South, dedicated

> *not just to support suffrage or the Lost Cause, but temperance societies, educational and civic reform groups, church and missionary organizations, literary leagues, and women's clubs involved ladies in a variety of efforts aimed at personal and social uplift.*[42]

In his writings after the war, Georgian Confederate colonel James C. Nisbet expressed his recognition of the suffering that Southern women had endured and the need to pay homage to the support that these women had provided:

> *It was upon the women that the greatest burden of this horrid war fell. While the men were carried away with the drunkenness of the war, she dwelt in the stillness of her desolate home. May the movement to erect monuments in every Southern State to our heroic Southern women carve in marble a memorial to her cross and passion.*[43]

The Oakwood Cemetery dedication to Southern women, Richmond, Virginia.

GROWING UP

Laura's parents were Ann McCarty Lee (b. circa 1805, d. 1878) and Francis Fitzhugh Ratcliffe (b. 1800, d. 1842). Laura Frances Ratcliffe was born on May 28, 1836, in Fairfax Court House. She had one brother and two sisters. John R. Ratcliffe was born about 1830, Ann Marie Ratcliffe was born about 1833 and Cora L. Ratcliffe was born about 1835. Laura and her siblings were the great-grandchildren of Richard Ratcliffe, the founder of the town of Providence, commonly referred to as Fairfax Court House in the mid-1800s.[44]

When her great-grandfather died in 1825, he willed his property to his children, who mismanaged their money so badly that their heirs had to sell their properties to pay off their debts.[45] Laura's father, Francis F. Ratcliffe, sold his interest in his two lots to his brother Robert in 1829.[46]

In the 1840 census, Francis Fitzhugh Ratcliffe was recorded as living in the town of Providence, just southwest of the courthouse itself. The last official record of Laura's father, Francis, is from April 20, 1842, when he was listed on the personal property tax roll. There are no records available to show whether he paid the taxes or not. Presumably, he died around this time, as he is not listed in the 1850 census. His wife, Ann, is listed as a widow in the 1860 census.

There are other records that shed a little light on Laura's life. Private schools for boys and girls had been established in Virginia around the 1840s. Dr. Frederick Baker, a surgeon from England who became an American citizen in 1844, built a private school in 1845 in the town of Providence near where Laura lived. Located on a fifteen-acre tract next to the Zion Episcopal Church on the north side of the Little River Turnpike, Baker's school was a private finishing school for girls in Fairfax County, consisting of a small number of buildings for classrooms and his residence. He named the school Coombe Cottage and taught about eighty girls, both from within and from outside the estate.

Tuition was an expensive $100 per year for girls between the ages of thirteen and sixteen for room and board, indicating that it was only affordable to wealthy families. The girls typically attended for two years. Classes included instruction in English grammar, mathematics, history, geography, natural sciences, music, art, writing and the Bible. Kate Carper of Dranesville, who signed Laura's album, attended, as did her sister Frances Ellen. Their friend Antonia Ford also attended. The school was closed at the beginning of the Civil War[47] and was never reopened. The six buildings, including the Bakers' residence and four dormitories, were torn down after 1955.[48] The location is now occupied by the Mosby Apartments at 10560 Main Street.[49]

In July 1852, the year after Kate Carper graduated, one of her cousins wrote her a letter and mentioned that "the girls at Mrs. Baker's were disappointed as you did not go down. Laura Ratcliffe was there, more lovely than ever."[50] Laura was sixteen years old at this time, and although there is no record of her attending Coombe Cottage, this letter at least places her at the school on one occasion. Laura, being Episcopalian, would have attended Zion Episcopal Church, located next to Coombe Cottage, while living in Providence, as did a number of girls at Coombe Cottage.[51] Coombe Cottage was within walking distance of Laura's 1850 and 1860 residences.

Later, a schoolmate of Kate Carper, Kate Keech, sent a letter to Kate on January 28, 1858, that mentions Laura. It reads:

> *I got a long letter from Jenny Baker a few days since. She was begging me to come up about the middle of February and I only wish I could see you while there—cannot you come? Laura Ratcliffe asked me to come and I will spend part of my time with her.*[52]

The Ratcliffes kept Mount Vineyard, the home of Laura's great-grandfather Richard Ratcliffe, located west of the town of Providence, in the family until 1842, when it was sold to the family of W.T. Rumsey from New York.[53]

In September 1850, Laura was listed in the Fairfax census with her mother Ann, brother John and sister Cora. Laura's sister Ann Marie married her second cousin Richard Coleman, the son of Patsy Ratcliffe, in 1850 and moved near Dranesville. Due to the wide-ranging nature of the properties in the sequence of this census, it is impossible to determine with any certainty where Laura lived. Laura's brother John later moved to Centreville to live with the Grisby family and work as a clerk in their store.[54]

In her landmark article "Portrait of Laura," Jeanne Rust states, "Laura attended school in the city of Fairfax at an early age but upon her father's

One of the six dormitories at Coombe Cottage. *Courtesy of the Fairfax County Public Library, Photographic Archives.*

The Zion Episcopal Church prior to the war.

death moved to the Frying Pan area with her mother and two sisters." Her mother had originally come from this area. Her mother's family owned large plantations from Herndon to Chantilly. They settled on a large farm near Chantilly, "where [Laura] grew into a beautiful young lady—capable and loyal." She had dark eyes and jet black hair. "Her face and figure made a striking appearance as she rode about the farm helping her mother manage the workers." Her neighbors admired and were very fond of her. Laura loved her home in the South and became loyal to the Confederacy.[55]

Unfortunately, there are no records of the Ratcliffe family owning such farms until after the war, a matter that will be discussed later. It seems more plausible that Laura moved to the Frying Pan area after her sister Ann Marie married George Coleman, who lived, and whose relatives also lived, in the area. It is also possible that the Ratcliffes moved into an empty house, as it was common for families to abandon their houses and properties during the war for fear of reprisals from one side or the other.

Laura did not move to the Frying Pan area immediately after her father's death, as she and her family were still listed in the Fairfax Court House area in the September 8–10, 1860 census. She lived with her mother, Ann M., age fifty-five, listed as a widow; her sister Cora, "C.L.," age twenty-five, listed as a lady; her brother, John R., age thirty-one, listed as a clerk; and William H. Dulany, listed as an attorney at law. Laura, listed as "L.F.," was twenty-three. William H. Dulany, later the captain of Company D, Seventeenth Virginia Infantry, is noted elsewhere as residing with the widowed Mrs. Ann McCarty Ratcliffe and her children Laura and John R. in Fairfax County in 1860.[56]

In 1860, the location of the Ratcliffe family's residence can best be deduced by the sequence of families listed in the census. Since the Ratcliffe family did not own property, one can only make an educated guess as to where Laura lived. Two possibilities were that the Ratcliffes were living in a house on one and three-quarters acres owned by Margaret C. Farr[57] or on the property just to the south of Margaret Farr's lot owned by Harrison Monroe. It turns out that the Ratcliffes and the Farrs were related, as Samuel Farr married Ann Ratcliffe,[58] sister to Richard Ratcliffe's father.[59]

A third possibility is that the Ratcliffe family lived on a lot in Providence proper owned by Narcissa Monroe, the wife of Harrison.[60] Narcissa claimed that she had nine buildings consisting of storehouses and tenement houses on three lots when she sought compensation from the Southern Claims Commission in May 1877 for losses to Union soldiers during the war. She claimed that two of her houses had been torn down to build quarters for Union soldiers camping in the courthouse area. Having had to prove her loyalty to the Union during the war, however, her claim was not allowed.[61]

The Civil War Album of Laura Ratcliffe

Rentals were often not recorded, and owners did not always live on their properties. Due to the inability to trace the exact sequence of the houses in the census—especially considering that when no one was at home, the census taker had to return later—it is maddeningly difficult to trace the census taker's path and to completely understand who lived where.

Today, the location of the Farr property is the northeast corner of Route 236, Main Street and Old Lee Highway in the city of Fairfax. More precisely, this house would have been located just east of the intersection of Old Lee Highway and North Street, in what is the Main Street Marketplace at 10320 Main Street. The Harrison Monroe property was just south at the corner of Old Lee Highway and Main Street, also part of the Main Street Marketplace. One Narcissa Monroe property was lot number fifteen of the original nineteen lots laid out in the town of Providence by Richard Ratcliffe on the southwest corner of East and Main Streets. The second property was a part of lot number twelve, closer to the courthouse itself. The Farr and Harrison Monroe properties to the east of Old Lee Highway were not considered a part of the town of Providence; rather, they were a part of Fairfax Court House.

Based on the 1860 census, we know that Laura and her family moved to the Frying Pan area after September 1860 and probably before the Battle of Dranesville in December 1861, when Laura attended to J.E.B. Stuart's wounded soldiers at nearby Frying Pan Church.

Ann McCarty Lee had inherited land, 113 acres on lot four, from her mother, Sinah Chichester Lee, in 1851, located about sixteen miles southeast of Frying Pan in the Burke area between Burke Lake and Lee Chapel Road. There were no buildings on the land, however, so they could not have lived there. Ann's mother, Sinah, resided on lot nine in the same area. Ann Ratcliffe did not own land in Frying Pan until after the war.

Ann sold lot four to her brother, Richard Lee, in 1869. He had inherited the adjacent lot five.[62] It wasn't until she sold this lot that Ann purchased the Merrybrook property, where Laura lived after the war until she died. In all likelihood, Ann and her family chose to move to Frying Pan to live in a vacant house near the Colemans, where her daughter Ann Marie lived.[63]

There are two locations frequently mentioned when discussing where Laura, her mother and sister lived during the war. One location, in the Frying Pan area, was known after 1908 as the Peck house. Margaret Cockerille Peck of Floris (as Frying Pan was renamed in 1879) is married to H. Ben Peck, whose family purchased the house.

According to local legend or lore, Mrs. Peck believes that Laura and her sister lived in the house at 3106 Centreville Road, where her husband, Ben,

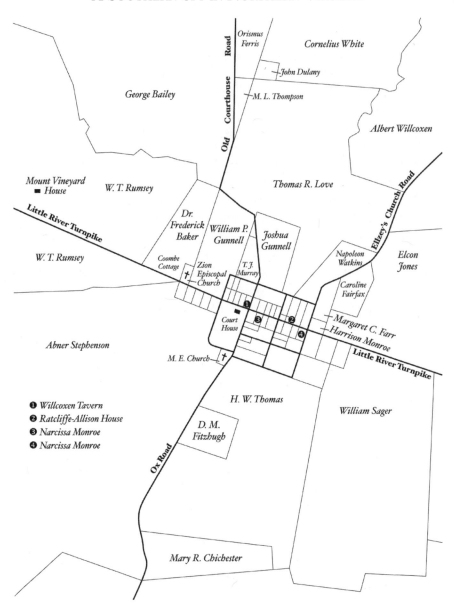

An 1860 map of the Fairfax Court House area. *Courtesy of Stephen Wolfsberger.*

was born in 1920. Margaret says that Cora and Laura lived in this house, a one-and-a-half-story frame house, from which a portion was removed before 1948. Cora taught school to local students, and classes were held in the room facing Centreville Road (east). The north room had a fireplace and at one time had been divided into two rooms. She noted that the woodwork on the first floor was similar to that at nearby Sully Plantation.

The house, with acreage, was deeded to the Peck family in 1908 and remained in the Peck family until the eastern half of the farm was sold in 1958. The location of this house was on the west side of Centreville Road, just south of the northern intersection of Kinross Circle.[64] During the Civil War, this house belonged to William T. Smithson, who purchased it on April 27, 1861, from Henry S. and Mary Halbert.[65] Of note is the fact that all of these parties are listed as living in the city of Washington, making it plausible that the Ratcliffe family also lived there.

The second location in which the Ratcliffes might have lived during the war was a little farther north on Centreville Road at what was known as the Patton house. This house was closer to the Frying Pan, now the Floris, area and was also located on the western side of Centreville Road, just north of the intersection with McLearen Road. The Patton family purchased this house in 1915.[66] This property was adjacent to and just south of property owned by Charles T. Coleman, which in turn was just south of the property owned by George Coleman in 1851.

One theory is that the Ratcliffes lived in a house abandoned by its owners. Mayo Janney owned the Patton house during the war,[67] and there is at least one reference to him living there in December 1861. A soldier from the Second Virginia Cavalry in Dranesville wrote a letter to Kate Carper of Bloomfield on Christmas Day 1861 stating that he had spent the previous evening at a party at Mr. Mayo Janney's home. Janney's house was noted in the letter as being about one mile south of Frying Pan Church on Centreville Road, and it indeed is so.[68]

As mentioned earlier, William T. Smithson of Washington purchased the Peck house and 440 acres of farmland on two lots in 1861.[69] On the deed of April 27, 1861, Smithson is noted as living in Washington. Based on the District of Columbia city directories, Smithson is also listed as living in Washington in 1862[70] and 1863.[71] He is not listed there in 1864 but was living in Baltimore City in 1865, when he mortgaged the Peck property.[72] Smithson eventually sold the property in 1870.[73]

There are no records of a lease or rent paid by the Ratcliffe family, but this certainly supports the theory that the Ratcliffes lived in Smithson's house during and after the war, while Smithson and his wife lived elsewhere. The

size of the Smithson property on two lots certainly could have led to Jeanne Rust's misconception that Laura's mother "owned" large plantations.

Fortunately, there are two maps from the war that shed light on the location of the Ratcliffe family residence. The first is the January 1, 1862 *Map of North Eastern Virginia and Vicinity of Washington*, drawn for Union general Irvin McDowell. This map shows Centreville Road from Frying Pan south to Lee Jackson Highway. On this map, M. (Mayo) Janney's house is shown just to the south of Frying Pan, and the Halbert house is farther to the south on Centreville Road. William Smithson is not yet shown as having taken ownership of the house from the Halberts.

The second map is a *Map of Fairfax and Alexandria counties, Virginia, and parts of adjoining counties*, dated April 25, 1854,[74] by Captain Michler, U.S. Corps of Topographical Engineers, Army of the Potomac.[75] On this map, Frying Pan Church is noted as being in ruins, and to the south, on Centreville Road, the Radcliffe [*sic*] house is shown, with other unnamed houses marked in between. The location of the Ratcliffe house is much farther to the south than where the Janney/Patton house was, and it is in the same location as the Halbert/Smithson/Peck house. Both maps also note the location of the Chantilly Church. Based on the relative positions of these two houses between Frying Pan and the Chantilly Church, it seems most likely that the Ratcliffe family lived in the house purchased by the Peck family on April 1, 1908. While the Ratcliffe family was likely not known to the Federal authorities in early 1862, they were well known to the Union army by 1864.

There is another reference to the location of Laura's house by noted Mosby experts Thomas J. Evans and James M. Moyer. These authors describe the location of Laura's house during the war in their book *Mosby's Confederacy, A Guide to the Roads and Sites of Colonel John Singleton Mosby*. For this book, the authors were guided to the site of Laura's house during the war by local resident Gladys Utterback, who knew Laura as a young girl, before she died. According to Mr. Evans, this was just before the book was published in 1991. The house was torn down shortly thereafter.

Mr. Evans noted that the house was a small frame bungalow that had been faced with brick. He said that Laura may have fed Mosby and his men in the house but that they may have stayed in a barn set farther back from Centreville Road. The size of the house, however, was larger during the Civil War than when Evans and Moyer saw it, since a portion of the house was removed in 1948, as described by Margaret Peck.

In their book, Evans and Moyer describe the location of Laura's house as "the Old Peck Home." The house was on the left, or western, side of Centreville Road at the location noted by Ben Peck. "In front of the old silo

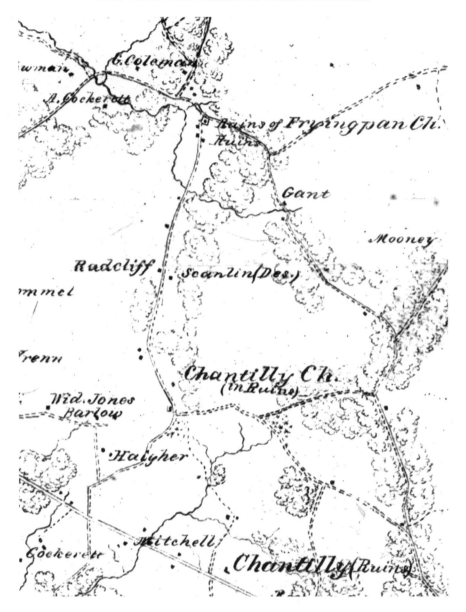

The 1864 Michler map of Centreville Road between Frying Pan and the Chantilly Church showing the location of the "Radcliffe" house. *Courtesy of the Library of Congress.*

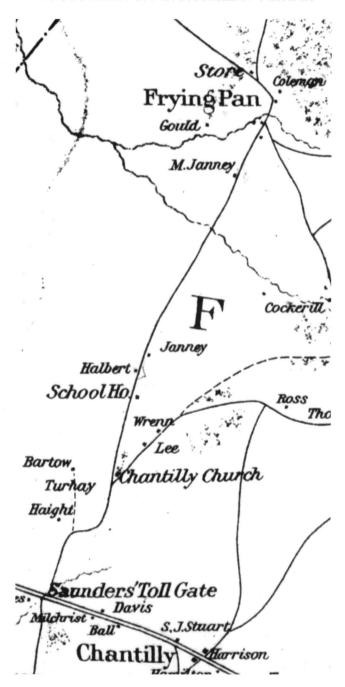

The 1862 McDowell map of Centreville Road between Frying Pan and the Chantilly Church showing the location of the Halbert house, where the Ratcliffe family lived during the war. *Courtesy of the Fairfax County Public Library, Photographic Archives.*

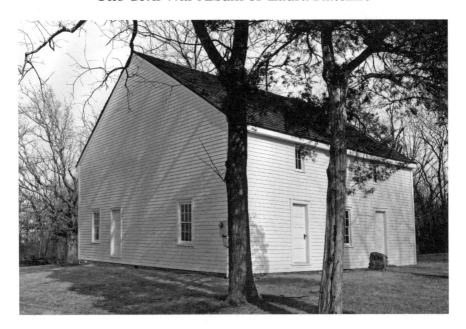

Frying Pan Church.

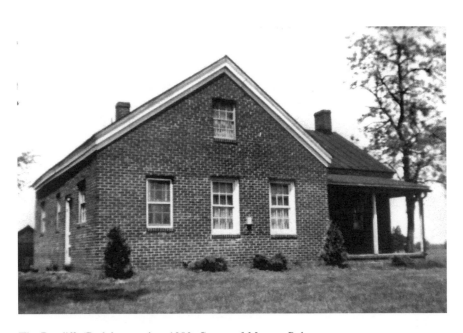

The Ratcliffe/Peck house, circa 1950. *Courtesy of Margaret Peck.*

Fairfax 26th July /65

Dear Girls

Can't some of you come this evening and go to Mr. Lee's? I have only had seven scholars to-day, and ca be free this evening. I don't think there is any probability of being disappointe by company this time: try and come.

Yours truly — Cora

Letter from Cora Ratcliffe, July 26, 1865. *Courtesy of Margaret Peck.*

A brass buckle, possibly from a woman's coat, from Laura Ratcliffe's Civil War house. *Courtesy of the Herndon Historical Society.*

A flower button from a woman's dress or coat, from Laura Ratcliffe's Civil War house. *Courtesy of the Herndon Historical Society.*

A small Confederate flat button, from Laura Ratcliffe's Civil War house. *Courtesy of the Herndon Historical Society.*

A Federal jacket button, from Laura Ratcliffe's Civil War house. *Courtesy of the Herndon Historical Society.*

is the childhood home of Laura Ratcliffe. Here she spent many happy years before the war." The book goes on to note that the Frying Pan Church is one and a half miles farther north of Centreville Road.[76]

Margaret Peck provided a picture of the house, which corresponded to Mr. Evans's memory[77] of the house before it was torn down.[78]

Mrs. Peck also provided the author with a letter written to her great aunts, Mary and Nancy Cockerille, from Cora Ratcliffe, whom she states was living in the Peck house in 1865. The letter reads:

Fairfax 26th July/65

Dear Girls:
Can't some of you come this evening and go to Mr. Lee's? I have only seven scholars to-day, and can be free the evening. I don't think there is any probability of being disappointed by company this time: try and come.
Yours truly—Cora

The Historical Society of Herndon allowed me to take pictures of the artifacts in its possession that Mr. Evans collected while visiting the Peck house during his research and later donated to the society.

LETTERS AND POEMS

At the beginning of the war, Laura lived in the Frying Pan area, just south of the village of Herndon in the western end of Fairfax County, with her mother, Ann, and her sister Cora. Her sister Ann Marie lived to the north in Dranesville, and her brother, John R., became a member of the Seventeenth Virginia Infantry. The area was under constant patrol by both Northern and Southern troops due to its proximity to the city of Washington. Battles were fought in nearby Manassas, Chantilly and Dranesville, keeping the residents in a constant state of alarm. Fairfax County and the entire Northern Virginia area were devastated—fences were used for firewood and scores of houses were destroyed.[79]

Following his home state of Virginia's secession from the Union, First Lieutenant James Ewell Brown Stuart mailed his letter of resignation to the U.S. Army on May 3, 1861, while at the same time requesting a command in the new Confederate army. He received a commission as lieutenant colonel in the Provisional Army of Virginia.[80] Following his successful participation in the Confederate victory at the First Battle of Manassas, Stuart proceeded to Fairfax Court House on July 23, now as a full colonel of cavalry. He set up camp there but spent most of his time during the following three months in forward positions in Falls Church, six miles from the Potomac River, keeping an eye on the city of Washington and the Federal troops in the easternmost portion of Fairfax County.[81] Gaining prominence for his achievements, Stuart was quickly promoted to brigadier general on September 24, with command of a brigade of six regiments of fifteen hundred horsemen.[82] Stuart's headquarters staff consisted of forty-eight men, with over two hundred others also serving him.[83]

In October, Stuart was given command of all of the advanced forces in Northern Virginia. He established new headquarters in the Millan house, which was located a little farther back from Falls Church, between Fairfax

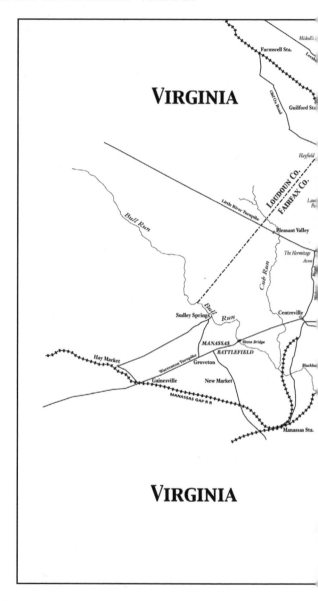

A map of Fairfax County during the Civil War. *Courtesy of Stephen Wolfsberger.*

Court House and Centreville on today's West Ox Road, just south of today's Lee-Jackson Highway, or Route 50. He named this Camp Qui Vive (or Camp "Who Goes There?"), challenging a person's political sympathies. "On the qui vive" was also a common expression at the time, meaning to be vigilant or on the alert.[84] The Millan family had already left for Warrenton with their furnishings prior to Stuart moving in.[85]

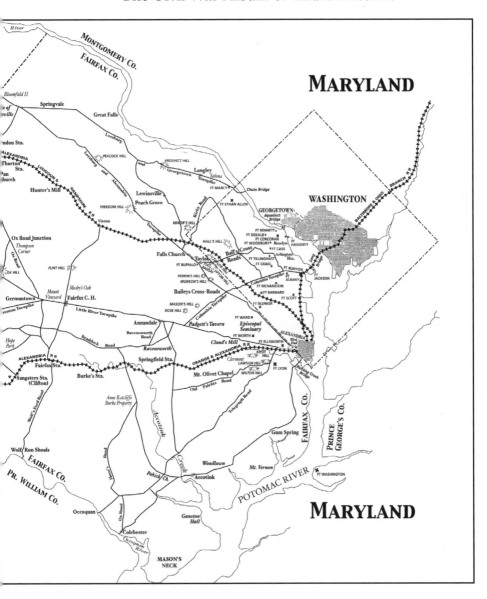

Stuart's everyday duties at camp were interrupted on December 20 when Stuart took 150 of his cavalry and 1,600 infantry to Dranesville to cover a foraging expedition for hay from Manassas. Here the Confederate force unexpectedly ran into 4,000 men under Union general E.O.C. Ord who were in Dranesville to capture a Confederate cavalry picket and to do some foraging of their own. A two-hour artillery and infantry battle took place, with Stuart retreating and returning the next day to find that the Federal

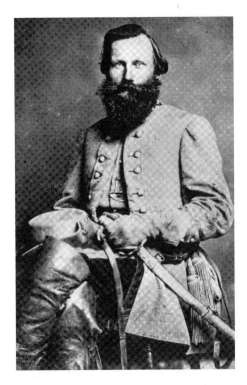

Left: J.E.B. Stuart.

Below: The Millan house, Camp Qui Vive.

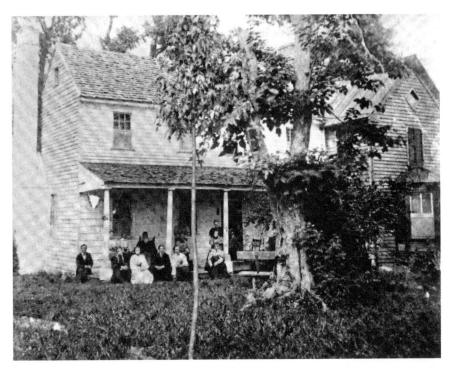

forces had withdrawn. The battle was a Union victory, with 7 Union soldiers killed and 61 wounded and 43 Confederate soldiers killed, 143 wounded and 8 missing.[86]

In Stuart's report on the battle, he noted that during the retreat after the battle on the twentieth "the enemy was evidently too crippled to follow in pursuit, and after a short halt at the railroad I proceeded to Frying Pan Church, where the wounded were cared for." The next day, Stuart continued:

> *Learning that the enemy had evacuated Dranesville,* [and] *had left some of our wounded there, I pushed on to that place to recover them and take care of the dead. I found our dead on the field, and proceeded at once to remove them all to Centreville for interment. The wounded (about 10) were left by the enemy at a house in Dranesville, who intended to send for them the next day. They were cared for with the utmost devotion by several of the ladies of the place. They were also removed to Centreville, except two, who were not able to survive the removal, who at their own desire and at the surgeon's advice were left in charge of the ladies.*[87]

Stuart then returned to Camp Qui Vive.[88]

It was at this time that Stuart met Laura, who had tended to his wounded soldiers at Frying Pan Church after the Battle of Dranesville. In his book *Lee's Cavalrymen*, Edward Longacre wrote:

> *Captivated by Laura's beauty, pleasant nature, and helpfulness (he had observed her nursing some of his wounded), the cavalry leader not only waltzed with the young woman, but accompanied her on horseback rides as well. When snow fell after the first of the year, the couple went sleighing. It would appear that Stuart was smitten. Even as he wrote letters home expressing his devotion to (his wife) Flora, he composed moonstruck poetry to Laura Ratcliffe.*[89]

While there is no record of Laura's feelings for Stuart, it is clear that Stuart attempted to use Laura to gather military intelligence.[90] Letters that Stuart wrote to Laura over the next three months of relative inactivity illustrate their newfound friendship:

> *Camp Qui Vive Dec 25th*
> *A Merry Christmas to you this bright morning!*
> *I deeply regret that duty will prevent me from enjoying the pleasure I so much anticipated of taking my Christmas dinner with you. It so happens*

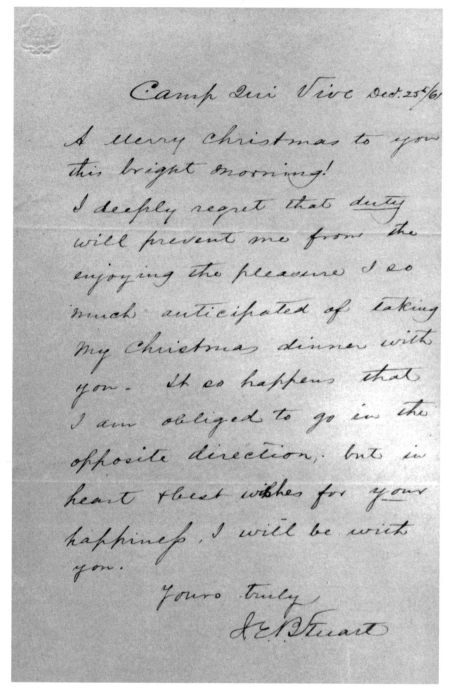

Camp Qui Vive Dec. 25th/61

A Merry Christmas to you this bright morning!

I deeply regret that duty will prevent me from the enjoying the pleasure I so much anticipated of taking my Christmas dinner with you. It so happens that I am obliged to go in the opposite direction; but in heart & best wishes for your happiness, I will be with you.

Yours truly,
J.E.B. Stuart

A letter to Laura from J.E.B. Stuart at Camp Qui Vive on December 25, 1861. *Courtesy of the Library of Congress.*

Camp Qui Vive
 Jany 6 1862.
A Happy near Year.
I send you a nice
bean Capt Rosser
(Miss Antonia's friend)
he will escort you
here to dinner, and
thence to the CH: to
spend a night with
Mrs Ford. Be assured
I sacrifice a great
personal pleasure in
foregoing this visit for

This page and next: An envelope and letter to Laura from J.E.B. Stuart at Camp Qui Vive on January 6, 1862. *Courtesy of the Library of Congress.*

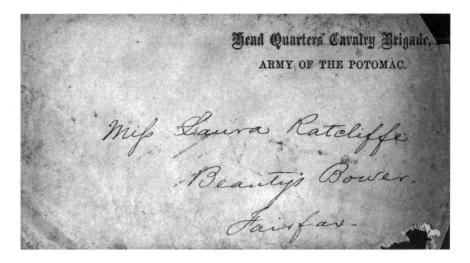

that I am obliged to go in the opposite direction: but in heart and best wishes
for your happiness, I will be with you.
Yours truly
J.E.B. Stuart

Laura was a friend and cousin of Antonia Ford, who, like Laura, was a staunch Confederate supporter. Antonia, however, was suspected for her activities in aiding Mosby and spying, and she was arrested and taken to the Old Capitol Prison for three months in 1863.[91] As one letter was addressed to both Laura and Antonia at Frying Pan, it is possible that Antonia was staying with the Ratcliffe family at this time:

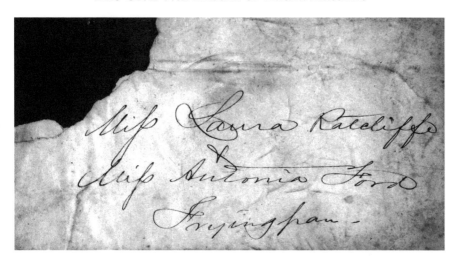

Miss Laura Ratcliffe
& Miss Antonia Ford
Fryingpan —

Centreville Jan. 30ᵗʰ 1862
My Dear Ladies —
 It is such a muddy
day that I refrain from visit
-ing you because, I would
dislike to appear in such
an impresentable a
costume as the roads
would give me.
Nevertheff you may expect
me soon rain or shine.
 Yours
 J.E.B.

This page: An envelope and letter to Laura Ratcliffe and Antonia Ford from J.E.B. Stuart in Centreville on January 30, 1862. *Courtesy of the Library of Congress.*

Miss Laura Ratcliffe
Beauty's Bower
Fairfax
Camp Qui Vive
Jany 6, 1862
A Happy new year.
I send you a nice beau Capt. Rosser (Miss Antonia's friend) he will escort you to here to dinner and hence to the Csd. to spend a night with Mrs. Ford. Be assured I sacrifice great personal pleasure in forgoing this visit for your sake and Capt. R's.
With sincere regards
Yours J.E.B. Stuart

Miss Laura Ratcliffe &
Miss Antonia Ford
Frying Pan Centreville, Jan 30th 1862
My Dear Ladies—
It is such a muddy day that I refrain from visiting you because, I would dislike to appear in such an unpresentable a costume as the roads would give me.
Nevertheless you may expect me soon rain or shine.
Yours
J.E.B.

Soldier's Lodge
Feby 3, 1862
Ladies:
It is snowing too hard for you to think of travelling to-day, but look out for a sleigh-ride tomorrow.
Yours,
J.E.B.

Stuart also wrote to Laura noting that she didn't write as frequently as he would have liked:

If you knew how I would prize a letter you would write to me every opportunity. Have you forgotten?—
J.E.B.

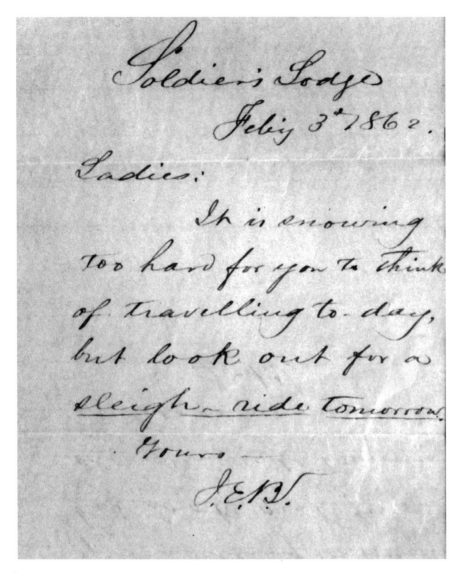

A letter to Laura from J.E.B. Stuart at Soldier's Lodge on February 3, 1862. *Courtesy of the Library of Congress.*

Starting in January 1862, Stuart returned to scouting, as the poor conditions of the road delayed any major campaigns until spring. Stuart now had 185 officers and 2,200 enlisted men patrolling the area from the Blue Ridge Mountains to the Potomac River, a front forty to fifty miles wide.[92] During the first week of March, Confederate general Joe Johnston, fearing that McClellan would move on his position, decided to leave Manassas and

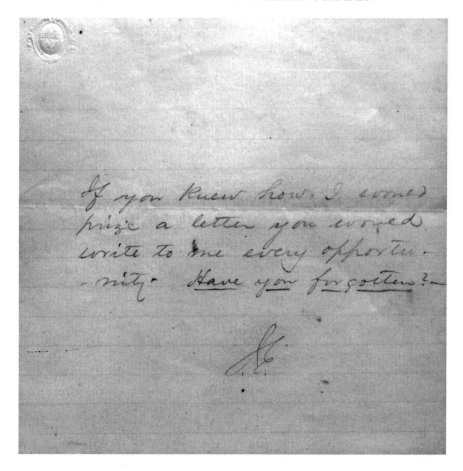

An undated letter to Laura from J.E.B. Stuart. *Courtesy of the Library of Congress.*

move the Confederate army south to Fredericksburg. Stuart stayed behind to cover the rear of Johnston's army. On March 12, Stuart reported that McClellan's troops had indeed moved into Manassas. Stuart then moved south to Warrenton until the end of March to ascertain if McClellan would follow Johnston or advance on Richmond via the Potomac.[93]

While near Warrenton, Stuart wrote to Laura and asked her to remain true to the Confederate cause. He offered his protection should she decide to leave her home, as the Yankees knew that he and his troops were no longer surrounding her in Northern Virginia.

In the same letter, Stuart disguised the names but was probably talking about Captain Andrew Pitzer and Colonel Richard C.W. Radford, both of the Second Virginia Cavalry, who served with him in Fairfax County in late 1861[94] and

This and next 3 pages: A letter to Laura from J.E.B. Stuart near Warrenton on March 17, 1862. *Courtesy of the Library of Congress.*

probably met Laura at Camp Qui Vive. He also discussed the recent success of the ironclad ship *Merrimac* at Hampton Roads on March 8:[95]

Camp Laura
Mar. 17, 1862

fair promises and soft whining speeches. Will my Laura regard such? Can her faithful heart be turned? something whispers "no never". I hope you will give the yankees a wide berth and only use the list I gave you in case you got into any serious trouble & required protection. I have no friends on the yankee side. The enemies of my country are my enemies, and I feel assured are also my Laura's enemies.

I saw Major P–g–a, the other day – and all of R f d's command are with me again. Your friends are all well and in fine fighting trim – We are bound to whip the yankees this time worse than ever, and it will not be many months before I lead the trium-phal advance into Pennsylvania.

My Dear Laura,

I have thought of you long and anxiously since my last tidings from you. I had splendid quarters provided at Bell Air near Warrenton for you and Mrs. Coleman whose husband led me to hope that you were coming—but I was disappointed. I could not counsel you to leave your mother but if you for any cause make up your mind to leave Fryingpan and will find your way to our lines I will provide you a home and take good care of you. Our enemies are playing a good game pretending to restore instead of destroying as we

Let me caution you in the mean time to be prepared for the most outrageous slanders on us and our cause. Turn a deaf ear to all accounts, and keep an abiding faith in the justness of our cause and the help of God.

We had a glorious naval success at Norfolk _ sinking and disabling 3 vessels. the Cumberland, Congress and Minnesota. It was all done by the Merrimac whose name is changed to "Virginia."

You will no doubt find opportuni-ties to send me an occasional note, I need not say how much it will be prized _ dont you know? Have it well secreted, & let it tell me your thoughts, freely & without reserve. Can I ever forget that ~~~~~~~~~~ that never to be forgotten good-bye? Will you forget it?

Will you forget me? I am vain enough Laura to be flattered with the hope that you are among the few of mankind that neither time, place, or circumstance can alter— that your regard, which I so dearly prize, will not wane with you moon that saw our last parting, but endure to the end. That whatever betide me in this eventful year you will in the corner of that heart so full of noble impulses find a place in which to stow away from worldly view the "young Brigadier", even when that bullet-proof helmet (raven-look) has fulfilled its last mission. I do not wish you to destroy this but keep it and take it out occasionally to remind you of the thoughts & sentiments of "the absent one". I left my notepaper in my trunk which is not now here, you must therefore excuse this sheet. You will no doubt get this tomorrow. Can you guess who wrote this, I'll let you try.

do; and I have no doubt we have a plenty silly enough to put confidence in their fair promises and soft whining speeches. Will my Laura regard such? Can her faithful heart be turned? Something whispers "no never." I hope that you will give the yankees a wide berth and only use the list I gave you in case you got into serious trouble requiring protection. I have no friends on the yankee side. The enemies of my country are my enemies, and I feel assured are also my Laura's enemies. I saw Major P_z_r the other day and all of R_f_d's command are with me again. Your friends are all well and in fine fighting trim—We are bound to whip the yankees this time

worse than ever, and will not be many months before I lead the triumphal advance into Pennsylvania. Let me caution you in the mean time to be prepared for the most outrageous slanders on us and our cause. Turn a deaf ear to all accounts, and keep an abiding faith in the justness of our cause and the help of God.

We had a glorious naval success at Norfolk—sinking and desabling [sic] *3 vessels, the* Cumberland, Congress *and* Minnesota. *It was all done by the* Merrimac, *whose name is changed to "Virginia." You will no doubt find opportunities to send me an occasional note, I need not say how much it will be prized—Don't you know. Have it well secreted, and let it tell me your thoughts, freely and without reserve. Can I ever forget that* [two words scratched out]—*that never to be forgotten goodbye? Will you forget it? Will you forget me? I am vain enough Laura to be flattered with the hope that you are among the few of mankind that neither time, place, or circumstances can alter—that your regard, which I so dearly prize, will not wane with your moon that saw our last departing, but endure till the end. That whatever betide me in this eventful year you will in the corner of that heart so full of noble impulses find a place in which to stow away from worldly view the "Young Brigadier," even when that bullet-proof helmet (raven-lock) has fulfilled its last mission. I do not wish you destroy this but keep it and take it out occasionally to remind you of the thoughts and sentiments of "the absent one." I left my notepaper in my trunk which is not here, you must therefore excuse this sheet. You will no doubt get this tomorrow. Can you guess who this is, I'll let you try—*[two words scratched out]—*Good bye.*[96]

It is likely that Stuart gave Laura the album, or had it sent to her, before leaving Northern Virginia in early March as he left Camp Qui Vive, knowing the uncertainty of when he might return and not knowing where the upcoming year's campaigns might take him. The album, printed by E.H. Butler & Co. in Philadelphia,[97] measured ten and a half inches high, eight inches wide and one and a half inches deep. It was full of blank pages except for the cover page.

Stuart also gave Laura his watch chain with a gold dollar attached.[98] It was an opportunity to make an impression on young Laura and to keep her gathering information for his, and others', benefit should he pass through Fairfax County in the future.

The cover page of the album had the words "Presented To" preprinted on it, followed by Stuart's explanation of why he had given it to her:

The cover of the album that J.E.B. Stuart gave to Laura Ratcliffe.

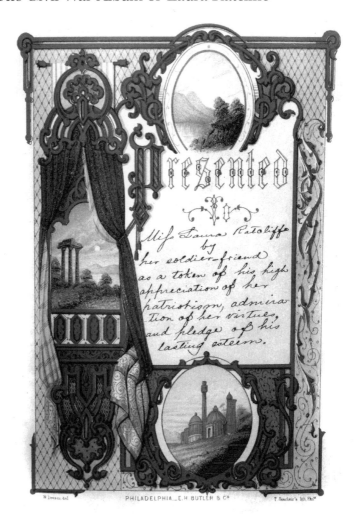

The cover page of the album that J.E.B. Stuart gave to Laura Ratcliffe.

Presented
To
Miss Laura Ratcliffe
by
her soldier-friend
as a token of his high
appreciation of her
patriotism, admira-
tion of her virtues,
and pledge of his
lasting esteem.

Of the eleven written pages, however, there are only three with dates, and there is no indication of when Stuart actually gave the album, or had it delivered, to Laura.

The first of two poems that Stuart wrote entitled "To Laura" was dated March 3, 1862:

To Laura

We met by chance: yet in that 'ventful chance
The mystic web of destiny was woven:
I saw thy beauteous image bending o'er
The prostrate form of one that day had proven
A hero fully nerved to deal
To tyrant hordes—the south avenging steel.
'Twas woman's cherished sphere. Thy self-devotion—
Enchanted my heart; were all true as thou,
This war were not, and peace were still our portion.
I saw thee soothe the soldier's aching brow—
And ardent wished his lot were mine—
To be carresses [sic] with care like thine.
Fair Laura, (I flatter not,)—thy praise
Is writ in words which war's alarms
Or time can ne'er from mem'ry efface.
Thy worth, they modesty, not the least of charms—
Will be the soul-inspiring theme
To fill th' enraptured "soldiers dream"
The past to one is precious: and to thee—
I trust it is not all regret, but even
In war's dread desolation there may be
Some charmed remembrance of its havoc given
Some long-cherished, ne'er forgotten token
One friendship made ne'er to be broken.
To Him omnipotent I leave thee now—
Years, long years, our paths, may sever
May grief o'er shadow ne'er my Laura's brow—
And fortune smile upon thee ever.
And when this page shall meet your glance,
Forget not him, you met be chance
Mar. 3, 1862 J.E.B. ...

To Laura.

We met by chance; yet in that 'ventful chance
The mystic web of destiny was woven;
I saw thy beauteous image bending o'er
The prostrate form of one that day had proven
A hero fully nerved to deal
To Tyrant hordes—the south—avenging steel.

'Twas woman's cherished sphere—thy self-devotion—
Enchained my heart; Were all as true as thou,
This war were not, and peace were still our portion.
I saw thee soothe the soldier's aching brow—
And ardent wished his lot were mine—
To be caressed with care like thine.

Fair Laura, (I flatter not)—thy praise
Is writ in words which war's alarms
Or time can ne'er from mem'ry efface
Thy worth, thy modesty, not the least of charms—
Will be the sone—inspiring theme
To fill th' enraptured "soldier's dream"

The past to me is precious; and to thee—
I trust it is not all regret, but even
In war's dread desolation there may be
Some charmed remembrance to its havoc given
Some long-cherished, ne'er forgotten token
One friendship made ne'er to be broken.

To Him omnipotent I leave thee now—
Years, long years, our paths, may sever
May grief o'ershadow ne'er my Laura's brow—
And fortune smile upon thee ever.
And when this page shall meet your glance
Forget not him, you met by chance.

J. E. B.

Mar 3ᵈ 1862.

The first poem "To Laura."

It is the end of this poem ("To Him omnipotent I leave thee now— / Years, long years, our paths, may sever) that indicates that Stuart was planning to give the album to Laura as he was preparing to leave Northern Virginia in the spring of 1862, not knowing if he would ever return to see her. He had not yet decided to give John Singleton Mosby an independent command to operate in Northern Virginia, and he hoped that Laura would not forget him.

In addition, Stuart copied two poems glorifying the solder's life and the loved ones he left behind. The first was entitled "The Soldier's Dream," written in 1800 by Scottish poet Thomas Campbell:

The Soldier's Dream

Our bugles sung truce—for the night-cloud had lower'd,
And the sentinel stars set their watch in the sky;
And thousands had sunk on the ground over-power'd,
The weary to sleep, and the wounded to die.

When reposing that night on my pallet of straw,
By the wolf-scaring faggot that guarded the slain;
At the dead of the night a sweet vision I saw,
And thrice ere the morning I dreamt it again.

Methought from the battle-field's dreadful array,
Far, far I had roam'd on a desolate track:
'Twas Autumn,—and sunshine arose on the way
To the home of my fathers, that welcomed me back.

I flew to the pleasant fields traversed so oft
In life's morning march, when my bosom was young;
I heard my own mountain-goats bleating aloft,
And knew the sweet strain that the corn-reapers sung.

Then pledged we the wine-cup, and fondly I swore,
From my home and my weeping friends never to part;
My little ones kiss'd me a thousand times o'er,
And my wife sobb'd aloud in her fulness of heart.
Stay, stay with us,—rest, thou art weary and worn;
And fain was their war-broken soldier to stay;
But sorrow return'd with the dawning of morn;
And the voice in my dreaming ear melted away.

The Soldier's Dream —(Campbell)

Our bugles sang truce for the night-cloud had lowered,
And the sentinel-stars set their watch in the sky
For thousands had sunk on the ground over powered,
The weary to sleep, and the wounded to die.

Whilst reposing that night on my pallet of straw,
By the wolf-scaring faggot that guarded the slain;
At the dead of the night a sweet vision I saw;
And thrice ere the morning I dreamed it again.

Me thought from the battle-field's dreadful array,
Far, far I had roamed on a desolate track —
'Twas autumn, and sunshine arose on the way,
To the home of my fathers that welcomed me back.

I flew to the pleasant fields traversed so oft
In life's morning march when my bosom was young
I heard the old mountain-goats bleating aloft —
And knew the sweet strains that the corn-reapers sung.

Then pledged we the wine-cup and fondly I swore,
From my home and my weeping friends never to part,
My little-ones kissed me a thousand times o'er,
And my wife sobbed aloud in her fulness of heart —

"Stay, stay with us, rest, thou'rt weary and worn"—
And fain was the war-broken soldier to stay —
But sorrow returned with the dawning of morn,
And the voice in my dreaming-ear melted away.

A. Dreamer —

Hd 2n Cavalry Brigade A of P.
Centreville Mar 3d 1862.

"The Soldiers Dream."

The third poem in the album, and the second that Stuart copied, was Stuart's self-titled "The Proposal," a few select lines from the poem "The Bride of Abydos," written in 1813 by Anglo-Scottish poet George Gordon Byron, Sixth Baron Byron of Rochdale, or, as he was known, Lord Byron:

"The Proposal."

The Proposal

Borne by my steed, or wafted by my sail,
Across the desert, or before the gale,
Bound where thou wilt, my barb! Or glide, my prow!
But be the star that guides the wanderer, Thou!
Thou, my Zuleika, share and bless my bark;
The Dove of peace and promise to mine ark!
Or, since that hope denied in worlds of strife,
Be thou the rainbow to the storms of life!
The evening beam that smiles the clouds away,
And tints to-morrow with proheptic ray!

Following the Confederate army's withdrawal from Northern Virginia in early March 1862, Stuart acted as the army's rear guard, staying in the Warrenton area until the end of March, until Union general McClellan's intentions were clear. Once it was clear that McClellan intended a waterborne Peninsula Campaign to advance on Richmond, Stuart left Northern Virginia and traveled on the lower peninsula through Richmond to Yorktown by mid-April, although the cavalry was not an effective weapon in the wooded ground and deep ravines.[99]

The Civil War Album of Laura Ratcliffe

One last known letter to Laura was written on April 8, 1862, while Stuart was stationed on the Rappahannock River on his way to Yorktown, where "he still expected a major battle that would decide the war."[100] Stuart continued to boast of victories while hoping to see Laura and her family again.

Rappahanock April 8, 1862

My Dear Laura—
We are here quietly waiting for the yankees and if they ever come we will send them howling—through Fairfax again. We have won a glorious victory in New Mexico, capturing the whole Federal command 5000—under General Canby. We have also won a glorious victory near Corinth on the James. Captured 3 Genls Smith McClernand & Prentiss, & six thousand prisoners, all their artillery & camp equipage & Minor says we are sure to bag the remainder who are in full retreat, A.S. Johnston was killed. Beauregard & Bragg were there.
 I have thought of you much, & hope to see you all again. Before another week we expect to win another glorious victory.
 Hurrah! Hurrah!! I wish I could see you read this. My regards to your folks. The bullet-proof is all right. Yours ever truly.
J.E.B. [scratched out]

Interestingly, both the battles in New Mexico and Corinth were initially Confederate victories; however, the battles were followed by the withdrawal of Confederate troops and were ultimately considered Union victories. The New Mexico Campaign was an attempt by Confederate general Henry Hopkins Sibley to invade northern New Mexico to gain control of the West, including the gold fields in Colorado and the ports in California.

At the Battles of Shiloh and Corinth, near the Tennessee River, the Confederates overran the unsuspecting Union positions, only to have the Union army regroup and hold the battlefield, forcing the Confederates to retreat once again. Some details of Stuart's information are correct and some are incorrect, perhaps due to the erroneous reporting of the battles. Confederate general Albert Sydney Johnston was killed on April 6,[101] the same day that Union major general John Anderson McClernand was captured.[102] Neither Brigadier General Benjamin Mayberry Prentiss nor a Union general named Smith was captured.

Back East, it was in June when Stuart embarked on and completed his famous ride around McClellan's army east of Richmond to learn of the enemy's troop strength and disposition and to disrupt McClellan's supply

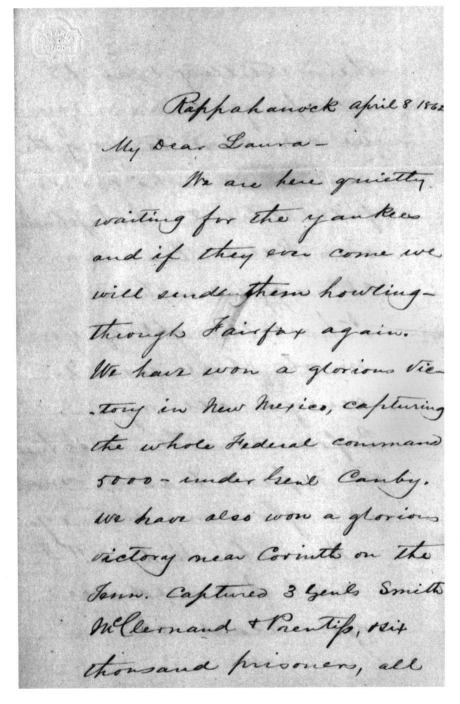

Rappahanock april 8 1862

My Dear Laura—

We are here quietly waiting for the yankees and if they ever come we will send them howling— through Fairfax again. We have won a glorious vic- tory in New Mexico, capturing the whole Federal command 5000 — under Genl Canby. We have also won a glorious victory near Corinth on the Tenn. Captured 3 Genls Smith McClernand & Prentiss, & six thousand prisoners, all

A letter to Laura from Stuart at the Rappahannock River on April 8, 1862. *Courtesy of the Library of Congress.*

their artillery & camp
equipage & rumor says
we are shure to bag the
remainder who are in
full retreat, A. S. Johnston
was killed. Beauregard
& Bragg were there —
I have thought of you
much, & hope soon to
see you all again —
Before another week
we expect to win anoth-
er glorious victory.
Hurrah! Hudrah!! I
wish I could see
you read this —

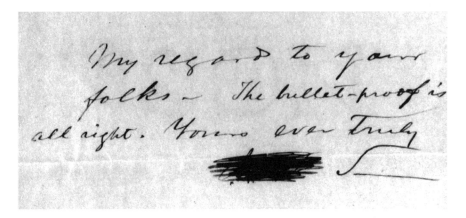

and communication lines.[103] The day after his return, Southern newspapers began printing the results of his "Magnificent Achievement," and the legend of "J.E.B." was born.[104] Stuart's intelligence was vital to Confederate general Robert E. Lee's plans to force McClellan's retreat from the outskirts of Richmond in the ensuing Seven Days Campaign. On July 25, Stuart was promoted to major general and rewarded with a third brigade.[105]

In mid-August, Lee sent Stuart back toward Northern Virginia to combat a new Union army created under Major General John Pope. This led him back to the Manassas battlefield for a second Confederate victory on August 29 and 30. Blending in well with the Army of Northern Virginia, Stuart performed a "most important and valuable service," according to Lee, scouting the area and delivering reports, providing much-needed communication on the battlefield.[106]

The next day, after Pope had retreated to Centreville, Stuart was moving east along the Little River Turnpike, today's Route 50, into Fairfax County for Lee's desired advance to strike the Union army before it could retreat to the defenses of the eastern portion of the county and the city of Washington. Early in the morning, a playful Stuart stopped at a plantation, whose owners had befriended Stuart the previous winter, and awakened them with a serenade performed to a banjo with his officers. After startling the sleeping residents before they realized who it was, Stuart and his men were provided breakfast in the predawn hours.[107] After probing as far east as Jermantown Road and running into Union forces, Stuart spent the night of the thirty-first along West Ox Road, near the current Navy Elementary School at the intersection of Thompson Road.

On the morning of September 1, Stuart traveled west along West Ox Road before turning south on Centreville Road. He joined with Major General Thomas "Stonewall" Jackson's Left Wing at 8:00 a.m. at the intersection of

Centreville Road and the Little River Turnpike. This trip took Stuart past the house where Laura, her mother and her sister lived. Given his penchant for waking sleeping friends, it is hard to imagine that he did not stop by Laura's to check on any intelligence that she might provide.

After meeting up with Jackson, Stuart tried again to push east on the Little River Turnpike during the day and into the evening. As Jackson's wing moved east, following Stuart along the Little River Turnpike, it clashed with Union forces to the south that had been sent to check the Confederate troops on the Little River Turnpike as they retreated east along the Warrenton Turnpike, today's Route 29. The Battle of Chantilly, or Ox Hill, was fought from 4:00 p.m. to 6:30 p.m. where West Ox Road intersects with the Little River Turnpike.

While the battle is usually considered an after action to Second Manassas, it prevented Lee from drawing the Union army into another major battle. It was the largest battle fought in Fairfax County and gave Lee pause to decide what to do next. He could not stay in the desolate area of Northern Virginia and attempt to assault the fortifications in eastern Fairfax County, nor could he cross the Potomac River into the city of Washington.[108]

During this lull, as "Stuart withdrew everyone into bivouacs north of Chantilly,"[109] Stuart found time to visit Antonia Ford's family in Fairfax Court House and his old Camp Qui Vive at the Millan house, now full of wounded Union soldiers. Even Confederate general Robert E. Lee was in the area, as documented by one of his letters of correspondence from his "Head Qtrs. near Chantilly."[110] On September 2, Lee's assistant adjutant general A.H. Chilton wrote a letter from "Head Qtrs. Ox Hill Little River Turnpike."[111]

Stuart moved back to Dranesville before the Confederate army forded the Potomac River at White's Ford into Poolesville, Maryland, on the fifth.[112] Although not recorded, it is hard to believe that he did not visit Laura during this respite. He was a short distance from her house while at Fairfax Court House, Camp Qui Vive and Dranesville. And as we have seen, he was given to visiting his old haunts. Even if Stuart himself did not visit Laura, it is entirely possible that some of his men did.

Stuart went into winter quarters south of Fredericksburg in what he called "Camp No-Camp." Moving north, Stuart left on Christmas Eve, reaching Burke Station of the Orange and Alexandria Railroad, between Fairfax Court House and the city of Washington, on the twenty-eighth. There he not only captured supplies but also sent a telegraph to Union quartermaster general Montgomery Miegs complaining "in reference to the bad quality of the mules lately furnished, which interfere seriously with our moving the captured wagons."[113]

Stuart moved on from Burke Station, heading west to Fairfax Station, Vienna and Frying Pan, where he stopped at the house of Ann and Laura Ratcliffe before leaving the next morning, the twenty-ninth.[114] Stuart's presence in Frying Pan was noted in numerous Union reports on the Burke Station Raid by Major General Samuel P. Heintzleman, Brigadier General J.J. Abercrombie and Colonel R. Butler Price, all of whom noted that Major Taggart was sent from Dranesville to intercept Stuart on the twenty-ninth, but "he found [Stuart] too strong for him" and traveled safely on to Annandale.[115]

The fourth poem in the album, and second original poem that Stuart entitled "To Laura," was dated December 29, 1862, when Stuart was in Frying Pan visiting Laura and her mother:

To Laura

When genius wealth and fashion bow in homage at thy feet
When youth & beauty smile in all thy happy glances greet
When I shall pitch beneath the sky, my bivouac in the lea
I ask not then for I would be in vain that thou would'st think of me.

When music's soft enrapturing swell, delight thy listening ears
When Zephyrs whisper all is well and all thou lovst are near
When skies are bright and thou art all that thou could'st wish to be
I dare not ask for I would be vain that thou could'st think of me.

But when misfortune frowns upon the fairest human face
And o'er the past thy mem'rys does can find no resting place
When friends are false serve one whose heart beats constantly for thee
Tis then I ask that thou would'st turn confidingly to me.

J.E.B.
Hdqrs "Grand Rounds"
Dec 29, 1862

It is interesting to consider whether Stuart wrote this poem beforehand and copied it into the album or whether he wrote it while he was at Laura's house. It is a question for which we will never know the answer. Another event occurred at Laura's house early on the morning of the twenty-ninth that bore far more significance for the war. Captain John Singleton Mosby accompanied Stuart on his visit to the Ratcliffes' home. Major John Scott, who wrote a "History of the Partisan Battalion" in his book *Partisan Life with*

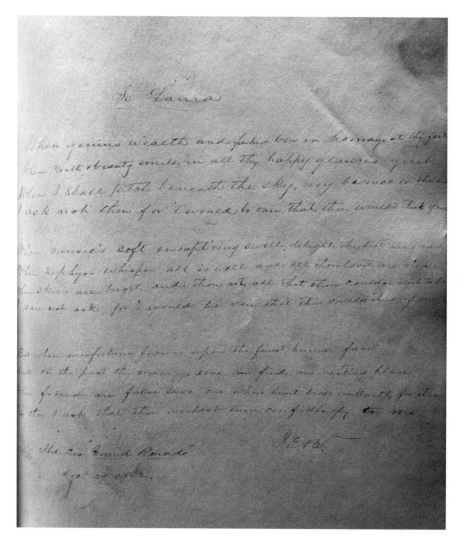

The second poem "To Laura."

Col. John S. Mosby, related a conversation that took place before Stuart left:

> *Stuart…called, in company with several of us, to make a visit to Miss Laura Ratcliffe, who resided near Frying-pan Church, in Fairfax County. As our party rose to bid this lady farewell, I was surprised and pleased to hear the general address her in the following language:*
> *"You are such good Southern people through this section, I think you deserve some protection, so I shall leave Captain Mosby, with a few men,*

to take care of you. I want you to do all you can for him. He is a great favorite of mine and a brave soldier, and, if my judgment does not err, we shall soon hear something surprising from him. "[116]

It wasn't until the next day, however, that Stuart actually left Mosby with a few men to take care of the "good Southern people through this section," as Stuart had promised Laura. Stuart and Mosby traveled west from Laura's house into Loudoun County to Oakham, the house of Colonel Hamilton Rogers. Oakham is located on today's Route 50, just east of Middleburg. As Stuart and his men left Oakham on the thirtieth, Mosby stayed behind with nine men.[117] Thus, Mosby began his life as a Partisan Ranger and would return many times to visit, protect and gather intelligence from Laura throughout the last two and a half years of the war. She would repay him by saving his life.

By today's standards, Stuart's poems to Laura would be considered love poems. Yet Stuart had married Flora Cooke in 1855. Flora stayed at Fairfax Court House in September 1861, while Stuart was in camp in the advanced position in Falls Church. He wrote letters to her from Camp Qui Vive in October, stating:

I have a very nice place here for you to visit me…I can't promise that you will see much of your husband when you come & you mustn't say it is cruel in me to leave you at short notice for the imperative calls of duty.[118]

Flora did visit her husband at Camp Qui Vive during Christmas that year.[119]

Stuart's relationship to the young, witty, attractive girls wherever he went is well documented. The kissing of girls in the streets, attending balls, having parties, staying at the homes of hosts with beautiful daughters and even giving away locks of his hair to the young girls he met was common behavior. So what are we to make of these actions of a married man? How do we interpret his relationship with Laura?

Emory Thomas explains his views of Stuart's intentions in his book *Bold Dragoon: The Life of J.E.B. Stuart:*[120]

Still did Stuart use the attention of women as an index of his worth. More than most men, he treasured his flirtations and in a sense counted them as "conquests." If women were such paragons of virtue and piety, then their favors were proof, not only of his fame, but also of knighthood. Stuart seemed to practice some nineteenth-century variant of courtly love. He idealized women, placed them on pedestals, and strove to please them. Stuart may have

Oakham, where J.E.B. Stuart first provided John S. Mosby with nine men for his independent command.

used women to measure his self worth. But knights of the sort Stuart believed himself to be did not deflower fair maids who inspired their gallantry.

Stuart wrote to Flora on October 5, 1863, addressing Flora's, and others', criticism and confirming Thomas's views that Stuart felt that women's adulation of him was natural and appropriate:

As to being laughed at about your husband's fondness for Society and the ladies. All I can say is that you are better off in that than you would be if I were fonder of some other things, that excite no remarks in others. The society of ladies will never injure your husband and ought to receive your encouragement. My correspondence with the ladies is that kind of correspondence which pertains to the position I hold, and which never could obtain with me were I a subordinate officer, such no doubt as you hear insinuations from.

One of Stuart's closest officers, Lieutenant Colonel William W. Blackford, who was on Stuart's staff from June 1861 until January 1864, first as an adjutant and later as Stuart's chief engineer, also addressed this issue in his recollections, *War Years with JEB Stuart*:[121]

Unsurpassed for close attention to duty, General Stuart had the remarkable facility of preserving his lightness of heart under all circumstances; he was as conspicuous as a leader in a ballroom as he was on the field of battle. Those who saw him only in his hours of recreation could form no true estimate of his character, and from such as these the impression prevailed with some that he was frivolous and indeed, I was even charged, dissipated and licentious. On the contrary, though he dearly loved, as any good soldier should, to kiss a pretty girl, he was as pure as they; and to his dissipation, he never touched wine or spirit of any kind under any circumstances. All this I know to be true, for it would have been impossible for it to have been otherwise and I not to have known it, associated with him as I was so long as a member of his military family, and one with whom he was perhaps more intimate than any other. Then, too, among all the ladies he met, and among their connections, there is not one who does not regard his memory to this day with feelings of respect and affection.

It is interesting that Laura was never arrested for supporting the Confederate cause during the war, despite her association with some of the South's most famous officers. It was certainly known by Union soldiers in the area where her allegiances lay. However, neither she, nor any of the civilians who signed her album, had any documented contact with the Union Provost Marshal Offices, nor did they have documented contact with Confederate authorities.[122]

It is probable that the two things that saved her from retaliation from Union troops was the fact that she was a woman and the fact that she was not caught red-handed providing information or safe harbor to the many Confederate soldiers in the area. Obviously, the album was never discovered during the war.

The small numbers of women who were arrested, tried and convicted of war-related illegal offenses were charged with smuggling, spying, telegraph wire cutting, harboring bushwhackers, aiding Confederate escapes, selling whiskey to soldiers, prostitution, writing to Confederate soldiers, fraudulent marriage, unauthorized travel, denouncing the Union, flag desecration, helping Union deserters and even armed robbery and murder.[123]

One woman expressed her feelings when arrested for harboring bushwhackers in her house, crying out, "I'm a Rebel and a Southern sympathizer and I don't care who knows it! If these men come back, I'll feed them again. It's no man's business what a women's politics are!" She was convicted of "violating the laws and customs of war" and was sentenced to take the oath of allegiance and post a $1,000 bond. If she failed to do either, she would be deported from her home state.[124]

The Civil War Album of Laura Ratcliffe

In *The Hard Hand of War: Union Military Policy toward Southern Civilians, 1861–1865,* author Mark Grimsley points out the dichotomy between the hands-off policy as developed by Union leaders and the hands-on reality as practiced by Union soldiers with respect to Southern civilians.

No matter the policies of the Federal government (thinking that Southerners would withdraw their allegiance to the Confederacy) during the war, the reality practiced by the soldiers was quite different. While most Union commanders preached restraint, Union soldiers basically took what resources they wanted, when they wanted them, from any Southern civilian, even those known to be Union sympathizers, in order to sustain themselves and their horses throughout the war. This was evidenced by the claims of over twenty-two thousand civilians in twelve Southern states after the war to the Southern Claims Commission of the Federal government for compensation for their losses due to the reality of life in the path of the Union army.[125]

Union major general John Pope wrote specific orders that were delivered to the Union soldiers in July 1862 upon the creation of his Army of Virginia operating in Northern Virginia. They addressed the heart of the matter with respect to the soldiers' conduct toward Southern civilians. Pope's Order No. 11 specified that unit commanders of the Army of Virginia "will proceed immediately to arrest all disloyal male citizens. Only those willing to swear an oath of allegiance and to furnish sufficient security would be permitted to remain within Union lines."[126]

Laura was either saved from arrest because she was a woman or she was skillful, or lucky, enough not to be caught in an actual act of sabotage. She probably used her tact to placate the Union soldiers in her neighborhood throughout the entire war, in spite of the fact that they knew her to be an "overt secessionist." In reality, however, most of the civilians in Fairfax County and Northern Virginia had Confederate allegiances. It would have been simply impossible to arrest them all. Secessionists had to be caught in the act of sabotage, or there had to be direct evidence of such acts, to be arrested.

We do not have any letters written to or by Laura to illustrate her feelings about the war. Frank Anderson Chappell published a book entitled *Dear Sister: Civil War Letters to a Sister in Alabama* that may be used to illustrate what letters written by a brother to a sister were like. These letters give us an idea of the sort of letters that Laura might have received from her brother, John, of the Seventeenth Virginia Infantry.[127]

In his book, Chappell presents letters written by four brothers in the Third Alabama Infantry to their sister. A letter from July 1861 illustrates one brother's early outlook on the war after joining the Third Alabama:

Dear Sister

Leaving home was not near so trying as I thought it would be. I felt that I was doing my duty. I may never return to you all it is true, but I feel assured I will. But if the worst comes to the worst I shall feel contented with my lot. Though I may reap at the harvest of death, it will be only to water the tree of liberty.[128]

In another letter, the same brother wrote:

My Dear Sister

I often think of home and friends, though not in sadness, but the happy days and years that I have spent at the old homestead and looking forward when I shall return to the embrace of my tender mother and loving sister.

Most of the letters typically discussed concerns about health, the weather, food, living quarters and the boredom of camp life, as well as apologies for not having written sooner and the wish to hear from their sister when they had not received a letter in a while. Typical illnesses that the soldiers complained about included pneumonia, measles and diseases of the bowels (typically, diarrhea).

Even in 1864, when the war was not going so well, one brother wrote a plea to his sister and family not to give up on the Southern cause and his continued wish to hear from the homefront:

Dear Sister

I learn that most everybody at home are whipped. I don't want to find you that way though you have been. Home folks should wait until the army is whipped before they give up. I don't want any body to tell me we are whipped. I am not whipped yet, Sister. We have good quarters and are doing very well. Write to me immediately.[129]

Dear and beloved Sister

I seat myself this morning to drop you a few lines to let you know I [am] still in the land of the living and injoying [sic] good health, not withstanding the many hardships and dangers we have passed through since I last wrote to you.

Sis I want to hear from home mighty bad. We got mail last night for the first in a long time. The boys all [got] letters but me. I think if you all knew the pleasure it gives us to hear from you you would write to us. Give my love to all.[130]

THE J.E.B STUART PAGE

In addition to the four poems that Stuart wrote, there are forty signatures—twenty-six by Confederate soldiers and fourteen by civilians—included in the album. J.E.B. Stuart and three of his men signed the first page of these signatures. Major John S. Mosby, a prior member of Stuart's staff, also signed it, as did one civilian, William H.P. Berkeley.

The signatures were written on "Calling Cards" presumably drawn on each page by Laura. Calling cards originated in France in the early 1800s, spread throughout Europe and became widely popular in the United States. They were mass-produced by printers, who used calligraphers to write the customer's name on the cards. Well-to-do men and women used them for all manner of social occasions.

Calling cards were employed to announce oneself when making social visits or calls. A table was kept at the front entrance with a silver calling card tray for receiving such cards. When a visitor knocked on the door, a housekeeper would answer and the visitor would present his or her card. The servant would take the card to the person the visitor wished to see. If the recipient was willing to see the visitor, he was escorted to the appropriate parlor. If the visitor was not to be seen, the calling card was left on the tray. Etiquette required that a call be returned within three days for those visitors who were not received.

It is entirely possible that during the war, with calling cards being unpractical, Laura followed the rules of etiquette as best she could by having her visitors write their names on the "calling cards" provided in the album. The fact that she drew the calling cards in the album also supports the presumption that the album was signed after she received it, not before.

A Union picket line stretched from the Potomac River above Dranesville through Centreville and back through Fairfax toward Alexandria. Union

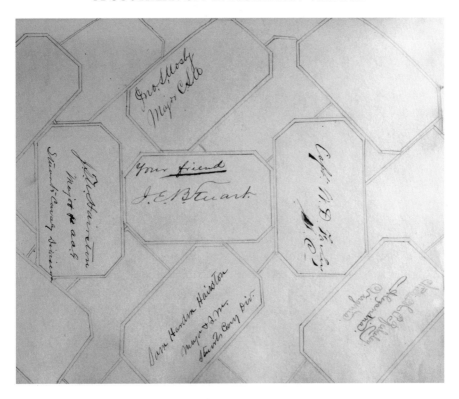

Signatures of J.E.B Stuart, J.T.W. Hairston, Sam Hardin Hairston, Captain W.D. Farley, John S. Mosby and William H.P. Berkeley.

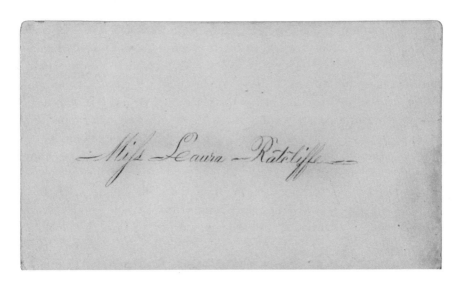

Laura Ratcliffe's calling card. *Courtesy of the City of Fairfax Historic Collections.*

troops were stationed at Frying Pan and Chantilly, with pickets every half mile.[131] The stretch of Centreville Road where Laura lived was a north–south connection between the villages of Herndon and Dranesville to the north and the area known as Chantilly and the town of Centreville to the south. It was also a link between two of the three major east–west thoroughfares in Fairfax County—the Little River Turnpike, Route 50, to the north and the Warrenton Turnpike, Route 29, to the south. As Frying Pan Church was a location for Union pickets, it drew the attention of Confederate soldiers throughout the war, and as a result, a great number of skirmishes occurred there.

Perhaps the most important things of value that Laura had to offer the soldiers and her fellow Southern civilians were intelligence, food, medical care and a safe house.

Your friend
J.E.B. Stuart

The fact that Stuart signed his name as "Your friend" is a meaningful sentiment, according to George Cary Eggleston, who served under Stuart at the beginning of the war.[132] In his recollections, Eggleston wrote:

> *There was no point in Stuart's character more strongly marked than the one here hinted at. He was "yours to count on" always: your friend if possible, your enemy if you want to have it so, but your friend or your enemy "to count on," in any case. A franker, more transparent nature, it is impossible to conceive. What he was he professed to be. That which he thought, he said, and his habit of thinking as much good as he could of those about him served to make his frankness of speech a great friend-winner.*

In other words, Stuart was a friend to Laura, one on whom she could certainly count, and he underlined this fact to make it ever so clear.

J.T.W. Hairston
Major & aaj Stuart's Cavalry Division

James Thomas Watt Hairston was a cousin of J.E.B. Stuart. He was born on January 26, 1835, in Mississippi. He graduated from the Virginia Military Institute in 1858 and became a captain of Company E, Eleventh Mississippi Infantry, just before the war. The company was mustered in Confederate

service on May 13, 1861, in Lynchburg, Virginia. Suffering from health problems due to rheumatism, however, he could not remain with the infantry and resigned his commission shortly thereafter in September.[133]

Watt, as he was called, then volunteered, in the same month, to accompany Stuart as an aide. His health failed him again, and he was assigned as a lieutenant commandant of Libby Prison from October 1861 until January 1862. On January 16, Hairston was relieved of his duties at the prison and took a one-month furlough to recover his health.

Stuart, in the meantime, had been working to have Watt transferred permanently from the infantry to his cavalry as a voluntary aide-de-camp. Watt finally received a commission and a promotion to major as Stuart's acting assistant adjutant general on August 8, dating back to July 25, 1862.[134] Finally able to perform his duties, Watt excelled, receiving mention by Stuart as "render[ing] very essential and gallant service during the action," including the Battle of Williamsburg in May 1862. He was also mentioned by Stuart, along with other members of the staff, as having deserved "honorable mention…for their valuable services" during the Seven Days Campaign.[135]

Watt continued to perform his duties and again received recognition from Stuart, this time at Second Manassas on August 30, for "render[ing] important service throughout the period embraced in this report."[136] Watt did not return to Fairfax County and Frying Pan until December 29, when Stuart visited Laura and her mother and announced that Mosby would have an independent command. The winter season, however, brought back Watt's rheumatism, and he was continually unable to fulfill his duties. Watt tendered his resignation to Stuart on March 1, 1863, and returned to Mississippi. He worked as a farmer, planting tobacco and cotton, married in 1873 and, despite his illness during the war, lived to the age of seventy-two. He died in Columbus, Mississippi, in 1908.[137]

As Stuart did not return to Frying Pan during the first three months of 1863, before Watt resigned, there are two possibilities for when Watt visited Laura and signed the album. The first was September 2–5, after Second Manassas, while Stuart was in Fairfax County before heading north to Maryland. Again, there is no documentation of Stuart visiting Laura during this time, although he was in Fairfax Court House, Camp Qui Vive and Dranesville, all within a short ride of Frying Pan.

The second opportunity was the documented trip that Stuart and members of his staff took to Laura's house on December 29, 1862. In this case—as is the case with others since the signatures are not dated—there is no way to be certain when Watt signed the album.

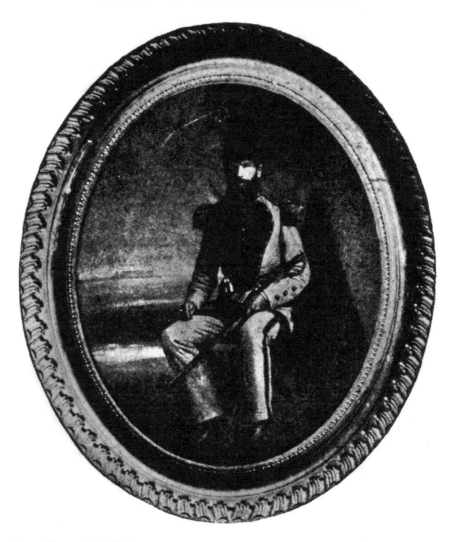

James Thomas Watt Hairston.

For Watt Hairston, the window of opportunity was very brief—a mere seven months, from August 8, 1862, when he was promoted to major, the rank he used when he signed the album, to March 1, 1863, when he resigned. This evidence would lead one to believe that he signed the album sometime between September 2 and 5 or on December 29, 1862.

Sam Hardin Hairston
Major and Q.M.
Stuart Cav. Div.

Sam Hardin Hairston was the older brother of James Thomas Watt Hairston. He was born in Mississippi in April 1822. Nearly thirteen years older than his brother, he attended William and Mary and was married before the war. He enlisted in his brother's company, Company E, Eleventh Mississippi Infantry. Like his brother Watt, he also suffered from chronic rheumatism and was discharged from the infantry in October 1861. By May 1862, he had also joined Stuart as a voluntary aide-de-camp as a captain.[138]

In August, Sam became the quartermaster of Stuart's brigade, having unofficially served in the position since June. He served with Stuart until January 14, 1863, when, like his brother, he resigned, but unlike his brother, he did not give a reason for his resignation. He stayed with Stuart until May 31, when his resignation was accepted.[139] Sam died five years after the war in 1870 at age forty-eight while attending a case at the Virginia State Capitol building in Richmond. A support for the gallery broke and he was killed, along with dozens of other people.[140] He is believed to be buried at his family's cemetery near Martinsville, Virginia.

Stuart mentioned Sam, under the rank of captain, for gallantry at the Battle of Williamsburg in May 1862:

> *Two gentlemen, who had joined me but a few days before as volunteer aides, Capts. Samuel Hardin Hairston and Samuel G. Staples, gave evidence, by their coolness, intelligence, and conspicuous gallantry, of future distinction in arms, and were of invaluable service to me.*[141]

Stuart also noted Sam in a report on July 14, for the Seven Days Campaign, this time under the rank of major:

> *Major Samuel Hardin Hairston, quartermaster, and Maj. Dabney Ball, commissary of subsistence, were prevented from their duties of office from participating in the dangers of the conflict, but are entitled to my thanks for the thorough discharge of their duties.*[142]

At Second Manassas, Stuart wrote that Sam exceeded his duties as a quartermaster once again:

My division quartermaster, Maj. Samuel Hardin Hairston, in coming to join me, was put in command of a detachment of cavalry at Salem by the commanding general, and sent on an important reconnaissance toward Warrenton, of which the report is appended.

One must assume that Sam Hairston was present at Laura's house and signed the album at the same time as his brother. Like his brother, he could have only done so on the same two occasions. The first was September 2–5, after Second Manassas, while Stuart was in Fairfax County before moving north. The second opportunity was the trip that Stuart and members of his staff took to Laura's house on December 29, 1862. Like his brother Watt, the window of opportunity for Sam was very brief—only eight and a half months, from July 14, 1862, when he held the rank of major, which he used when he signed the album, to May 31, 1863, when he left Stuart's service.

Capt W.ᴰ D. Farley
S.C.

William Downs Farley was born in Laurensville, South Carolina, on December 19, 1835. He attended the University of Virginia and was fond of reading and writing poetry. Interestingly, before attending college, at the age of seventeen, he took a walking tour of Northern Virginia during the summer of 1852 with a friend, a trip that provided him with valuable knowledge that would serve him well during the war. After graduation, he worked in the family business in South Carolina and became an ardent advocate for secession.

Farley enlisted in the First South Carolina Regiment under Colonel Maxcy Gregg and later served as an aide-de-camp to Brigadier General Milledge L. Bonham. He was stationed at Leesburg, Virginia, in June 1861 as a captain of the Seventh South Carolina Volunteers under Bonham.[143] He provided information about the enemy to both Generals Bonham and P.G.T. Beauregard prior to First Manassas. He fought valiantly at that battle, despite suffering from a fever, a symptom of the measles.[144]

After the battle, as the Confederates pushed their lines east to Fairfax Court House and Falls Church, Farley started to prove his worth as a scout, which eventually led him to Stuart's staff. Late in the year, Farley took three men and captured and held Upton's Hill in Falls Church, ten to fifteen miles beyond the Confederate lines. He continually attacked Union pickets

and any passing column of Union soldiers. An attack on several hundred men of Colonel George D. Bayard's First Pennsylvania Regiment led to Farley's capture and imprisonment in the Old Capitol Prison in the city of Washington, but he was released that winter.[145]

Back in Centreville, Farley met Stuart, who was impressed with Farley's capabilities, daring and accomplishments. Stuart immediately attached Farley to his staff as a volunteer aide-de-camp. The position as a scout gave Farley the freedom he wanted to come and go as he pleased, not tied down to the "routine of common, or the commonplace round of camp duty."[146]

On November 26, 1861, Farley was stationed at a camp in Frying Pan when he learned of a Union plan by his nemesis Colonel George D. Bayard to capture members of the Dranesville Home Guard. Farley stationed three men along Georgetown Road to attack Bayard before he could reach Dranesville. On the twenty-seventh, Bayard arrested six secessionist members of the guard and marched east to Camp Pierpont in Langley, Virginia. Farley missed finding Bayard's men until after they had captured their prize, and on Bayard's return, he ambushed the Union patrol and their prisoners, killing Bayard's horse and wounding an assistant surgeon who came to Bayard's aid.

During the confusion, a local citizen called to Bayard that there were only four men in the pines to the side of the road, at which point the Union soldiers dismounted and came after Farley, capturing him with "eight bullet holes in his clothes and one in his cap." Once again Farley and ten of his men were sent to the Old Capitol Prison in Washington, where Farley would stay until February 1862. Upon his release, he was granted a sixty-day furlough to visit his family in South Carolina, and then he returned to his duties with Stuart.[147] Farley returned to Stuart at Camp Qui Vive in time to follow Stuart as Stuart's cavalry left Northern Virginia in March 1862.[148]

He would become known as "Farley the Scout," a "chivalrous" volunteer on Stuart's staff. He was described as "a man so notable for daring, skill, and efficiency as a partisan, that all who valued those great qualities honored him as their chiefest exemplar."[149]

Following the Battle of Sharpsburg, Farley returned to Virginia and visited Kate Carper, another signer of the album, in Dranesville in late September 1862.[150] He continued to serve Stuart away from Fairfax County until the Burke Station Raid and Stuart's visit to Laura's home on December 29, 1862.

The early months of 1863 found Stuart in central Virginia, seeking replenishment of horseflesh and forage around Fredericksburg. The Battles of Kelly's Ford and Chancellorsville followed in mid-March and

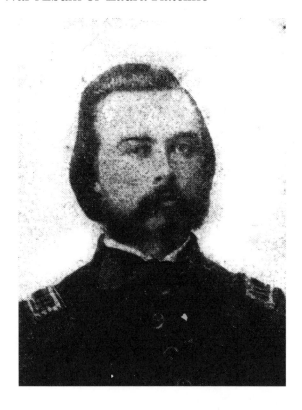

William Downs Farley.

early May, and Stuart moved on to Culpeper County in mid-May. In June, he went into bivouac atop Fleetwood Heights at Brandy Station. On June 1, Stuart's staff consisted of twenty officers, including Captain W.D. Farley, a volunteer aide.[151]

On the morning of June 9, ten thousand cavalrymen under Union major general Alfred Pleasanton attacked the Confederate cavalry of perhaps seven thousand under Major General J.E.B. Stuart to determine Lee's movements. The Battle of Brandy Station was the largest cavalry battle of the war.

As the sound of battle awakened Stuart and his camp, Farley eagerly anticipated action, shouting, "Hurrah, we're going to have a fight" as he threw his hat into the air. Stuart quickly sent his staff off with orders, dispatching Farley with orders for Colonel Matthew C. Butler of the Second South Carolina Cavalry. After Farley reached Butler and relayed the orders from Stuart, both men were struck by an enemy shell, which took off Butler's foot and Farley's right leg below the knee. Farley's wound was fatal, and as he was carried from the field, he requested that his leg be brought with him, saying, "It's an old friend, gentlemen, and I do not wish to part with it." As he was loaded into an ambulance, he told those who had carried him from

the field, "Goodbye, and forever. I know my condition. I won't meet you again. Let me thank you for your kindness. It is a pleasure to me that I fell into the hands of Carolinians at my last moment."

Farley was taken to a nearby house and laid on a mattress on the floor of the parlor. As he lay there, he closed his eyes for a few seconds, reopened them, looked around the room and said clearly and distinctly, "To your post men! To your post!" He died a few moments later.[152]

In a letter to Farley's mother, Stuart wrote:

Permit me…to throw a garland over the grave of your dear boy and the beloved and the brave Capt. W.D. Farley who did me the honor to serve so long, so faithfully, through without emolument or commission, as a member of my staff. His bravery amounted to heroism of the highest order. [He] displayed even in death the same loftiness of bearing and fortitude which have characterized him through life. He had served…faithfully and always with distinction. No nobler champion has fallen. May his spirit abide with us.[153]

Perhaps because there was no time to send Farley's body back to South Carolina, Farley was buried at Fairview Cemetery in Culpeper, Virginia. It wasn't until April 2002 that the body of William Downs Farley was exhumed, including his amputated leg, and reburied in his hometown of Laurensville, South Carolina.[154]

As with Watt and Sam Hairston, it is most likely that Farley signed Laura's album in the days immediately following Second Manassas or on December 29, 1862. It is also possible that he could have visited Laura while staying at Kate Carper's house in Dranesville in late September 1862.

Jno. S. Mosby
Major, CSA

John Singleton Mosby spent much of the war in Fairfax County. He is noted for having moved through western Fairfax County to attack Union targets of opportunity in the eastern end of the county throughout the war. On many of his trips, he passed through Dranesville, to the north of Laura, through Frying Pan itself or through Chantilly or Centreville, to the south of Laura's home. Mosby's association with J.E.B. Stuart started early in the war. Mosby enlisted in the Washington Mounted Rifles, a militia formed in Abingdon, Virginia, on May 14 and was mustered into Confederate service as a private on May 30, 1861, in Richmond as part of the First Virginia

Cavalry following the bombardment of Fort Sumter. He initially served as a scout and performed picket duty under Colonel Stuart in the Shenandoah Valley.[155] Following First Manassas, Mosby began his patrols from Fairfax Court House in late July; they continued through February 1862.[156]

It was on February 12 when Mosby met the head of his cavalry unit, Brigadier General J.E.B. Stuart. He spent the night at Stuart's headquarters at Camp Qui Vive[157] after escorting two of Stuart's lady friends, possibly Laura and her sister or Antonia Ford, from Fairfax Court House to Frying Pan.[158] Mosby was also promoted to first lieutenant that day. Mosby continued his service with Stuart in Fairfax County until Stuart moved south in March,[159] and Stuart's confidence in him continued to grow until December 1862.[160]

Captain Mosby was instrumental to Stuart's success as a guide and was commended by Stuart for his role in Stuart's ride around McClellan. Mosby returned to duty at Fairfax Court House[161] after Second Manassas and passed through Dranesville on September 5 on his way to Leesburg and Maryland for the Battle of Sharpsburg.[162]

Mosby did not return to Fairfax County until he accompanied Stuart on the Burke Station Raid and on his subsequent visit to Laura's house on December 29, when Stuart announced that he intended to allow Mosby to be the leader of an independent command.

In a second account of the night of the twenty-ninth, as they were crowded in the Ratcliffes' small house, Laura spoke to Stuart as he and his staff were preparing to leave. "It's a shame you can't stay longer General," she said. "It's hard on us, living in conquered territory, under enemy rule."

Stuart replied:

> Well I won't desert you entirely, Miss Ratcliffe. I'm returning to Culpeper in the morning, as you know, but I mean to leave Captain Mosby behind with a few men, to look after the loyal Confederate people here until we can return in force and in victory.

Mosby realized that for the first time he was to be given an independent command to operate in the conqueror's territory.[163] And on the thirtieth, at Oakham in Loudoun County, on the way to Culpeper, Mosby began his independent command with nine of Stuart's men.[164]

Although Mosby spent much of his time in Fairfax County and visiting Laura's house, he did not sign this page in Laura's album until at least four month's later, when he was promoted to major on April 26, 1863.[165]

For the nearly nine months that Mosby held the rank of major until he was promoted to lieutenant colonel on or about February 11, 1864,[166] he

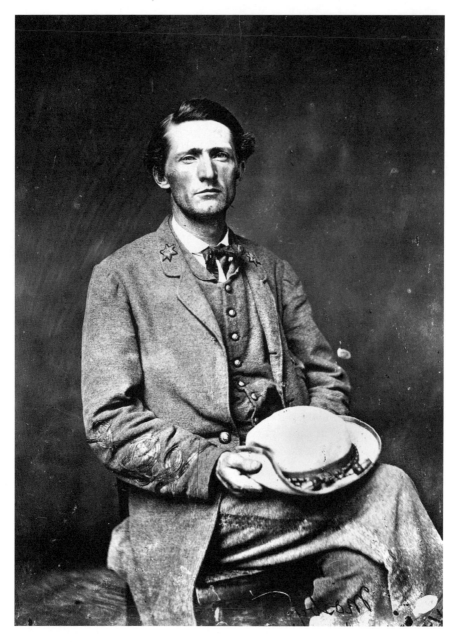

John Singleton Mosby.

had many opportunities to visit Laura. On June 3, 1863, Mosby, along with fifty men, marched toward Frying Pan Church to attack Michigan cavalry, baiting the Michigan troops to attack by building fires in their camp. Mosby's attack the next morning scattered the men from the Fifth Michigan Cavalry, but Mosby withdrew from the fight when the Sixth Michigan Cavalry joined the combat.[167]

Prior to Gettysburg, about June 23, Stuart sent a note to Mosby to determine if the Union army was crossing the Potomac. Mosby passed through Frying Pan to make his reconnaissance. It was documented that he stopped by himself to visit "his trusty friend, Miss Laura Ratcliffe, who lived not twenty yards from the highway." Laura later reported the visit to one of Mosby's men:

> *When Hooker's army was watching General Lee, trying to find out his intentions, Reynolds's corps was camped at Guilford Station, [Ashburn] and the wagon-trains with cavalry escorts were constantly passing our homes to and from the [Alexandria, Loudoun & Hampshire] railroad. One day a soldier on a white horse, with an oil-cloth around him, rode up to the house, and we could scarcely believe our eyes when we found it was Major Mosby. He dismounted, and came in to see if we had any late papers or any news, and left his horse standing at the front door. One of my sisters was so afraid the Yankees would come while he was there that she led his horse behind the barn, and kept him there till the major was ready to start; but he did not appear the least uneasy, nor did he make a hurried visit. That evening two Yankees came to our house and told us that it was rumored that Mosby had ridden several miles with them between here and Guilford; that when he got ready to turn off he said "good-evening," and then dashed through the woods, and was out of sight in an instant. I told them the story was improbable, but suppose it was really true.[168]*

Laura's "license for trickery" served both her and Mosby well.[169]

Mosby returned to Fairfax County in late July 1863. Late in the month, he captured a number of sutler wagons in Germantown and Fairfax Court House.[170] Mosby also captured a number of prisoners near the courthouse on August 1 and 2.[171] On the eleventh, they captured a number of sutler wagons at Billy Gooding's Tavern on the Little River Turnpike between Fairfax Court House and Annandale.

On the twenty-fourth, Mosby again attacked a number of Union horsemen at the tavern, but in the fight he was wounded in the side and thigh and was taken to his father's house in Amherst County to recuperate.

Mosby returned to lead his men less than a month later on September 20.[172] On the twenty-seventh, Mosby took one of his men, Daniel French Dulaney, on a raid of Rose Hill, south of Alexandria, and captured Dulaney's father, Colonel Daniel H. Dulaney.[173]

Mosby and forty of his men bivouacked in the pine trees near Frying Pan Church on the evening of October 9 and spent the next day there as well. Mosby's scouts found nothing to attack, and not wanting to be found by the enemy, Mosby moved on to Guilford (Ashburn) on the eleventh.[174]

On October 16, Mosby was once again at Frying Pan Church before moving on to attack an unsuspecting Union wagon train along the Little River Turnpike in Chantilly. He captured thirteen prisoners, seven horses and thirty-six mules.[175] On the seventeenth, Mosby rode to Fairfax Court House and captured a thirteen-man outpost at the Little River Turnpike and (West) Ox Road.[176] Mosby operated primarily outside of Fairfax County until he was promoted to lieutenant colonel on or about February 11, 1864.[177]

While Mosby served under Stuart around Frying Pan after Second Manassas in the first few days of September 1862, he was certainly at Laura's house on December 29, 1862, when Stuart announced that Mosby would begin his independent service. At neither of these times, however, had he yet attained the rank of major, with which he signed his name.

While in Frying Pan on June 3, 1863, as major, Mosby was involved in a fight with too many Michigan troops in the Frying Pan area to safely stop by Laura's house. A short time later, on October 16, he was again on a raid that passed through the Frying Pan area, but he was probably moving too quickly to stop at Laura's house. And although he went on numerous raids in Fairfax County during the time he served as major—from April 26, 1863, to February 11, 1864—none of these accounts provides evidence of him stopping or moving through the Frying Pan area.

It seems most likely that Mosby signed the album during his visit, by himself, to Laura's house in late June or during the evening of October 9 or on the tenth, when he was concealed at Frying Pan for a full day while his men scouted the area for enemy troops. Perhaps Mosby signed the album on the page signed by J.E.B. Stuart and his men in June—he was certainly at ease while visiting Laura, as she reported. The October visit, however, may have given Mosby the opportunity to spend enough time at Laura's house to sign the album, along with his men, on a following page. If only these signatures were dated!

William H.P. Berkeley
Alexandria,
Virginia

William H.P. (Pattison) Berkeley appears to have been a civilian quasi-scout or spy who provided information to Confederate agents and friends on a frequent basis, as he signed the album on three different pages. He was born in 1846 in Alexandria and was the son of William Norris Berkeley, a successful dry goods salesman. He is listed in the *Alexandria City Directory* in 1877 as residing at 116 Prince Street, which is the same address as his father. The 1883 directory has him living at 601 Queen Street and working at his father's dry goods store, William N. Berkeley Dry Goods. He died on August 31, 1893, around the young age of forty-eight.

The William H.P. Berkeley residence at 601 Queen Street, Alexandria, Virginia.

His father, William Norris Berkeley, was born in Fairfax County and at the age of sixteen, upon his father's death, went to Alexandria to work to support his siblings and widowed mother. He became a successful merchant and lived in Alexandria for the rest of his life. He was "an ardent unionist who opposed secession."[178] He was appointed mayor of Alexandria by the Union forces in 1866 and was elected mayor in 1872 after Virginia was readmitted to the Union. He resigned in 1873 after being appointed postmaster by President Grant, a post at which he served until 1877.[179]

William H.P. was fifteen when the war started and nineteen when it ended. He probably provided information to Laura and others on the activities of the Union soldiers in the occupied city of Alexandria. He may have even provided land transportation or information of passage for those Confederate sympathizers moving in and out of the port of Alexandria. His actions certainly support the theory "that the Berkleys were divided on the issue of secession,"[180] as Waverly Berkeley states in his book *The Berkleys of Berkley*.

William H.P.'s youth may have led him to sign as many pages in the album as he could with those soldiers, officers and other civilians whom he admired. Signing the page with J.E.B. Stuart and John S. Mosby would have certainly been an impressive feat for any civilian, notwithstanding his age. Did he meet these famous men with whom he shared pen and paper? Did he sign the album on the same dates as his heroes did?

Since Berkeley was located in Alexandria and he needed a pass to travel through Union lines to reach Fairfax Court House, he probably was unable to make a quick journey to Laura's house on the spur of the moment, unless he had a pass based on his father's reputation. It is possible that he signed the album with the others after Second Manassas, when Stuart was in Fairfax County for four days. This may have allowed Berkeley the time to travel through Union lines to reach Laura's house while Stuart and his staff were in the western portion of the county. Unfortunately, there are no records of his secret activities to let us know.

This brings us to the final question: when did Stuart sign the album?

Compared to the other signatures on this page, Stuart's salutation of "Your friend" was very informal, denoting his relationship to Laura. One can imagine the other guests signing the book with their ranks as formal guests, some perhaps meeting Laura for the first time, while Stuart playfully signed his name as an old and personal acquaintance.

One opportunity for Stuart presented itself in mid-October 1863, when the Union army was situated under General George Meade on the heights

in Centreville. Lee probed for an opportunity to attack Meade and gave up after two days of trying. On the seventeenth, Lee left to move to the Rappahannock, and Stuart traveled along the Little River Turnpike through Gum Springs (now Arcola) and Frying Pan. He stopped at Laura's house to visit Laura and her mother and offered to move them from the path of the nearby enemy.[181]

Having already signed the album that he gave, or sent, to Laura in March 1862, it wouldn't seem necessary for him to sign it again by himself. Therefore, it seems likely that Stuart signed this page along with his staff officers Watt and Sam Hairston when they signed it later in 1862, either sometime between September 2 and 5, after Second Manassas, or on December 29, 1862, when they visited Laura's house. By the time Stuart visited Laura and her mother on October 17, 1863, the Hairston brothers had resigned and Farley had already been killed.

THE WILLIAM THOMAS
CARTER PAGE

W.T. Carter
Phillips Legion
Georgia, Vol

William Thomas Carter was born on July 7, 1842, presumably in Murray County, Georgia, where he was listed in the 1850 census. On the eve of the Civil War, the eighteen-year-old Carter was living in Whitfield County, Georgia, as a farm laborer, as noted in the 1860 census.[182]

Following the firing on Fort Sumter on April 12, 1861, the governor of Savannah, Georgia, ordered Militia General William Phillips to organize his Fourth Brigade Volunteers, which Phillips had been raising since late 1860 as the first brigade in the defense of the state of Georgia. Training was begun on April 15 on the old Smyrna Camp Meeting Ground, which was located four miles to the south of Marietta.[183] William Thomas Carter enlisted in Phillips Legion Infantry Battalion, Company B, Dalton Guards, on June 11.[184]

On August 1, 1861, over two thousand troops were reviewed in front of Governor Brown before marching off to Lynchburg, Virginia, to begin their service to the Confederacy as the Phillips Legion on August 9.[185]

The Phillips Legion saw service in a number of locations before reaching Northern Virginia. On July 29, 1866, it was located in Richmond.[186] The legion had yet to see serious combat, but that was about to change. The Phillips Legion was attached to Major General James Longstreet's wing of the Army of Northern Virginia. It left Richmond on August 2. Colonel Phillips did not accompany his legion, however. Following numerous bouts with typhoid fever, he was moved to a hospital in Lynchburg and, without

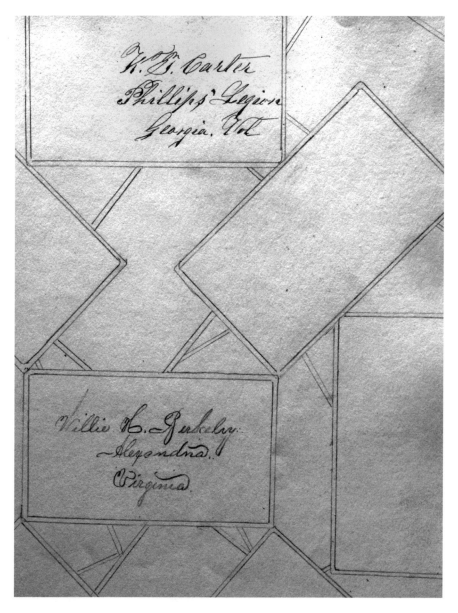

Signatures of W.T. Carter and William H. Berkeley.

improvement, returned to Marietta, Georgia, in October. He was eventually forced to resign in January 1863.[187]

His legion moved north through Virginia, reaching Manassas on August 29 under Longstreet, and the men were sent out as skirmishers midmorning as part of Drayton's Brigade. Companies A and E were severely hit by Union

artillery. Ordered to Chinn Ridge on the thirtieth, they came under artillery fire once again, sustaining increased casualties. Confusion reigned on the battlefield, and the legion eventually settled in for the night.[188]

Longstreet's wing left Manassas on September 1, following Jackson's wing, but arrived too late to participate in the Battle of Chantilly that afternoon.[189] Longstreet's wing stayed in Fairfax County with the Army of Northern Virginia until it moved northeast to White's Ferry on the Potomac River on September 5.[190]

On October 10, Carter was detailed to the Division Signal Corps and served throughout the remainder of the war without a scratch, but never again in Northern Virginia. Upon his return home after his surrender at Appomattox, he enjoyed a meal of "cornbread, cabbage and pot licker," exclaiming, "This is the best food I have eaten in a long time." He received a Southern Cross of Honor.

Carter is noted as having been well educated, and he had excellent penmanship. After the war, he became a schoolteacher, and in 1869, he left Georgia and moved to Wylie, Texas, where he was married at the age of twenty-seven. He lived to the age of ninety-one, dying in 1933. He is buried with his wife at Kendrick Cemetery, Denton Valley, near Clyde, Texas.[191]

The only time that Carter could have signed Laura's album was sometime between September 1 and September 5, after the Battle of Second Manassas, as the Army of Northern Virginia bivouacked in the Frying Pan area before moving north for the Maryland Campaign.

William H. Berkeley
Alexandria,
Virginia

William H. Berkeley signed Laura's album for the second time on the same page as W.T. Carter. This further suggests that Berkeley visited Laura's house sometime between September 1 and 5, after Second Manassas. It is possible that he signed the album along with Carter, although what their relationship was is not known. It is also possible that Stuart and Carter signed their pages on different days that September and that Berkeley was at Laura's house long enough to have been there on both occasions. It is clear when Carter signed the album. It is therefore a strong conjecture that Berkeley was there at the same time that the entire Confederate army was located within a few miles of Laura's house, providing him with a secure opportunity to visit.

THE JOHN SINGLETON
MOSBY PAGE

Jno. S. Mosby
Major 43d Va. Cav. Battalion

During the eight months that Mosby held the rank of major, he made numerous trips to Fairfax County, which included stops at Laura's house. Laura saved Mosby's life in his first days as a Partisan Ranger. Mosby's success came from the aid of many civilians, who provided him with information that guided his efforts and probably saved his life numerous times.

Tom Evans, an expert on Mosby in Northern Virginia, explained how Mosby's intelligence was gathered throughout the wide expanse of Mosby's Confederacy:[192]

Much of the intelligence for Mosby's raids was gathered by simple line of sight. When a Union wagon train was passing, everybody in the neighborhood saw it and sent the information to the local Mosby Ranger. The ranger would notify others, going from one house to the next. Then the rangers staying in those houses would go to the houses that they were responsible for notifying, and soon they would have a large group gathering at a predetermined site. As soon as he found a target of opportunity, Mosby put out the word and soon had a group assembled for attack. Most of Mosby's communication was by word of mouth, but there were probably dispatches and notes passed along, as well as "drops."

Mosby's Rock, near Frying Pan Church, was a "drop," as well as an assembly point for rangers. These drops were also used for personal mail. If a family in Fauquier County had a son staying in the Frying Pan area and they wanted to send him a letter, they would give it to a local ranger, and it would work its way to Mosby's Rock. Then the son could pick it up the next time that the rangers assembled there, or whoever else checked the drop on a regular basis would see that he received it.

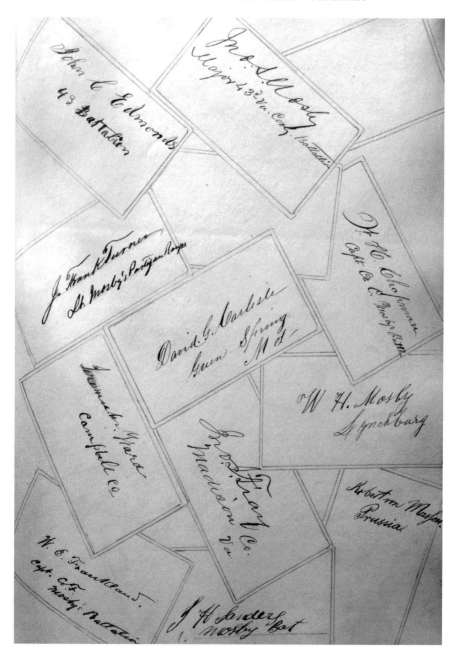

Signatures of John S. Mosby, W.H. Chapman, W.E. Frankland, W.H. Mosby, John C. Edmonds, David G. Carlisle, John J. Fray, J.H. Sanders, Robert von Massow, J. Frank Turner and Jeremiah Ward.

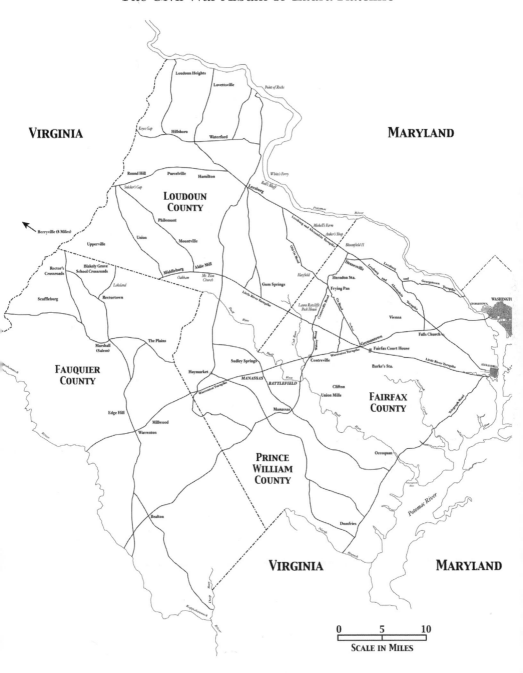

A map of Mosby's Confederacy. *Courtesy of Stephen Wolfsberger.*

A lot of the raids were "planned happenstance." Mosby's men were out scouting every day, and everybody was ready to go when a target of opportunity arose, day or night. "Mosby owned the night," they always said.

Mosby didn't particularly target women for his support, but women were the ones who were at home during the war. Everybody reported what they knew. Everybody knew a ranger in their neighborhood.

Many of the Confederate sympathizers provided Mosby and his men with safe houses throughout Fairfax, Loudoun and Fauquier Counties. His men worked out of their own homes where they could. But that was very limited, as many of their identities were known by Union soldiers. Mostly they worked out of the safe houses.

Civilian intelligence was very important. Civilians who provided safe houses were at risk themselves for supporting the Confederate cause. Civilians could have their houses burned for being suspected of supporting Mosby. They could be arrested or taken into captive prison. It is surprising that Laura was not arrested for her support of both Stuart and Mosby. The Union soldiers in the area certainly knew of her support and visited her house.

The civilians also had a method of sending signals to Mosby's men when there were Union soldiers in the area. They would simply hang a blanket, a quilt or something similar out of the upstairs window, like it was being dried. The Confederates could tell if it wasn't safe to approach simply by looking. This was common practice when Union soldiers were in the neighborhood.

When Mosby or his men were able to use a safe house, they paid. Mosby was known for this. If he stopped for dinner, he paid. He would give a quarter for a meal or something like that. He didn't own a tent. I don't think he ever spent a night in a tent. When the local civilians claimed, "Mosby slept in my house," he probably did!

Mosby himself never accepted any money. Whatever money he and his men took was divided among the troops on that particular raid. His men also gave rewards or thanks to civilians. There were certain houses that Mosby liked. He liked to go to some houses because the people had good coffee. He always appreciated a good cup of coffee!

In January 1863, Mosby conducted the first raids of his career as the leader of his Partisan Rangers. Mosby recruited John Underwood, a twenty-two-year-old farmer in the Frying Pan area whose knowledge of the terrain in Fairfax County was indispensable to Mosby. Underwood guided Mosby on his first raid near Frying Pan Church, capturing seven men of the Fifth New York Cavalry. Underwood was rewarded with a horse and a pistol for

Mosby's Rock, located in Frying Pan near Laura's house. The rock was used as a meeting place and drop off for correspondence for Mosby's men.

his part in the raid. Two days later, Underwood again guided Mosby south on another raid of the Fifth New York pickets near Cub Run, along the Little River Turnpike, capturing five more pickets. On the same day, Mosby captured more men from the First Vermont Cavalry at the Frying Pan Church, just north of Laura's house on Centreville Road. The prisoners, horses and equipment were taken to Middleburg in Loudoun County, where the prisoners were paroled and the equipment divided up among the captors.[193] These exploits prompted Stuart to loan Mosby six additional men, bringing his total to fifteen by mid-January.[194]

On February 11, 1863, Mosby met a number of his men and started toward Fairfax County from Rectors Crossroads in western Loudoun County.[195] At the same time, a large number of Union troops under Lieutenant Arthur S. Palmer, Company C, First West Virginia Cavalry, were hiding in a grove of pine trees near the Frying Pan Church on Centreville Road, while a small number of men were picketing at a crossroads nearby. The Union plan was to entice Mosby to attack the small number of pickets, and then the bulk of the soldiers would rush from their hiding places in the woods to capture Mosby and his men.[196]

By this time, Laura was known to the local Union troops as a Confederate sympathizer and a friend of Mosby. Captain Willard Glazier, Second New

York Cavalry, described Mosby's movement on or about January 10, 1863, following an attack by Mosby on a picket relief at Cub Run near the Little River Turnpike:

> *Later in the same night a similar assault was made upon our post at Frying-Pan Church. Not far from this church resides a Miss Laura Ratcliffe, a very active and cunning rebel, who is known to our men, and is at least suspected of assisting Mosby not a little in his movements. Colonel Percy Wyndham, who is in charge of the brigade, to arrange and change the alternation of the pickets, so that the regiments to picket at any given point may not be known beforehand; yet by the means of Miss Ratcliffe and her rebellious sisterhood, Mosby is generally informed of the regiment doing duty, and his attacks are usually directed against the unskilled and unsuspecting.*[197]

Perhaps the Union troops were blaming Laura for the information and skillful guidance newly provided by Laura's neighbor, John Underwood.

Unfortunately for the plan, a young Union soldier came to Laura's house to buy milk and eggs, and trying to impress the attractive Southern girl, he boasted openly about the trap. "We'll get Mosby this time," he said. "On his next raid he will certainly come to Frying Pan and it will not be possible for him to escape." He even told Laura that he knew she would warn Mosby if she could:

> *I know you would give Mosby any information in your possession; but as you have no horses and the mud is too deep for women folks to walk, you can't tell him; so the time you hear of your "pal" he will be either dead or a prisoner!*[198]

Even though "that fellow Mosby" was just beginning to be known for his exploits in Fairfax County,[199] Laura knew him from his visit two months earlier with Stuart when Stuart had offered his protection. As soon as the soldier was gone with his milk and eggs, Laura set out with her sister, despite the mud, to warn local sympathizers to watch for Mosby. She walked north on Centreville Road for three miles to the home of another Confederate sympathizer, her relative George Coleman,[200] after stopping at a number of homes,[201] hoping that he would help her.[202] While at his house, she saw cavalry through a window and went out with her sister to see who they were.[203] As the riders approached, she was at first alarmed that they might be Union soldiers, as she saw blue uniforms. She

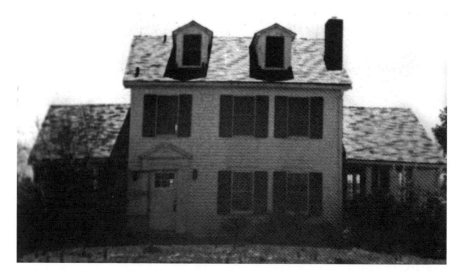

The Coleman House, located near today's Worldgate Center in Herndon, Virginia.

then recognized the lead rider as John Underwood, her fellow resident of Frying Pan, followed by Mosby. It turned out that Mosby's men were wearing captured Union coats.[204]

Laura and her sister had literally come in the nick of time. The Union plan was working. Mosby had already seen the pickets and was preparing to attack. Warned by Laura and her sister of the trap,[205] Mosby changed his plans and rode safely back to Middleburg.[206]

Mosby himself recalled the incident in his war reminiscences:

We then proceeded on toward Frying Pan where I heard that a cavalry picket was stationed and waiting for me to come after them. I did not want them to be disappointed in their desire to visit Richmond. When I got within a mile of it and had stopped for a few minutes to make my disposition for attack, I observed two ladies walking rapidly toward me. One was Miss Laura Ratcliffe, a young lady to whom Stuart had introduced me a few weeks before, when returning from his raid on Dumfries—with her sister. Their home was near Fryingpan, and they had got information of a plan to capture me, and were just going to the house of a citizen to get him to put me on my guard, where fortune brought them across my path. But for meeting them, my life as a partisan would have closed that day. There was a cavalry post in sight at Fryingpan, but near there, in the pines, a large body of cavalry had been concealed. It was expected that I would attack the picket, but that my momentary triumph would be like the fabled Dead Sea's

fruit—ashes to the taste—as the party in the pines would pounce from their hiding-place upon me. This was not the only time during the war when I owed my escape from danger to the tact of a Southern woman.[207]

During Mosby's many raids in and around Fairfax County, he visited the Frying Pan area on many occasions, either making attacks or passing through the area. On his way to attack forty to fifty members of the Eighteenth Pennsylvania Cavalry stationed at Thompson's Corner, today's intersection of West Ox and Thompson's Road,[208] Mosby left his column of men on February 25 to consult with Laura for her latest intelligence before successfully conducting the raid early the following morning.[209]

After Mosby raided Fairfax Court House on March 8—an act that brought him fame when he captured General Edwin Stoughton, Union commander at Fairfax Court House—one of Mosby's men stopped by to visit Laura. She told him, "The day after our expedition the Yankees came out in swarms, but looked very sullen and would have nothing to say." She knew that

there was some cause for the unusual excitement. At last one of them came up, seemingly greatly amused, and told us they were ordered by their officers not to tell what had happened in "Devil's Corner," as they call this neighborhood, as it would delight us too much. But he thought the smartest thing that had been done in either army since the war ought not to be kept secret. He then told us that Stoughton and his staff had been captured in bed the night before by Mosby.

The news, Laura said, "was too good to keep, so we went round among our neighbors to tell it, and that day was one of rejoicing among us all."[210]

Stuart personally sent a note, or had a note sent, to Laura on March 12 with the news of Mosby's "brilliant exploit...unparalleled in the war," with the salutation "To Miss Laura with lasting regards of JEB Stuart."[211]

On March 23, President Jefferson Davis promoted Mosby to captain, and General Robert E. Lee responded to Mosby's successes with "Hurrah for Mosby! I wish I had a hundred like him!"[212]

W.H. Chapman
Capt. Co. C. Mosby's Battalion

William Henry Chapman was born on April 17, 1840, in Madison County. He became a highly valued and trusted lieutenant colonel in Mosby's

Battalion, rising to second in command to Mosby. He was twenty-one years old and a student enrolled at the University of Virginia Southern Guards at the beginning of the war. He then transferred to Page County, where his parents lived, and enlisted in the Dixie Artillery on June 21, 1861. He was successively promoted to lieutenant, captain and, finally, commander of a battery in October 1861. He fought in the Seven Days Campaign and at Second Manassas and Sharpsburg.

When the Dixie Artillery was disbanded on October 4, 1862, he was reassigned as a recruitment officer for Fauquier County and was stationed in Warrenton. In the early months of Mosby's operations in 1863, Chapman joined Mosby on a number of raids before finally transferring to Mosby's Battalion as captain to command Company C when it was formed on December 15, 1863, at Rectortown. Chapman was involved in most of the major operations of Mosby's command.[213]

Prior to Chapman joining the Forty-third, he rode with Mosby not long after Mosby began his independent command. On March 23, 1863, Chapman rode with Mosby as the rangers[214] attacked a picket of the Fifth New York Cavalry near Chantilly, capturing seven.[215] After the Battle of Dranesville on March 31, Mosby mentioned Chapman, "late of the Dixie Artillery," among others, "whose promptitude and boldness in closing in with the enemy contributed much to the success of the fight."[216] Chapman also participated in the fight at Miskel Farm on April 1, when the Union forces attacked Mosby and Mosby returned the favor by routing the Union troops. Chapman was credited with firing the first shot for the rangers. He was captured by a party of Union soldiers that he was trying to capture, and then he was recaptured by arriving rangers. Chapman ended up taking a pistol from a Union soldier and capturing six or seven men.[217]

He was noted as a leader, with

a dark complexion with deep, dark eyes, thick black hair, and a beard that seemed always in need of attention. He possessed an intense determination that, more often than not, let him achieve what he sought after. An oft-times rough exterior hid a keen intelligence, and…he had a competitive nature that made him a formidable adversary.[218]

Chapman had almost a full year to sign the album as a captain, from December 15, 1863, until he was promoted to lieutenant colonel on December 7, 1864. In late January 1864, Chapman was with Mosby on a raid of Vienna in Fairfax County. A deserter from the Second Massachusetts Cavalry had joined Mosby and volunteered to lead Mosby into his former

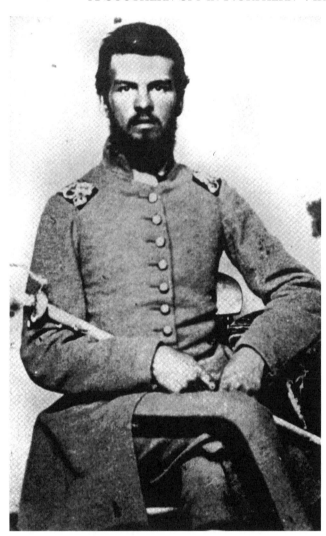

William Henry
Chapman.

camp there. Chapman volunteered to ride with the deserter to ensure that
he would not betray them. He ordered another ranger to kill the deserter if
he tried to betray them. Chapman successfully scouted the camp before the
rangers made off with a number of horses.[219]

Chapman was placed in command of the battalion while Mosby
traveled to Richmond on official business from February 2 to 18. Mosby
ordered Chapman not to attempt a raid unless he was certain of its success.
Chapman traveled with thirteen men to Berryville, where he learned that an
equal number of the enemy had just left and were traveling to Charlestown.

Intending to cut them off before reaching Charlestown, Chapman came upon the rear of the enemy. A fight broke out in which nine of the enemy were killed, wounded or captured.[220]

Chapman returned to Fairfax County on February 22. He arrived in Dranesville, where he led Company C and part of B on a successful raid of Federal cavalry. Captain Reed, a captured prisoner who had surrendered, wounded Baron Von Massow during this raid. Chapman, in turn, killed Reed. Mosby's report stated, "My thanks are due Captain Chapman…for [his] fidelity in executing every order."[221] On December 6, 1864, Mosby recommended Chapman for promotion to lieutenant colonel, stating, "[He has] on many occasions been distinguished for valor and skill, to which my reports bear witness, especially so in engagements with the enemy at Dranesville, Aldie, Charlestown and Newtown."[222]

Lieutenant Colonel Chapman, among others, conducted a number of raids to keep the enemy from capturing Mosby while he was moved to safety after Mosby was wounded on December 21, 1864, while eating dinner at the house of Ludwell and Mary Lake near Rectors Crossroads. Chapman was subsequently put in charge during Mosby's absence, until he returned on March 9, 1865.[223]

Chapman's final duties were delivering papers back and forth from Mosby to Union major general Hancock on April 15 and 16, discussing an armistice, while Mosby decided on his course of action and confirmed his knowledge of General Lee's surrender.[224] These duties took place just days before Mosby's farewell address to his rangers at Salem in Fauquier County on April 21. Chapman was paroled near Winchester with twenty other rangers on April 22, 1865.[225]

It seems likely that Chapman signed Laura's album in January 1864, when, as captain, he led a raid on Vienna in Fairfax County and captured much-needed horses.

W.E. Frankland
Capt. Co. F.
Mosby's Battalion

Walter E. Frankland was born on April 10, 1839, in Warrenton. He was living in the city of Washington with his family prior to the war. He enlisted in Company K, Seventh Virginia Infantry, on April 22, 1861, led by Captain John Quincy Marr in Warrenton. He was honorably discharged on May 19,

Edgehill, north of Warrenton, where William Chapman married Josephine Jeffries on February 25, 1864, after taking Baron Von Massow there to recuperate from his wounds received at Dranesville on February 22.

William Chapman's partially remaining signature "CHAP," made by using a trowel applying mortar to cover the stone foundation of the root cellar of the Spring Kitchen at Edgehill.

1862, due to ill health. When he returned to health, he intended to enlist in Colonel E.V. White's command but was persuaded by Northern Virginia residents to join Mosby's command about February 11, 1863.[226]

Unfortunately, Frankland did not have a horse, and Mosby was not able to provide him with one. So Frankland, and a recent Union deserter, James "Big Yankee" Ames, from the Fifth New York Cavalry, who was also without a mount, walked thirty miles from Rectors Crossroads to Ames's old camp in Germantown to obtain mounts. They left on February 28, slogged through rain and mud, made a raft of fence rails to cross Cub Run and arrived at the Fifth New York camp in Germantown on March 1.[227] At midnight, two hundred men from the camp saddled up for a raid to capture Mosby. After the cavalry left, the two walked straight into the camp, "talking freely" with a guard who never suspected the Confederates as they bridled two of the horses he was guarding in his presence and rode away.

The Union raid against Mosby was unsuccessful, but Frankland and Ames became two of Mosby's most trusted rangers. It wasn't long until Mosby used their account of successfully striking deep into enemy lines to travel two miles farther into Fairfax Court House with twenty-nine men, including Frankland and Ames, on March 8 to capture Brigadier General Edwin Stoughton.[228] Mosby was back in Fairfax County a short time later, scouting near Fairfax Court House and Vienna on April 19.[229]

Frankland was captured, however, on April 25 near Warrenton and was sent to Old Capitol Prison in Washington for refusing to betray Mosby. He was paroled on May 10. During his interrogation, Frankland was made to "walk the circle" for hours, possibly carrying a rail or other heavy object at bayonet point or carrying a knapsack full of bricks or rocks.[230] This was considered cruel and unusual punishment for prisoners of war.[231] He was recaptured on May 23 or 24 and was once again sent to the Old Capitol Prison before being paroled again. This time, he enlisted in Mosby's Company A at Rectors Crossroads on June 10, 1863. He was promoted to assistant quartermaster on October 27, 1863.[232]

On October 16, 1863, Frankland was with Mosby and a party as they followed a Union wagon train through Chantilly, acting as if they were part of the train's guards. At Mosby's signal, the men captured the train and accompanying Union soldiers. They took thirteen prisoners, seven horses and thirty-six mules. Frankland and five other rangers escorted the prisoners to Fauquier County.[233]

Frankland was involved in numerous raids and was rewarded by being elected captain to lead Company F on September 13, 1864, at Piedmont.

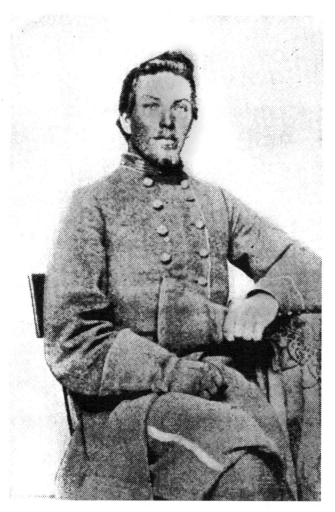

Walter E. Frankland.

His friend James "Big Yankee" Ames was his first lieutenant, Walter Bowie was his second lieutenant and Frank Turner was his third lieutenant.[234]

The next day, Frankland accompanied Mosby to Falls Church, where they captured a horse and one Union soldier before the camp was alarmed. Mosby abandoned the attempt at capturing additional horses.[235]

At the end of the war, after General Lee had surrendered, Mosby and his men were uncertain as to what action to take. While waiting for direction from Richmond, Mosby sent a response to Union general Hancock's letter authorizing him to receive Mosby's surrender. On April 15, Mosby sent Captain Frankland, Lieutenant Colonel William Chapman, Dr. Aristides

Monteiro and Adjutant Willie Mosby with a letter back to Hancock stating that he was willing to suspend hostilities until he was able to communicate with his own authorities.[236] On April 17, Mosby informed his men at Salem to respect the terms of the truce. On April 21, Mosby met with his men for the last time at Salem.

Frankland was paroled with almost two hundred other rangers at Winchester on the twenty-second. After the war, Frankland found employment as a postmaster at Stephens City. He attended an 1895 reunion of the Forty-third (Mosby's) Battalion in Marshall. He died on February 2, 1897, and is buried at Green Hill Cemetery in Stephens City, Frederick County.

It is likely that Chapman signed the album about September 14, 1864, while accompanying Mosby on the raid in Falls Church.

W.H. Mosby
Lynchburg

William (Willie) H. Mosby was the Partisan leader's younger brother. Born in Albemarle County in 1845, Willie was almost twelve years younger than his famous brother. Willie served as John's first lieutenant and adjutant, enlisting in the Forty-third Battalion's Company A on October 10, 1863, and serving until he carried his brother's proposed terms of surrender and truce on April 20, 1865.[237]

The Forty-third Battalion, Partisan Rangers, was formally organized on June 10, 1863, with the enlistment of sixty men into Company A at Rectors Crossroads. James William Foster was elected captain, Thomas Turner of Maryland first lieutenant, W.L. Hunter second lieutenant and George H. Whitescarver third lieutenant. The officers were proposed by Mosby and unanimously elected by the men.[238] Foster was only nineteen years old.

Willie enlisted in Company A four months later, on October 20, in Fauquier County. He was promoted as his brother's adjutant on July 28, 1864, replacing Samuel F. Chapman, who had been elected captain of Company E.[239] Willie received his promotion to first lieutenant on August 8.[240]

Willie traveled to Fairfax County on September 1, 1864, when General Lee instructed Mosby to prevent any Union raids from Alexandria. Willie was sent with Company A and successfully captured pickets at Chain Bridge. The company fell back past Fairfax Court House and camped for the night between Centreville and Union Mills. Raids on Centreville,

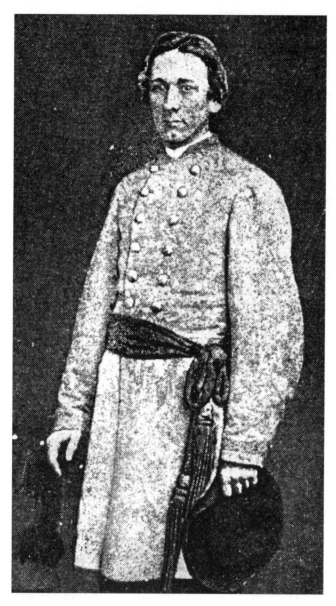

William H. Mosby.

Fairfax Station, Fairfax Court House and Falls Church followed in the next weeks.[241]

Willie took charge of his brother's care after John was shot in the abdomen on December 21, 1864, near Rectors Crossroads, while eating dinner at Lakeland. A Union officer examined Mosby, who concealed his

rank as colonel, and, not recognizing the wounded soldier, left him there, assuming that he would die within twenty-four hours. The Lakes wrapped Mosby in a blanket and had a "colored" man, Daniel Strother, drive him in an ox cart to Wheatland, the house of Aquilla Glascock, one of Mosby's men, where he was attended to by two of the command's doctors. Willie Mosby, along with other rangers, gathered to move his brother over the next week to their father's house at McIvors Station to recuperate.[242]

Willie also performed important duties at the end of the Forty-third Battalion's life, as he served as a courier with other officers at the end of the war. After Mosby received a letter from Union general Winfield S. Hancock on April 14, 1865, notifying him of General Lee's surrender on the ninth, Mosby sent one if his rangers to Richmond for guidance. While waiting for return information, Mosby sent Willie and three other officers with a letter on April 15 to Hancock, who commanded the Union forces around Winchester. Willie returned to his brother on the seventeenth with the message that "all guerilla operations should cease" and extended terms of surrender.

On the eighteenth, Mosby ordered the battalion to gather at Salem, where Mosby informed his men that a truce was in effect and ordered them to respect the terms, disperse and wait for further orders. Mosby had received his courier from Richmond. Lee, who was under parole, could not provide advice for Mosby. Mosby assembled his men on the eighteenth at Paris and told them to disperse once again and await his instructions.

After negotiations failed at the Clarke Hotel in Millwood on the twentieth, Mosby again called for his men to assemble at Salem at noon on the twenty-first. Two hundred men were present as Mosby disbanded the Forty-third Battalion, including Willie. Mosby stated that he had "summoned [them] to gather for the last time [to] disband [their] organization in preference to surrendering it to our enemies. I am no longer your commander."[243]

After the war, Willie moved to Amherst County, Virginia, where he married Lucy Booth of Baltimore in 1872 and had five children. He moved to Bedford County, where he worked in a retail business before being appointed postmaster at the direction of President Grant. Willie died in 1913 and is buried at Greenwood Cemetery, Bedford City, Virginia.[244]

It is possible that Willie signed Laura's album during his two weeks in Fairfax County in September 1864, during which time he made multiple raids in and around Centreville, Fairfax Station, Fairfax Court House and Falls Church.

John C. Edmonds
43d Battalion

John Carter Edmonds was born in 1848. He enlisted in Company A as a private on August 15, 1863, in Fauquier County.[245] He was the brother-in-law of two other rangers, Joseph Hancock Blackwell and Jacob Jennings "Jake" Lavinder. Less than two months after his enrollment, on October 1, 1863, Edmonds transferred to Company B when sixty men were mustered into the company at a tiny hamlet called Scuffleburg, on the eastern side of the Blue Ridge Mountains.[246] On October 9, Mosby met with forty men at Rectors Crossroads and rode to Frying Pan. The next morning, Edmonds set out with others to scout the area. At the end of the day, the rangers moved on to Guilford Station (Ashburn) on the Alexandria, Loudoun & Hampshire Railroad before moving on toward Alexandria. On the eleventh, the rangers captured three Union wagons that had become separated from the rest of the guarded train at a deep hole in the road near Padgett's Tavern, west of Alexandria. The rangers captured the three carts and ordered them to be moved into the woods, where they confiscated plenty of clothing and food. They even supplied a passing pro-Confederate couple with a wagon full of goods. The men were dismissed after dividing the rest of the loot.[247]

John C. Edmonds.

Edmonds was wounded in action on the Leesburg Pike in Dranesville on February 22, 1864. He was also involved in the raid on Point of Rocks, Maryland, and the subsequent fight at the Mount Zion Church near Aldie.[248]

After the war, Edmonds made a living as the commandant of the Bethel Academy in Fauquier County and later as the sheriff of Sherman, Texas. He served as a colonel in the Spanish-American War in 1898 before returning to Sherman, where he was killed in a duel in 1907.[249]

Edmonds could have signed the album when he was in the Frying Pan area on October 9 and 10, 1863, as part of Mosby's forty-man scouting party.

David G. Carlisle
Green Spring
Md

David Grafton Carlisle was born on August 19, 1838, in Green Spring, Maryland. Green Spring is located northwest of Baltimore. He served in the Twelfth Virginia Cavalry and was taken prisoner at Pikesville, Maryland, on September 12, 1862. He was sent to Fort McHenry two days later. He enlisted as a private in the original Company A at Rectors Crossroads on June 10, 1863, when the Forty-third Battalion was formally organized. He was involved in the raid at Seneca Mills, Maryland, the following day. He was captured on Christmas Day at Salem and was sent to the Old Capitol Prison on New Year's Day 1864. He was transferred to Point Lookout, Maryland, on April 17, 1864, and was exchanged on May 3.[250]

Among others, Carlisle was involved in the raid at Point of Rocks on July 4 and 5 and was scouting ahead for Mosby early on the sixth as the men rode toward Leesburg. Upon reaching Leesburg, Mosby and his men were informed that troops of the Thirteenth New York and the Second Massachusetts Cavalry, under Major William H. Forbes, were scouting for the rangers and boasting about what they would do to Mosby and his men if they were caught. One of the rangers recalled:

> It was no light circumstances, either, that these taunts were communicated to us by the pretty girls of Leesburg, who lined the streets as we passed through the town and presented us trays laden with most acceptable breakfast.

Mosby caught up with Forbes's command at Mount Zion Church, where the Federals had stopped to rest and feed their horses. Promising "a horse a

David Grafton Carlisle.

piece" for his rangers, Mosby successfully attacked and scattered the Union cavalry, which fled east to camps in Fairfax. One of the Union soldiers described the attack:

> *Mosby and his Rangers were upon us, swooping down like Indians, yelling like fiends, discharging their pistols with fearful rapidity, and threatening to completely envelop our little band. Who could stand before such a charge? No one. The Union troopers fought bravely before breaking.*[251]

Carlisle was involved in a sutler wagon raid between Vienna and Fairfax Court House on November 14, 1863. The captured sutler's wagon included "gloves, calico, buttons, cakes, crackers, canned goods." Another wagon "carried a supply of milk…to wash down the cakes and pies."

Carlisle was captured a third time on February 18, 1865, at Upperville and was sent to Fort McHenry with a note that identified him as a "guerilla, not to be exchanged." He finally took the oath of allegiance on May 1, 1865. After the war, he resided in Cockeysville, near Baltimore. He attended the 1897 reunion of the Forty-third Battalion in Baltimore, where he lived in 1909. He died in 1920 and is buried at Loudoun Park Cemetery in Baltimore.

It is possible that Carlisle signed the album on November 14, 1863, during the sutler raid between Vienna and Fairfax Court House with Company A or with Willie Mosby during the first two weeks in Fairfax County in September 1864.

Jno. J. Fray
Madison Co.
Va

John Joseph Fray was born on May 23, 1840, in Madison County, Virginia. He entered the University of Virginia at the age of sixteen. He served in a battery of the Madison Artillery (Thirty-fourth Virginia Infantry) under Captain G. Bouton at Yorktown before joining the Forty-third Battalion. He enlisted in Company B in Fauquier County on October 5, 1863, four days after the company was formed. He was transferred to the Artillery Company and was promoted to first lieutenant, second in command to Captain Peter A. Franklin, when the company was formed on July 28, 1864.[252]

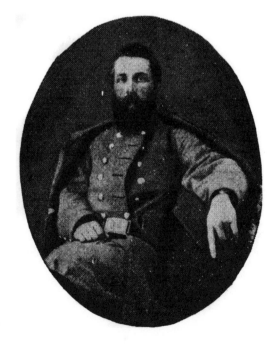

John Joseph Fray.

The Artillery Company only lasted about three months before it was disbanded on November 2, 1864. The men were incorporated into other companies or forwarded to Camp Lee to be assigned as conscripts. On November 28, the Artillery Company met to be reorganized, although Fray is not listed in this company.[253] He is, however, listed on the clothing receipt roll during the fourth quarter of 1864.

Fray was married after the war, in 1868, in Culpeper County and moved in 1877 to Raleigh, North Carolina, where he established the Raleigh Male Academy. He died in 1884 in Raleigh and is buried at the Masonic Cemetery in Culpeper, Virginia.[254] His uniform coat and canteen can be found at the Civil War Museum at the Exchange Hotel in Gordonsville, Virginia.

It is likely that Fray signed the album when he was in the Frying Pan area on October 9 and 10, 1863, as part of Mosby's forty-man scouting party.

J.H. Sanders
Mosby Bat

John Hylon Sanders was involved in a scouting trip on May 12, 1863, before he enlisted as a private in Company A on June 10 at Rectors

John Hylon Sanders.

Crossroads. He was involved in a sutler wagon raid between Vienna and Fairfax Court House on November 14, 1863. As the rangers left, Sanders sang:

> *When I can shoot my rifle clear,*
> *At Yankees on the roads,*
> *I'll bid farewell to rags and tags*
> *And live on Sutler's loads.*[255]

He was listed on the June–December 1863 muster roll. He was paroled at Winchester on April 22, 1865. He was a resident of Pleasant Valley, Fairfax County, after the war and died in 1907. He is buried at Chestnut Grove Cemetery in Herndon, Virginia.[256]

It is likely that Sanders signed Laura's album during the sutler's raid on November 14, 1863, or as part of Company A, with Willie Mosby, during the first two weeks of September 1864.

Robert von Massow
Prussia

Baron Robert Von Massow was the son of the chamberlain, the officer in charge of the household, of the king of Prussia. He had served in the Prussian army for seven years without seeing any active duty before coming to America to rectify this situation. He was recommended to Mosby by a letter of introduction from J.E.B. Stuart and Heros Von Borke on Stuart's staff. Von Massow and Von Borke had known each other in the Prussian army.[257]

Von Massow joined the Forty-third Battalion, company unknown, in early to mid-November 1863, according to Hugh Keen and Horace Mewborn. In an article published in 1914, William Chapman remembered that Von Massow first came to America in 1863 and came to Virginia in the fall of that year:

> *I always called him Baron. He came to me in Colonel Mosby's absence with a letter from General Stuart, the letter stating the German officer was here for observation and that he wanted to see some real service. I first met him at Oak Hill, in Fauquier County, and learned that he was an officer in the Prussian army on leave of absence. He wore a steel*

Baron Robert Von Massow.

gray uniform with green trimmings and carried a huge saber. He was a striking handsome man. He was as brave as a lion and he saw service all right, and he seemed to enjoy it.[258]

Von Massow was colorful, riding "into battle wearing a long, lined cape over a glittering uniform and from his hat waved a big ostrich plume. And he was not without the ever-present European sabre."[259]

Von Massow was wounded in the same fight as John Edmonds; in fact, he was wounded so severely along the Leesburg Pike in Dranesville on February 22, 1864, near Anker's Shop, that he was not able to rejoin Mosby's Command.[260] Von Massow returned to Europe after the war and commanded the Ninth Corps of the German army during World War I.

According to William Chapman's account, Von Massow could have joined Mosby's command anytime between late August and late September 1863. This would have allowed Von Massow to be present in the scouting party in Frying Pan on October 9 and 10, 1863, with John Edmonds, or with John Sanders and David Carlisle on the sutler raid between Vienna and Fairfax Court House on November 14, 1863.

The memorial marker at the location of the Anker's Shop Cemetery in Dranesville.

"J. Frank Turner
Lt. Mosby's Partisan Rangers"

James Frank Turner was a first lieutenant in Company F. He enlisted in the Forty-third Battalion in Company B when it was formed on October 1, 1863, at Scuffleburg in Fauquier County, where he served with distinction. He was present on the October–December muster rolls. On May 1, 1864, he was admitted to Chimborazo Hospital No. 3 for abscesses on his right thigh. He was then furloughed on May 6 for sixty days.

Turner was wounded in action at Fairfax Station on August 8, 1864. On August 7, Mosby had taken 35 men into Fairfax County while he sent 225 men to forage in northern Loudoun County. In Fairfax County on the eighth, Mosby captured a picket post of 3 men from the Sixteenth New York Cavalry three miles southeast of Annandale and then 12 more men on the outskirts of Alexandria. With 20 rangers, Mosby then traveled to Fairfax Station, where they attacked 60 more men of the Sixteenth New York who broke and fled from the charging rangers. It was in the initial volley with the New Yorkers that Turner was wounded.[261]

Turner was promoted to third lieutenant of Company F when the company was formed on September 13, 1864, at Piedmont. On the next day, Company F accompanied Mosby to Falls Church, where the men captured a horse and one Union soldier before the camp was alarmed. Mosby abandoned the attempt at capturing additional horses.[262] Six days later, Turner was promoted to second lieutenant. He then fought in a number of actions in the Shenandoah Valley and West Virginia. He was promoted to first lieutenant on October 10, 1864. Turner died in 1872 in Selma, Alabama.[263]

It is likely that Turner signed Laura's album while on the raid to Falls Church on September 14, 1863.

Jeremiah Ward
Campbell Co.

Jeremiah "Jerry" Ward enlisted as a private in Company C on November 11, 1863, in Fauquier County. He was listed on the muster rolls from December 1863 to February 1864. In late January 1864, Company C rode with Mosby on a raid of Vienna in Fairfax County. Ward was captured

at Philomont on April 29, 1864, and was sent to Vienna and then on to Old Capitol Prison on May 3. He was transferred to Fort Warren and took the oath of allegiance there on June 13, 1865. Campbell County is south of Lynchburg. Ward may have lived in Frederick, Maryland, before the war.[264]

It is likely that Ward signed the album while on the raid in Vienna in late January 1864.

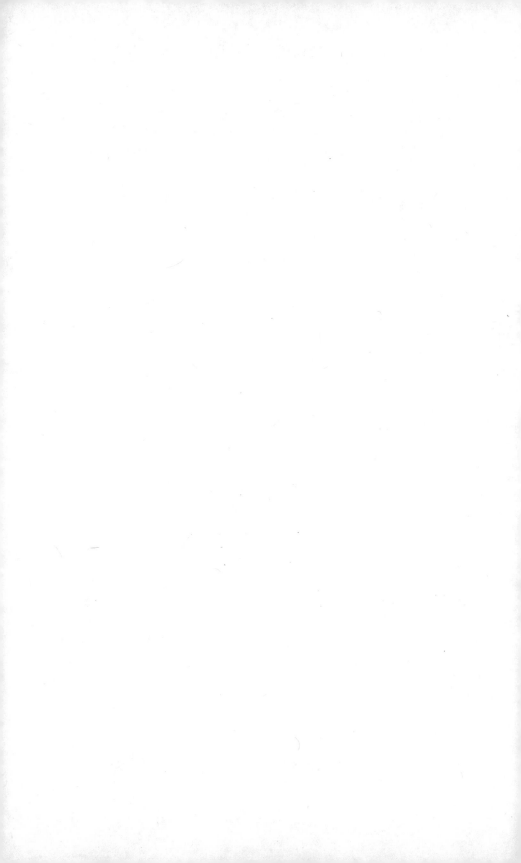

THE FITZHUGH LEE PAGE

Fitz Lee
Brig Gen
Cav: Div:

Fitzhugh "Fitz" Lee was born on November 19, 1835, at the Clermont Estate in Fairfax County, five miles west of Alexandria. He was born into one of Virginia's most distinguished families. He was the grandson of Henry "Light Horse Harry" Lee, cavalry commander for George Washington in the Revolutionary War. He was the nephew of Confederate general Robert E. Lee. Fitz's great-great-grandfather was George Mason, author of the Virginia Declaration of Rights, which was used as the basis for the first ten amendments to the U.S. Constitution. Even his father, Sidney Smith Lee, was an accomplished and well-regarded officer in the U.S. Navy.[265]

Influenced by the military achievements of his family, Fitz Lee applied for admission and was accepted into West Point in 1852 at the age of sixteen. It was at West Point where Lee met a future military influence in his life, an upperclassman by the name of J.E.B. Stuart.[266] At the beginning of the Civil War, it was evident that his family still strongly influenced him, as Fitzhugh Lee resigned from the U.S. Army on May 21, 1861, shortly after his uncle Robert E. Lee resigned and his father, Sidney, became a lieutenant commander in the Confederate States Navy.[267]

Fitz Lee moved into Fairfax Court House after First Manassas with Colonel Stuart and General Longstreet.[268] He left after a few days to go to Richmond with a recommendation from Brigadier General Richard S. Ewell to find a new assignment in the cavalry.[269] On September 30, he received a choice assignment to the First Virginia Cavalry on the Alexandria line from Annandale

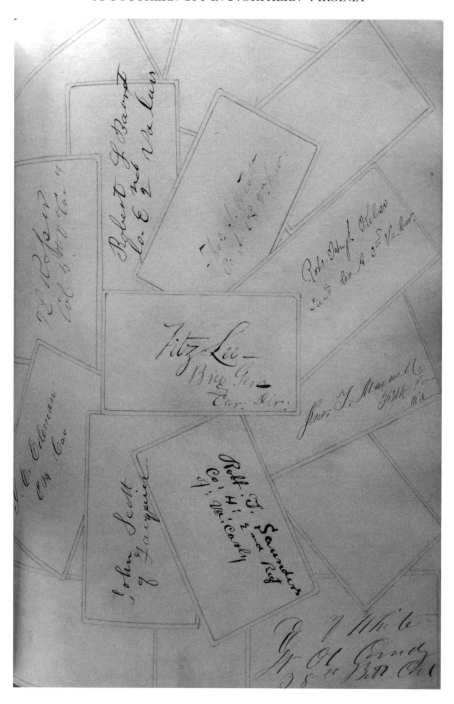

Signatures of Fitzhugh Lee, E.V. White, T.L. Rosser, Robert Hugh Kelso, Thomas S. West, Robert L. Barrett, Robert T. Saunders, J.C. Coleman, John T. Maxwell and John Scott.

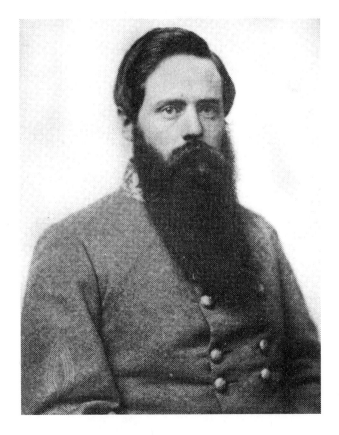

Above: Clermont, the home of Fitzhugh Lee.

Right: Fitzhugh Lee.

to Leesburg, which had been forged under fire into fame at First Manassas under Lieutenant Colonel J.E.B. Stuart. By the time Lieutenant Colonel Fitz Lee arrived, Stuart, however, had been promoted to brigadier general, and the First was under the command of William "Grumble" Jones.[270]

Throughout the rest of 1861, Lee gained recognition for his fighting ability in Northern Virginia. He spent time during the winter with his classmate Stuart at Camp Qui Vive, "fast becoming Stuart's most trusted subordinate."[271]

Lee left Northern Virginia along with the Confederate army in March 1862. He was involved in the Battle of Williamsburg and the Peninsula Campaign in May. Lee accompanied Stuart in his famous ride around McClellan in June. On July 25, 1862, Stuart was authorized to reorganize his command into two brigades. Fitz Lee was promoted to brigadier general to lead the Second Brigade, while the two-month Brigadier General Wade Hampton commanded the First.[272]

General Robert E. Lee and the Confederate Army of Northern Virginia's main focus of attention was now the newly designated Union Army of Virginia, created in June under Major General John Pope. Events over the next two months led both armies to the west of Fairfax County, where they met for the second time at Manassas.

On August 27, the two armies approached each other at Manassas Junction. Stuart sent Fitz Lee and his men west to Fairfax Court House to cut off any retreating Yankees. Lee reached the courthouse on the twenty-eighth as the armies lined up against each other at Manassas. On the twenty-ninth, Lee rejoined his comrades and remained relatively idle through the thirtieth and thirty-first, while the Confederate army gained victory for the second time in a little over a year on the fields of Manassas. Stuart and Fitz Lee followed up the victory by attempting to get ahead of the retreating Yankees along the Little River Turnpike. The Battle of Chantilly was fought at the intersection of West Ox Road on September 1.[273] Stuart's Camp Qui Vive, just south of the battlefield on West Ox Road, was used as a Union hospital.

On September 2, Stuart, along with Lee, pushed as far east as Flint Hill, today's Oakton, before falling back to Fairfax Court House for the evening.[274] Stuart also visited his old Camp Qui Vive.[275] On the third, Stuart sent Fitz Lee's brigade to make a demonstration toward Alexandria. They then moved on to Dranesville on the fourth[276] before heading north into Maryland on the afternoon of the fifth, leading to the Battles of South Mountain and Sharpsburg two weeks later.[277]

Fitz Lee did not return to Fairfax County until the very end of the year. He traveled north from Kelly's Ford on the Rappahannock with eighteen

hundred men under Stuart on December 26, with a target of the local storehouses in Dumfries. From there, the troops moved on to Burke Station on the twenty-eighth, capturing the mules. Stuart telegraphed a complaint to U.S. quartermaster Montgomery C. Miegs.[278] After a brush with enemy forces at Fairfax Court House, Stuart, Fitz Lee and others traveled west to visit Laura in Frying Pan for the evening and following morning[279] before returning to their headquarters in Fredericksburg on January 1, 1863.[280]

Fitz Lee returned to Fairfax County one more time as a brigadier general. On June 27, 1863, Lee moved north through the county on his way to Gettysburg, stopping at Burke Station, Annandale and Dranesville before continuing on into Maryland, crossing the Potomac River at Seneca Ford.[281] It was the month after Gettysburg, August 25, that Lee was promoted to major general when Robert E. Lee reorganized the cavalry into two division corps.[282]

In mid-October 1863, Major General Fitzhugh Lee traveled to Frying Pan for the last time during the war. Leaving Centreville with Stuart on the seventeenth, after Union general Meade had dealt a severe defeat to Hill's infantry at Bristoe Station, Stuart and Lee traveled past Gum Springs and Frying Pan. It was noted by one of Stuart's officers that Stuart helped move two women from Frying Pan, perhaps Laura and her mother, along with the rest of the retreating Confederates, to get them out of the path of the Union army's advance.[283]

Lee spent the rest of the war fighting outside Fairfax County. He fought with Stuart at Yellow Tavern. When Stuart was shot on May 11, 1864, he relinquished his command to Lee, saying, "Go ahead, Fitz, old fellow. I know you will do what is right."[284] Stuart died of his wound the next day.

On February 11, 1865, Robert E. Lee assigned his nephew, Fitzhugh Lee, command "of all the cavalry now serving around Richmond, and on the north side of the James River," reporting to James Longstreet.[285] Fitz Lee was, however, at his uncle's side at Appomattox on April 8, when the Confederate command held the last council of war. Fitz's cavalry made one last attempt early on the ninth to lead an escape west from the surrounding Union army before overwhelming numbers of the enemy forced the end of all hope, and surrender followed the same day.[286]

On New Year's Day 1886, Fitzhugh Lee was sworn in as Virginia's governor.[287] The end came on April 28, 1905, for "Stuart's most trusted lieutenant."[288] A fellow veteran proclaimed at his funeral, "His name is burned into our hearts as a hero whom we love."[289] Lee was the last governor of Virginia born in Fairfax County, Virginia.

Fitzhugh Lee had multiple opportunities to sign the album as a brigadier general in the days following Second Manassas and the Battle of Chantilly in

early September 1862, while the Confederate army was camped near Laura's house. Lee was also documented as visiting Laura's house on December 29, 1862, as well as on June 27 and October 17, 1863.

E. V. White
Lt. Cl. Camdg
35th Batt Cav.

Elijah Viers "Lige" White was born on August 29, 1832, in Poolesville, Maryland. Born to an affluent family of farmers, Elijah received a formal four-year education beginning at age sixteen, first in New York and then in Ohio. In 1856, he purchased farmland along the Potomac in Loudoun County. He was married and started farming the following year. A shallow point on the river on his property was used as a crossing point for both armies during the war—it came to be well known as White's Ford.[290]

As the signs of war loomed, White joined a company under Captain Shreve to protect his county's interests, rising to the rank of corporal. With a change of officers in 1861, Lige White joined the company of Dr. Frank Mason under Turner Ashby's Seventh Virginia Cavalry Regiment. White scouted during the summer and fall under the orders of Colonel Eppa Hunton.[291]

After performing scouting duties at the Battle of Balls Bluff on October 21, 1861, White was turned down to be commissioned in the Regular Army of the Confederate States, so he applied to Colonel Hunton in Richmond and received permission to raise his own independent command as a captain in the Provisional Army. Upon returning to Leesburg, he opened a recruiting office, and by the end of the year, Captain White reported to General D.H. Hill with fifteen men for courier duty between Leesburg and Winchester.[292] Over the period of the war, White's Men, White's Rebels, White's Comanches or White's Battalion, as they were called, served as Partisan Rangers at home in Loudoun County, under regular service as scouts and couriers under General Ewell in the Shenandoah Valley and as a battalion as part of the Laurel Brigade under Turner Ashby's Seventh Virginia Cavalry.[293] However, his men were always known for serving under their leader, Elijah Viers White.[294]

White's Rebels came into being in January 1862, and by March, White had enough men to become a company under Colonel Munford's Second

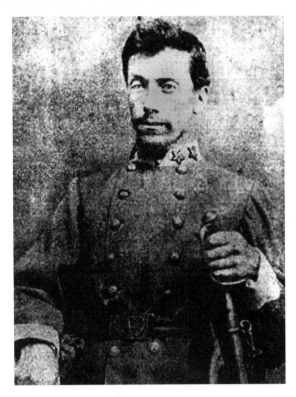

Elijah Viers White.

Virginia Cavalry while scouting at Dranesville. A month later, White's men were transferred to General Richard S. Ewell's headquarters in the Shenandoah Valley.[295] At the end of August, White received permission from Ewell to return to Loudoun County with his group of over one hundred men. On August 26, White's men overwhelmed a group of Union rangers from Loudoun County under Captain Means at Waterford's Baptist Church.[296]

On October 28, Stuart formally mustered five companies of White's Battalion into the Confederate service as the Thirty-fifth Battalion, Virginia Cavalry. White was elected a major to command the new battalion. On February 4, 1863, White was promoted to lieutenant colonel and ordered into Loudoun County and then to New Market and West Virginia for the next few months.[297]

Following the Battle of Gettysburg, White immediately requested leave from Stuart to once again operate independently, and Stuart approved his request. In August, September and October, White's Battalion operated in Loudoun, Fauquier and Fairfax Counties. White even drew the praise of Robert E. Lee, who sent a letter to Stuart on September 9, 1863, calling White's Battalion's actions at Poole's Farm on August

27 and its attack on Union major general H.J. Kilpatrick's cavalry on September 1

> *an evidence of the great boldness and skill of that officer. The activity and energy of his commanders and the gallantry of his officers and men especially in his attack on Poole's farm reflect great credit upon his service. I hope his operations will always be attended with the same success.*[298]

While in Fairfax County near Fairfax Court House, White's men noted that the civilians in the area always found food for his men.[299] White also led a raid through Fairfax, Hunter's Mill and Lewinsville to Green's Store in Vienna to capture a notorious Union spy named Amy.[300] About October 10, 1863, White led fifty men to Lewinsville, where he killed four men and captured twenty prisoners and sixty-four horses.[301]

The Thirty-fifth was assigned to Colonel Rosser when he was promoted to brigadier general on October 10. It was Rosser who gave the battalion the name "White's Comanches in late November for their wild riding and ear-piercing yells."[302] It does not appear that White returned to Fairfax County, though he fought with valor during the rest of the war.

Today's Angelica Run Farm on Hunter Mill Road, between Hunter Station and Hunter Views Roads, where E.V. White pastured the horses captured in Lewinsville.

On April 6, 1865, White was placed in command of the Laurel Brigade when General James Dearing was wounded.[303] The Comanches fought for the last time on April 9 a short distance from Appomattox Court House and rode to Lynchburg, not wishing to surrender. White addressed his men for the last time, disbanding them on the tenth and thanking them "for the cheerful obedience you gave my orders and the gallant achievements you won under my command."[304]

Shortly thereafter, White returned to Loudoun County and received his parole from the Winchester office. In 1866, White was elected sheriff for four years in his native county. He had a grain and farm supply business that prospered, started a ferry at White's Ford that still operates today and served as president of the People's National Bank of Leesburg.

In 1877, he was named an elder in the Primitive Baptist Church.[305] He preached at the Frying Pan Baptist Church, a short distance from Laura's postwar home. The first baptism performed by Elder E.V. White at Frying Pan Baptist Church was Robert L. Spindle, a former member of Company B, Mosby's Rangers.[306]

White died on January 11, 1907, and is buried at Union Cemetery in Leesburg. White could have signed the album while in Fairfax County on October 10, 1863, during the raid on Lewinsville. Stevan Meserve, author of *The Civil War in Loudoun County: A History of Hard Times*, notes that White was in and out of Fairfax County numerous times during the war.

T. L. Rosser
Col. 5th Va Cav'y

Thomas Lafayette Rosser was born on October 15, 1836, in Campbell County, Virginia. He attended the U.S. Military Academy at West Point in 1856 and resigned on March 22, 1861, two weeks before graduation. He was appointed as a first lieutenant in the Confederate army and was assigned as an instructor in the Washington Artillery in New Orleans. He commanded a company at First Manassas on July 21, 1861. He was promoted to captain on September 27, 1861, and to lieutenant colonel on June 11, 1862, in the Washington Artillery.[307]

In September 1861, Captain Rosser served under Stuart in Fairfax County, using two artillery pieces to quickly and effectively scatter Federal forces at Lewinsville. It was at this time that Stuart started to think of offering Rosser, also a good horseman, a permanent position on his staff.[308] Rosser spent the winter and spring with Stuart at Camp Qui Vive,[309] where he no doubt met

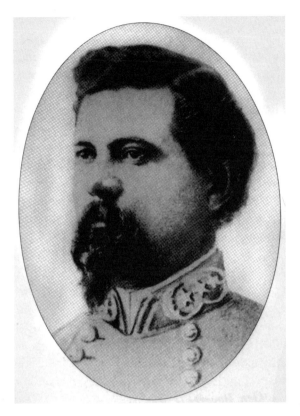

Thomas Lafayette Rosser.

the beautiful young Laura Ratcliffe after the Battle of Dranesville, as she tended to Stuart's wounded at Frying Pan Church and Camp Qui Vive.

In the spring of 1862, Captain Henry Pate of the Petersburg Rangers had an idea for the new Virginia Cavalry regiment—he enlisted men from every part of the state so that they would be better able to serve as scouts wherever needed. Nine hundred men were quickly organized as the Second Battalion, Virginia Cavalry, on May 25, 1862. As McClellan was advancing on Richmond in late June, General J.E.B. Stuart sent for Pate, informing him that Stuart was incorporating Pate's Second Battalion into a new Fifth Virginia Cavalry under Stuart by adding two new companies under the command of Rosser, who was promoted to colonel to command the Fifth on June 27, 1863.[310] Rosser's immediate challenge was to quickly develop the ill-disciplined and poorly drilled Fifth into fighting trim.[311]

Rosser arrived in Fairfax County on August 27, along with Fitz Lee, to harass enemy communications[312] before returning, under "Stonewall" Jackson, to the Brawner House at Manassas on the twenty-eighth for the battle brewing there.[313] On September 1, Rosser and the Fifth rejoined the brigade

at Centreville, and on the second, they camped at Fairfax Court House. On the afternoon of September 5, 1862, Rosser and Fitz Lee's brigade led the Confederate army's move across the Potomac into Maryland.[314]

Stuart recommended the twenty-six-year-old Rosser for promotion to brigadier general in October, but the promotion was not granted, perhaps due to Rosser's penchant for drinking.[315]

Rosser returned to Fairfax County with Stuart and Fitz Lee on their raids at Dumfries and Burke Station on December 27 and 28, 1862, before stopping with both of his superiors at Laura's house on the twenty-ninth.[316]

Rosser finally received his promotion to brigadier general on October 10, 1863, as the head of Stuart's Laurel Brigade.[317] In mid-October, Brigadier General Rosser traveled to Frying Pan with Stuart and Fitz Lee for the last time during the war. They stopped at Laura's house to visit Laura and her mother and offered to move them from the path of the nearby enemy.[318]

In the end, Rosser did not surrender at Appomattox with Fitzhugh Lee. He was paroled in May 1865. Rosser wrote after the war that he did not think much of Stuart, as Stuart's high standard of obedience affected his men, who loved, hated, envied or feared him.[319] Rosser lived until March 29, 1910, passing away in Charlottesville, Virginia.

Rosser had multiple opportunities to visit Laura and sign her album. He held the rank of colonel from June 27, 1862, until October 10, 1863. As with many others, he would have been near Laura's house from September 2 to the 5, 1862, after the Second Battle of Manassas and the Battle of Chantilly. He also accompanied Stuart and Lee to Laura's house on December 29, 1862. Additionally, he accompanied Lee to her house in mid-October 1863, very close to the time he was promoted to brigadier general.

Robert Hugh Kelso
Lieut Co A 2nd Va Cav

Thomas S West
Co. A 2nd Va.

Robert L Barrett
Co. E 2nd Va Cav

Robt. T. Saunders [Lieutenant]
Co. H. 2nd Reg
Of Va Cavly

Robert Hugh Kelso, Thomas Scott West, Robert Lewis Barrett and Robert Thomas Saunders were all members of the Second Virginia Cavalry, which began as the Thirtieth Virginia Regiment of Virginia Volunteers in May 1861 and was eventually transferred to General Fitzhugh Lee's brigade under J.E.B. Stuart in October 1861.

Robert Hugh Kelso was born on December 23, 1836. He graduated from Hampton-Sydney College in 1856.[320] Thomas Scott West was born on January 28, 1842, in Appomattox County before moving to Bedford County in 1857. He attended Randolph-Macon College.[321] Robert Lewis Barrett was born about 1843.[322] Robert Thomas Saunders was born about 1842 and was a resident of Buckingham County.[323]

The Thirtieth Regiment, Virginia Volunteers, was formed under Colonel Richard C.W. Radford starting on May 20, 1861, at Lynchburg, Virginia. Lynchburg was chosen as a training camp because it was a railroad center and a convenient location for Virginia's troops. Colonel Jubal A. Early was initially in charge of the troops arriving in the city.[324]

Company A, the Clay Dragoons, had been organized in 1857. The new volunteers were enrolled in Liberty on May 11 and were sworn into state service on May 13 at Lynchburg. Robert Kelso enlisted as a third lieutenant in Liberty on the eleventh, and Thomas West enlisted in Lynchburg on the twenty-second.

Company E, the Amherst Mounted Rangers, enrolled at Amherst Court House on May 12 and was sworn into state service in Lynchburg on May 29. Robert Barrett enlisted at Amherst Court House on May 23.

Company H, the Appomattox Rangers, enlisted at Appomattox Court House on May 24 and entered state service on June 3 at Lynchburg. Robert Saunders enlisted as a private at Appomattox Court House on the twenty-fourth.

The companies drilled for a month before heading off to Northern Virginia.[325] Kelso and West of Company A left for Manassas Junction on June 10 before moving on to Camp Radford at Frying Pan Church on June 16, picketing, scouting, patrolling and performing courier duty in the Northern Virginia area.[326] Robert Barrett of Company E and Robert Saunders of Company H were camped at Milford Mills near Manassas.

Colonel Maxcy Gregg of the First South Carolina Infantry joined Company A at Frying Pan. From there, they marched to Dranesville, Hunter's Mill and the Potomac. Company A, with Kelso and West, participated in the firing on the First Ohio Infantry on the Alexandria, Loudoun & Hampshire Railroad on June 17 at Vienna, with Gregg pursuing the fleeing Federals after the attack.[327]

Barrett and Company E reached Fairfax on July 1, 1861,[328] but Radford's regiment was withdrawn to Manassas in late July upon the advance of Federal forces from eastern Fairfax County under Brigadier General Irvin McDowell. During the Battle of First Manassas, Company A was in action early near the stone bridge over Bull Run.[329] Companies E and H were engaged, although their captains either did not submit reports detailing their action or their reports were lost.[330] Following the battle, the regiment followed the fleeing Federals to Centreville and then on to Fairfax Court House, Mason's and Munson's Hills, near Falls Church, and Flint Hill, where they remained for several weeks.[331]

In late September, Companies A and H were in camp near Centreville, with Company E in Dranesville. Company A moved from Centreville to Vienna and then between Centreville and Frying Pan in October.[332] Robert Kelso was promoted to second lieutenant on October 11. Company E performed picket duty at Hunters Mill, with Company H making a reconnaissance to Dranesville in late October.[333]

By the end of October 1861, the Thirtieth Virginia Regiment had been re-designated the Second Virginia Cavalry under Stuart.[334] The Second Virginia went into winter quarters around Centreville, Leesburg and near Bull Run until March 7, when it covered the rear and flanks of the Confederate army as it moved south from Northern Virginia.[335]

Most of the companies reenlisted for the war in April 1862.[336] Robert Barrett was detailed as a scout to General J.E.B. Stuart from February 24, 1862, through December 31, 1862, during which time he was promoted to second corporal.[337] Robert Saunders was elected second sergeant after reenlisting.[338] Thomas West was promoted to fourth corporal and again to third corporal between late 1861 and late 1862.[339]

The Second Virginia returned to the Northern Virginia area for the Battle of Second Manassas, protecting Jackson's flanks and rear during the combat on August 29 and 30 near Sudley Church.[340] Lieutenant Robert Kelso was wounded in action at Second Manassas, suffering five saber cuts on the thirtieth.[341]

On August 31, the Second rode with Stuart back into Fairfax County toward Chantilly. On September 1, however, the regiment was sent to Leesburg to capture Federal troops that were harassing the citizens. The Second chased them off to Waterford.[342] The regiment was then ordered to Lovettsville on the fourth to gather cattle for Lee's army. On September 6, the Second Virginia crossed the Potomac with Stuart into Maryland.[343] On November 10, 1862, the regiment was transferred to General Fitzhugh Lee's brigade.[344]

The Second followed Fitz Lee and J.E.B. Stuart back into Fairfax County on the raid at Burke's Station on December 28 before spending the night near Laura's house in Frying Pan on the twenty-ninth.[345]

No further record is available on Robert Barrett. Robert Kelso was an acting adjutant in late 1863. He was wounded at Yellow Tavern on May 11, 1864, and died of his wounds on July 25 in Richmond Hospital. He is buried at the Kelso family cemetery in Bedford County.[346]

Robert Saunders was elected second lieutenant on July 22, 1863. He was wounded at Spotsylvania Court House on May 8, 1864, and was sick in Lynchburg Hospital until July 31, 1864. He was promoted to first lieutenant on July 3, 1864, and was commanding Company H on December 30, 1864. He was killed in action at High Bridge on April 6, 1865.[347]

Thomas West was promoted to second corporal in the first quarter of 1863 and elected second lieutenant on November 29, 1864. He surrendered on April 9, 1865, at Appomattox Court House. After the war, he was a farmer in Bedford County in 1885 and also served as the commissioner of Bedford County. He died on November 11, 1923, and is buried at Oakwood Cemetery, Bedford.[348]

Kelso, West, Barrett and Saunders had two opportunities to sign Laura's album. With the rest of the Confederate army, they were camped near Laura's house in Fairfax County from September 2 through the 5 after the Battle of Chantilly. They were also with Fitzhugh Lee when he stopped at Laura's house on December 29, 1862.

J.C. Coleman
6ᵗʰ Va Cav

Johnston Cleveland Coleman was born in 1837. He was a farmer when he enlisted in Company K of the Sixth Virginia Cavalry on July 1, 1861.[349] Company K was originally formed as the Loudoun or Leesburg Cavalry in June 1858. It was involved in the Battle of First Manassas in July 1861 and was present, but not involved, at the Battle of Balls Bluff on October 21.[350]

The Sixth Virginia was formed under Colonel Charles William Field on September 12, 1861, at Ashland, Virginia, seventeen miles northwest of Richmond. As the different companies were formed in various counties in Virginia, and owing to the fact that they were immediately sent off on various assignments, it wasn't until late in the year that all the companies arrived in camp at Ashland.[351] Coleman and Company K never joined their new regiment at Ashland; instead, they joined it at Centreville on December 5, coming from Leesburg.[352]

Most of the companies were located in winter quarters at Camp G.W. Smith near Centreville as part of J.E.B. Stuart's brigade. Problems abounded. Of the 519 men in the regiment, 107 were reported sick in the month of December. Absenteeism also became a factor, as the spirits of the men of Company K "had fallen decidedly low" due to confinement to camp thanks to "ice-slick or mud-filled roads," which kept the men from "the occasional scout…[that]…revived their spirits." Notices were even posted in local newspapers identifying deserters and posting rewards for their return.[353]

Coleman epitomized both his regiment and the company's problems. He was absent on sick furlough and then went AWOL from February 21, 1862, until June 9, 1863.[354] As he lived in Loudoun County after the war, it is highly likely this was the location of his home before the war, and this probably provided a close and comfortable place to recover from his illness.

The Sixth Virginia Cavalry vacated Northern Virginia with Stuart in March 1862. Supporting the Confederate troops in the Shenandoah Valley Campaign in the summer, the regiment gained an excellent reputation and was called "the bloody sixth" by General Ewell.[355] Coleman was captured as a prisoner of war at Beverly Ford on June 9 and was paroled on June 25 at the Old Capitol Prison.

Coleman was discharged on August 1, 1863, on receipt of a substitute. However, he was present again on the rolls a short time later in November

Johnston Cleveland Coleman's grave at Chestnut Grove Cemetery, Herndon, Virginia.

and December 1863. On November 5, the Sixth was at Brandy Station for a grand review by General R.E. Lee and then went into winter quarters in Orange County.[356]

As the Sixth Virginia returned to battle in 1864, Coleman was wounded on May 6 at Spotsylvania and again on October 9 at Cedar Creek. He was taken as a prisoner of war for the second time on April 1, 1865, when the overwhelming forces of the Fifth Federal Corps turned a Confederate retreat after the Battle at Five Forks into a rout, forcing the Confederate evacuation of Petersburg and Richmond. Coleman took the oath of allegiance at Point Lookout, Maryland, on April 28. He lived until September 9, 1895, at his home, Hayfield, in Guilford (Ashburn) in Loudoun County, where he was buried. He was later reinterred at Chestnut Grove Cemetery in Herndon, Virginia. He is the brother of Kate Coleman, who also signed Laura's album and will be discussed later.

Coleman was near Laura's house after the Battle of Chantilly during the first few days in early September. As Kate's brother, he may have had other opportunities to sign the album as well.

Jno. T. Maxwell,
F'dk Co
MD

John Thomas Maxwell of Frederick County, Maryland, served in Company B of the Thirty-fifth Virginia Cavalry. His hometown was Park Mills, located near Buckeystown.[357] He was the reverend of the Flint Hill Methodist Episcopal Church South.[358] He was born in Baltimore on October 9, 1837.[359]

There were a total of twenty-four ordained and licensed clergymen from Maryland who left their parishioners behind to serve the spiritual needs of soldiers of the Confederate army in the field. They were commonly called fighting chaplains or fighting parsons. Some did not believe in killing the enemy and traveled with their companies unarmed. However, many volunteered as chaplains and then sought commissioned appointments as soldiers.

John Maxwell was not one of the unarmed chaplains. "Reverend Maxwell carried a revolver and saber and was always at the front of Company B, not letting his sacred responsibilities as a chaplain interfere with his patriotic duties as a soldier."[360] Since John Maxwell did not sign his name as a member of the Thirty-fifth, perhaps he was not yet, or did not become, a regular soldier. The roster for E.V. White's Thirty-fifth Battalion, Virginia Cavalry, lists a John Maxwell from Staunton, Virginia, in Company B; a Thomas Maxwell as chaplain in Company D; and an F.T. Maxwell in Company B.[361] Most likely, John Thomas was the chaplain. Maxwell joined the Thirty-fifth during the Battle of Bull Run in July 1861.[362]

Some Marylanders were listed as natives of other states, as Maryland was not a part of the Confederate government and volunteers from Maryland had difficulty obtaining upper-level positions.[363] Many traveled together in groups to other states and enrolled there. About 500 men from Baltimore, recruited in December 1860, were sent to South Carolina and placed in units from that state.[364] At least 272 Marylanders who were paroled after the war were identified as having served in White's Thirty-fifth, 11 as officers.[365]

Company B was formed on September 1, 1862, under Captain George W. Chiswell just after the Battle of Second Manassas. When White's Battalion entered Frederick, Maryland, on its march north, the entire army stopped to rest and close ranks. White issued a proclamation on September 9 to entice the men of Maryland to raise a regiment of

Maryland cavalry—this no doubt persuaded Maxwell to join the ranks. The company was known as "Chiswell's Maryland Exiles," and it drew men from Montgomery and Frederick Counties.[366] As the Confederate army traveled into Maryland for the first time, the First Maryland Regiment was not with it, so the men had to join the regiments that were there. Eight hundred men from Frederick joined.[367]

Interestingly, the men from Maryland had not seceded and felt that they could choose where and when they would fight. They chose to fight as independent partisans as opposed to becoming members of the regular army. It took White himself to convince Chiswell's men to stay in the Thirty-fifth and fight the common enemy, the Union soldiers, be it as regulars or irregulars.[368]

Maxwell's best-documented opportunity to sign Laura's album came when sixty men of Companies A and B accompanied Colonel E.V. White on the raid on the Union camp at Lewinsville on October 10, 1863. White stopped upon arriving within five miles of the camp, as he had no real idea of the disposition of the camp and needed to form a plan of attack. Donning a Yankee uniform, he walked around the camp after dark, determining where the pickets were located and the best route to attack.

White dismounted half of his men and sent them directly into the camp, while he accompanied the other half, mounted, in from the rear. Once White and his men on horseback reached their positions, the dismounted men entered the camp and fired their guns, causing havoc among the Union troops. The mounted men then rushed into the camp, where they captured about thirty prisoners and sixty-three horses and killed or wounded fifteen of the enemy. None of White's men, including Reverend Maxwell, was wounded or captured.[369]

After the war, Maxwell served as a pastor on fourteen arduous circuits throughout Maryland and Virginia, traveling great distances over

> *mountain roads, high altitudes, unbridged streams, and long distances between morning and evening appointments for preaching made the burden great, but all was courageously faced and faithfully done.*

He married Laura Gibson of Loudoun County in 1872. He continued in religious service until 1897, when, due to failing health, he moved to Staunton, Virginia, and assisted nearby pastors when able. He died at the age of eighty-one on October 12, 1918.[370]

John Scott
Of Fauquier

John Scott was born about 1821.[371] By 1858, he was a wealthy planter in Warrenton, Fauquier County. William Henry Fitzhugh Payne, whose grandfather had served in the Virginia Continental line under George Washington, was Fauquier County's commonwealth attorney. At a dinner meeting at Bellevue, held by Payne and attended by a number of the wealthiest, most influential and strongest secessionists in Warrenton, Payne turned to Scott and asked, "How would you like to command a squadron of cavalry?" Scott replied, "Very well; but why do you ask?" Payne responded, "Because the Union will certainly be dissolved in a few years and it ought to be prepared for," to which Scott replied, "Let's get to work."

Since the men were descendants of Cavaliers, the decision was made to raise a cavalry troop. Their Saxon forbearers' first flag had incorporated a white

John Scott at the 1890 Black Horse reunion in Warrenton, Virginia.

horse, and it was decided that they should also adopt the horse as their symbol. But as the men were proslavery, and the mayor was in favor of opening slave trade to Africa, they decided to adopt the black horse as their symbol, and the troop was called the Black Horse Cavalry. The cavalry troop was quickly and enthusiastically organized, and John Scott was elected as captain.[372]

William Payne did not join the Black Horse Cavalry, as he was a lieutenant colonel on the staff of Virginia governor Henry A. Wise. Being the sons of wealthy landowners, the cavalry members provided their own black boots, plumed black hats, black horses, sabers and pistols. However, the men had little to do but "meet, drill, and wait" from 1858 until 1861.[373]

Anxious for action, Scott left the Black Horse Cavalry after the Virginia Convention voted against seceding on April 4, 1861, and joined the Confederate army as a colonel. One week later, Fort Sumter was fired upon and President Lincoln called for troops from Virginia to put down the insurrection. On April 17, the Virginia delegates voted to secede.[374] On April 26, the Black Horse Cavalry was sworn into the service of Virginia[375] as a company in the Fourth Virginia Cavalry.[376]

Captain Scott did not miss out on the first major battle of the war. He was in command of two companies of cavalry under Colonel Jubal Early at Union Mills on July 17[377] and commanded the same two companies at First Manassas on July 21.

On May 23, 1862, Major Scott was put in command of the Twenty-fourth Virginia Battalion, Partisan Rangers. There are few records of the battalion, which was not long-lived due to a lack of horses, arms and discipline. The battalion saw action at Culpeper Court House on July 12.[378]

On that day, the Twenty-fourth moved to Culpeper Court House and was nearly captured in a skirmish, as it still did not have mounts. Captain Callan, the battalion's commander, resigned. From Culpeper Court House, the men moved to Richmond. They had not been paid for their services rendered so far, and morale was low.[379]

On August 1, 1862, the battalion was stationed at Charlottesville, where the local civilians complained of their rowdy behavior and lack of discipline. The troops complained of not having any horses. They remained in Charlottesville without horses for two weeks after Scott unsuccessfully made a requisition for mounts to General Jackson. The battalion was subsequently disbanded, and the men of the four companies were reassigned into other cavalry units for the rest of the war.[380]

Scott, however, made a contribution to the Confederate army of far more significance. He conceived and drafted the Partisan Ranger Law approved by the Joint Military Committee of the Confederate Congress. Based on the

prize principle of nautical warfare, the law was enacted on land, allowing those acting as irregular Partisan Rangers to keep the spoils of war that they captured. Colonel Mosby was the most successful of the Partisan Ranger groups, and after the war, he asked Scott to write the history of his command as the most successful application of Scott's law.[381]

Scott's fighting days were over. He was demoted to captain in the Provisional Army of the Confederate States and transferred to Little Rock, Arkansas, in the Trans-Mississippi Department. By June 25, 1863, he had risen to the rank of colonel, commanding the post. On February 18, 1864, he was assigned to General Pickett's staff and later served on General Kemper's staff. After the war, he was paroled in his home county of Fauquier on May 5, 1865.[382]

Due to the way that Scott signed the album "Of Fauquier" without a reference to his rank, it seems likely that he signed the album after the Twenty-fourth was disbanded in August 1862 and before he was transferred to Arkansas. This points to the possibility that he may have traveled north from Charlottesville and was with the Confederate army in early September 1862, just after the Battle of Chantilly in Northern Virginia.

The first week in September 1862 seems to have been a very busy time for Laura and her family. For nearly one week, the entire Army of Northern Virginia camped around Frying Pan. She must have provided all that she could for the soldiers she already knew and those she was just meeting. No doubt she welcomed many more, perhaps not all of whom were literate and able to sign their names in her album.

THE LOCAL WOMEN PAGE

Laura had a front-row seat to the comings and goings of Union troops through the Frying Pan area in western Fairfax County. She also had access to information from five other local women, strategically located to the north, south, east and west. Laura was the center of a spy, or intelligence-gathering, ring in western Fairfax County. The intelligence that Laura was able to provide to Stuart, Mosby and other Confederates came from visual observations of Union troops in the area, as well as the information provided by her neighbors and extended ring of observers.

Kate Coleman lived five miles away to the northwest in Loudoun County. Lucy E. Cockerille was located in Leesburg, thirty miles northwest of Laura. Mollie Millan was located three miles to the southeast. Laura Monroe was located ten miles to the southeast in Fairfax Court House. Kate Carper, who signed Laura's album on a separate page, was located eight and a half miles to the north.

Mollie Millan
The Hermitage

Mary Jones Millan, or Mollie, lived at the plantation known as the Hermitage, the home of her grandmother, Mrs. Thomas William Lee. The house was located on Lee Road, south of the Little River Turnpike, today's Route 50, in Chantilly. Mollie's sympathies and activities during the war were well documented by her sister, Virginia Lee Millan, in an article published in the *Confederate Veteran Magazine* in 1921.[383]

Virginia's account mentions the plantation next to the Hermitage by the name of Avon. Avon was located about one mile to the east of the Hermitage on the southwest corner of the Little River Turnpike and Walney Road.

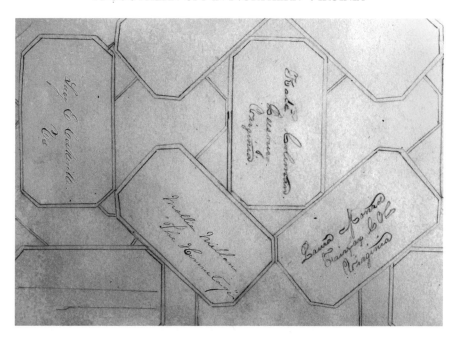

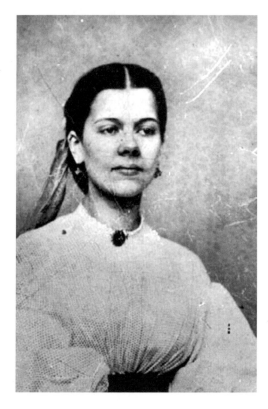

Above: Signatures of Mollie Millan, Lucy E. Cockerille, Laura Monroe and Kate Coleman.

Left: Mollie Millan.

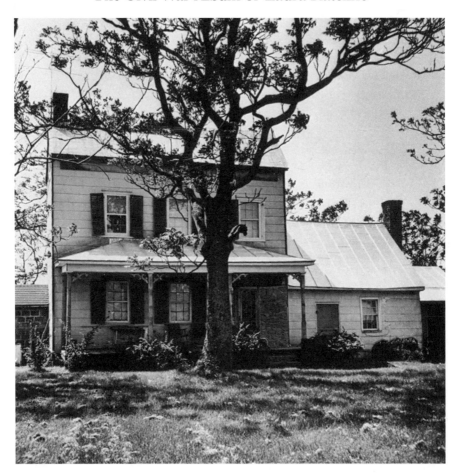

The Hermitage. *Courtesy of the Fairfax County Public Library, Photographic Archives.*

Walney Road is the southern extension of Centreville Road below the Little River Turnpike, about two miles from where Laura lived.

Mollie, born on March 19, 1844, was seventeen years old at the outbreak of the war. Her sister, Virginia, provided a firsthand glimpse of life during that first summer:

> *My sister and I had a great time all the summer of 1861. The crossroad, a few hundred yards from "Avon," the home of my aunt, Mrs. Richard Cockerille, was an important army post; the road leading from Centreville [north] by Fryingpan and on to Drainsville [sic]...crossed the Little River Turnpike...the turnpike leading [east] to Alexandria, twenty-four miles distant, via Chantilly, Ox Hill, Germantown, and Fairfax Courthouse.*

We were patriotic and the Confederates stationed at this strategic point had to be looked after. I suppose there were from fifteen to twenty-five cavalrymen from Captain Blackford's company sent out each day and relieved every other day from the company. The soldiers [taking] turns for guard duty, the others coming for breakfast. In that way, they had hot breakfast every morning for weeks, and it may have been months. And we did not forget them at dinner.

"The Hermitage, the home of my grandmother, Mrs. Thomas Lee, and "Avon" were adjoining plantations." [Both were located in Chantilly, Virginia.] *During those days everything was quiet and uneventful, and the friends we made on the [picket] post would get leave of absence to visit us between times. We learned to shoot pistols and had a fine time generally, as we were both young and knew little of the hardships of life.*

We were in the Confederate lines until the spring of 1862. We were four miles from Centreville. One night in the spring of 1862 we heard a tremendous explosion, which turned out to be the blowing up of the Stone Bridge near the old Henry House on the Manassas Battlefield. Our army was falling back and had blown up the bridge after crossing. Then we were left in the Yankee lines! O, the horrors we now looked forward to our houses searched and plundered and threatened of burning!

In the same article, one of Virginia's sons provided additional information about his mother that also gives us a picture of his Aunt Mollie during the war:

Virginia Lee Millan of the Hermitage, Chantilly, Fairfax County, Va., cared for Confederate soldiers, fed them, and looked after sick and wounded. She learned to spin, spun the yarn, and knitted a "whole lot of socks" for Confederate soldiers. After the battle of Ox Hill, in 1863, the Hermitage and the adjoining place, Avon, were turned into improvised hospitals, and at both places she helped nurse and care for the sick and wounded.

During the last two years of the war, Colonel Mosby came often to the Hermitage in the course of his famous "raids" to spend a social evening and to hear his favorite songs, especially Moore's melodies, from the lips of Miss Virginia and others; sometimes to get a cup of "good old government Java" coffee, if there was not time for an entire meal.

On one occasion he turned up at the Hermitage after an all-night raid with the Yankees so close behind that he did not have time to enter the house; accordingly the two sisters brought him a saucer of strawberries fresh from the garden, which he ate, reclining on his elbow in the back yard by the wood

pile, while they stood guard to warn him of the coming of the Yankees. Finishing his repast, he hastily mounted his horse at the rear of the house and galloped away over the fields to safety. At the close of the war, Colonel Mosby spent the night at the Hermitage on his way to surrender the next day to General Grant.

John S. Mosby himself validated Virginia's story in a letter to Professor A.W. McWhorter on September 5, 1914, printed in the same article: "I have a pleasing recollection of your mother, Virginia Millan, and of her sister Mary. A long time ago they used to sing and play on the piano for me."

How Mollie and Virginia married is an interesting story as well. The family tradition holds that two brothers, William David McWhorter and his younger brother, James Kyle McWhorter, were campaigning in Fairfax County when they spotted two pretty girls seated on a swing on the front porch of the Hermitage, "their pug noses showing coyly beneath their bonnets. The brothers vowed to return after the war to marry them." And they did! William David McWhorter received his medical degree from the Medical College of South Carolina in 1860. In 1861, he enlisted in the Confederate army and was a surgeon in Company A, First South Carolina Rifles. He married Mollie at the Hermitage on November 27, 1866. It took a little longer for his brother, James Kyle, to marry Mollie's sister, Virginia, on June 16, 1869, after receiving his medical degree from the University of Georgia.

Mollie continued to live in Fairfax County and eventually moved to Washington D.C., where her husband's practice was located. They had seven children. She died on March 5, 1895, less than two weeks after the death of her beloved husband on February 20, 1895. They are both buried at the Old Congressional Cemetery in Washington.[384]

Virginia Millan's son stated that it was after the Battle of Ox Hill on September 1, 1862, when the McWhorter brothers met the Millan sisters at Avon. All four were caring for the Confederate wounded—the brothers as surgeons and the sisters as nurses. The Millan girls were also nieces to one of Mosby's men from Chantilly, Philip DeCatesby Jones Lee.

Lucy E. Cockerille,
NC

Lucy Ellen Cockerille was born on September 15, 1834, in Fairfax County, Virginia.[385] She was a cousin of Mollie Millan. Mollie's sister, Virginia Lee,

Lucy Cockerille's grave at Union Cemetery, Leesburg, Virginia.

stated in her article in the *Confederate Veteran* that the adjoining plantation, Avon, was "the home of my Aunt, Mrs. Richard Cockerille." She also referred to her uncle as Judge Cockerille. Richard Henry Cockerille, Esquire, born July 10, 1817, in Fairfax County, married Martha Jane Lee at the Hermitage in April 1849. Judge Cockerille was the presiding judge in Fairfax County from 1870 to 1874.[386] He was the son of Richard Henry Cockerille, born in 1770 in Fairfax County, and his first wife, Nancy Ann Lee.

Lucy Ellen Cockerille was the daughter of Richard Henry Cockerille's second wife, Anne Coleman.[387] Nancy Ann Lee Cockerille, the first wife of Richard Henry Cockerille, had four children. Anne Coleman Cockerille, Richard's second wife, had six children. All were born in Fairfax County, although some lived in Leesburg.[388]

Prior to the war, Lucy was living in Leesburg, as noted in her letters of 1855 to Dranesville.[389] It is not known where Lucy lived during the war. If Lucy was living in Leesburg, her experiences might have been similar to those of Kate Carper. If Lucy was living at Avon during the war, her experiences would have been very similar to Mollie Millan's, as Mollie's sister, Virginia, wrote about the proximity of the Hermitage to Avon and their shared experiences during the war.

Lucy's brother Seth was born in 1842 in Fairfax County and was a private in Company I, Eleventh Virginia Cavalry. He initially enlisted in Leesburg in Company K, Sixth Virginia Cavalry.[390] Lucy lived until she was eighty-four years old and is buried at Union Cemetery in Leesburg, Virginia.

Laura Monroe
Fairfax C.H. Virginia

Laura (Stuart) Monroe was born in 1841 in Providence, later Fairfax Court House, to James Henry Monroe and Maria Elizabeth Berkley. Laura was the niece of William "Norris" Berkeley and therefore a cousin of William H.P. Berkeley. Her brother, J. Berkeley Monroe, enlisted in the Sixth Virginia Cavalry and was killed in the war.[391]

In 1880, Laura was listed as a milliner at what is now the corner of Sagar Avenue and University Drive. The *Fairfax Herald* of October 27, 1893, noted, "We are glad to hear that Miss Laura Monroe, who has been seriously ill, is improving." William Norris Berkeley sold his niece Laura a house and lot in Fairfax in 1896.[392] In 1900, she was named to the executive committee of the Confederate Reunion Committee in Fairfax.[393] Laura died in 1917

Laura Monroe's grave at Fairfax Cemetery.

and left $250 to the Zion Episcopal Church, now the Truro Church, for a monument in Fairfax Cemetery inscribed with the names of her mother, Maria Elizabeth Monroe, and her aunts, Julia A. Berkley and Fannie Berkley Taylor, along with her name.[394]

Her obituary stated:

> *Miss Laura Monroe, a well-known resident of this town, and one universally respected and beloved, died at her home. Her remains were laid to rest in the Fairfax Cemetery. Miss Monroe's life, it may with truth be said, was devoted to the service of others. One after another of her aged relatives, in their declining years, received her devoted attention, and finally, when her work in that respect seemed finished, her own health began to decline and she passed to her reward, having the record of a life filled with good works.*[395]

Kate Coleman
Leesburg, Virginia

Sarah Catherine "Kate" Coleman was the daughter of John and Elizabeth Carper Coleman, who lived at Hayfield, just west of the Fairfax County line in Loudoun County.[396] Elizabeth Carper Coleman was Philip Carper's daughter, and Philip was Kate Carper's grandfather. Kate Coleman was therefore a cousin of Kate Carper. Both Kates attended Coombe Cottage before the war.[397]

Philip Carper retired to Hayfield from his house, Bloomfield, in Fairfax County, and was listed in the 1850 Loudoun County census as living there. Kate was born in November 1845 and was eighteen years old in 1863, when her brother Philip Coleman was wounded in action at Brandy Station. He died on July 23.[398] Her other brother, Johnston Cleveland Coleman, a member of the Sixth Virginia Cavalry who grew up with Kate and Philip at Hayfield, also signed Laura's album.

Hayfield was located about three and a half miles west of the Herndon Train Station, about one and a half miles across the county line into Loudoun. Today, this is just south of the intersection of Old Ox and Lockridge Roads and north of Dulles International Airport.[399]

Kate was still listed with her brother Johnston Cleveland as living at Hayfield in the Loudoun County census in 1870. She married Oliver C. Beall in Loudoun County on April 24, 1877.[400] In 1880, the couple was

Kate Coleman/S. Catherine Beall's grave at Chestnut Grove Cemetery, Herndon, Virginia.

living in Front Royal Township, Warren County, where Oliver was a Methodist minister.[401] Kate died around the age of eighty-three in 1928 and is buried at the private Coleman Family Cemetery at the corner of Old Ox and Sterling Roads.[402] Her husband died in 1933, and his body was shipped to Cumberland, Maryland.[403] They had no children. In 1958, Kate and the rest of the Coleman family were reinterred at Chestnut Grove Cemetery due to the construction of Dulles International Airport.[404]

Kate had no blood relationship to Laura Ratcliffe. Kate was a second cousin to Richard Coleman, Laura's brother-in-law. Therefore, Laura and Kate were second cousins by marriage.[405]

I have unearthed no diaries, journals or letters belonging to the women on this page during the war, and no records were subsequently published on their covert activities. Due to their proximity to one another, one can assume that these women traveled to and from Laura's house many times during the war to secretly share information on Union activities from their locations and to sign the album.

Whether these four women came together or individually to Laura's house or other locations for their clandestine meetings is an alluring mystery—one that we can only use our imaginations to attempt to solve.

THE DRANESVILLE, VIRGINIA AND CAMBRIDGE, MARYLAND PAGE

Willie H. Berkeley
Alexandria, Virginia

Willie Berkeley signed this page as well as two others. It seems possible that this signifies a connection to the women of Cambridge and Kate Carper, who also signed this page. This connection is further discussed in the section on Cambridge, Maryland.

Kate L. Carper,
Bloomfield, Va.

Catherine Louise "Kate" Carper was born in March 1834. Her first ancestor came to this country through the Port of Philadelphia in 1732 from the Rhine Valley in Germany. In 1811, her grandfather, Philip Carper, purchased ninety acres on Difficult Run, including the Colvin Run Mill located along the Leesburg Road, a major thoroughfare connecting the Shenandoah Valley with Port Alexandria on the Potomac River.[406]

Philip rebuilt the original 1794 mill into a three-and-a-half-story modern brick merchant mill while working there before purchasing the property. It was completed in the same year that he purchased it. He prospered along the Leesburg Turnpike, the first major thoroughfare to be constructed in Virginia a decade later. He also purchased property that included what became known as the Dranesville Tavern. Carper sold the mill and property in 1842 and retired to the home of his daughter Elizabeth Carper Coleman, the mother of Kate Coleman, who lived at Hayfield in Loudoun County.[407]

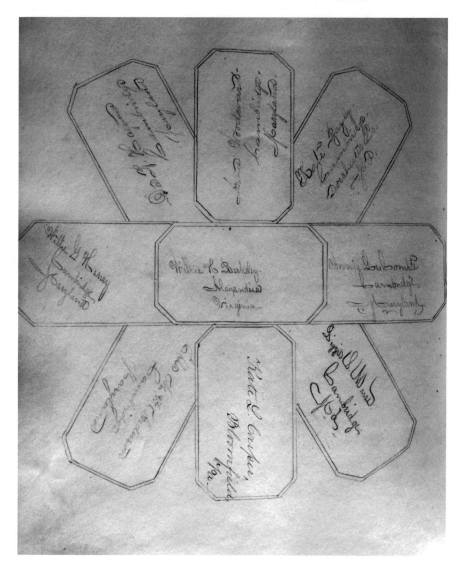

Signatures of Willie H. Berkeley, Kate L. Carper, Ella M. Anderson, Kate Bayly, Delia Hayward, Willie G. Henry, Annie LeCompte, Lizzie K. Muse and Annie Woodward.

In 1823, Philip's eldest son, Frederick, moved into a two-story log dwelling house with his wife, Catherine. He named the house Bloomfield, the first of two houses with that name. Catherine Louise, the second of their four children, was born in 1834. Their second daughter, Frances Ellen, was born in 1837, and their second son, Philip William Carper, was born in 1840.[408]

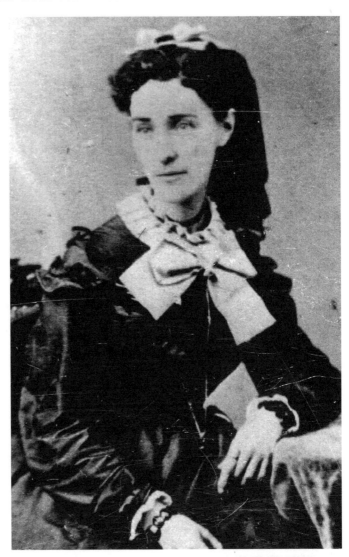

Kate Carper.

The middle-class Carper children were well educated, having first been tutored at home. Kate began her formal education at Mrs. Edward's School for Girls in Leesburg in 1847 but returned home homesick and resumed her schooling at a new school, Coombe Cottage, in Fairfax Court House. She graduated in 1851. Her sister, Frances, started her education at Coombe Cottage the same year that Kate graduated. Philip William attended Episcopal High School for two years starting in 1857. The isolation in the countryside and the confinement of many of Kate's friends in the winter months provided ample opportunity to write numerous letters as the

predominate method of personal communication. It was Kate, however, who kept the letters she received during her life, as well as a journal. These give us the opportunity today to gain an understanding of her life in Dranesville during the Civil War.[409]

While it is not likely that Laura Ratcliffe attended Coombe Cottage, Kate wrote a letter in 1853 complaining of not being able to visit Frying Pan, perhaps to visit Laura, due to rain.[410] Another of Kate's schoolmates from Coombe Cottage wrote to Kate in 1858. She mentioned Jenny Baker, the daughter of the Bakers (who ran Coombe Cottage), and Laura, saying:

> *I got a long letter from Jenny Baker a few days since. She was begging me to come up about the middle of February and I only wish I could see you while there—cannot you come? Laura Ratcliffe asked me to come and I will spend part of my time with her.*[411]

Antonia Ford wrote a letter to Kate's sister, Frances, in 1855, after having left Coombe Cottage and while attending Buckingham Institute.[412] She wrote another letter to Frances in 1855 after she graduated from Buckingham Institute, talking about returning home to Fairfax Court House and visiting Coombe Cottage. Antonia ended the letter with "Give my love to Kate,"[413] establishing her friendship with Kate Carper.

The only reference to the building of Bloomfield II, the brick home on Leesburg Turnpike facing the Dranesville Tavern where Kate lived during the Civil War, was a reference in the Carper family account book for $320 for making bricks in 1858.[414]

The war first intruded on life at Bloomfield when Kate's brother Philip William enlisted early in Leesburg on June 10, 1861. He joined the Seventh South Carolina Volunteers under Captain William D. Farley, then an aide to General Bonham and later a scout for J.E.B. Stuart. Philip probably first brought Farley to Bloomfield shortly thereafter while scouting the area between Leesburg and Washington.[415] Philip was captured and sent to the Old Capitol Prison in the city of Washington three times. The first time, he was with Farley and nine other soldiers, as Union troops had made a raid on Dranesville, where they arrested six secessionists on November 27, 1861. Carper, Farley and the others tried to recapture the Confederate sympathizers.[416]

Kate and her mother sent numerous letters and money to Phil. They also visited him and received his letters while he was in prison. Carper joined the Thirty-fifth Battalion, Virginia Cavalry, under E.V. White on December 17, 1862, and served for the duration of the war. He lived until 1918 and is buried at the Chestnut Grove Cemetery in Herndon, Virginia.[417]

Bloomfield II in Dranesville.

A brick marked with the date 1858 next to a downspout on the left front side of Bloomfield II.

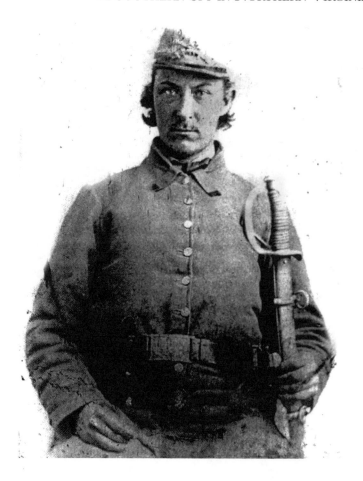

Philip William
Carper.

Philip spent time on duty in and around the Dranesville area, including Frying Pan. He also spent time at home at Bloomfield while on parole. The Carpers hid him from Yankee patrols in the attic of the house behind a small door to the eaves concealed by a piece of furniture.[418] Kate and her family cared for numerous Confederate soldiers at Bloomfield, including three soldiers who stayed at Bloomfield for four weeks after the Battle of Ox Hill on September 1, 1862, as the rest of the Confederate army moved west on the Leesburg Turnpike on its way through Dranesville into Maryland.[419] Bloomfield was also the host to many soldiers camping in Frying Pan in late 1861.[420]

Kate saw some of the action on Leesburg Turnpike. On April 1, 1863, she wrote, "We have the pleasure of seeing the Yankees flying down the road with Moseby's [sic] men at their heels. Capt. Moseby [sic] captured about 100 men & horses and put the others to flight."[421]

The attic where Philip Carper hid from Union soldiers in Bloomfield II while home on furlough.

She also learned news from the soldiers who stayed at Bloomfield II during the war. On June 27, 1863, J.E.B. Stuart's cavalry pickets stayed at Bloomfield on their way to Gettysburg. Kate learned of the death of William Farley and William G. Brawner. Brawner was Kate's favorite of her many suitors. Mourning his loss, Kate never married.[422]

On August 15, 1864, Kate lamented in her journal about the Yankees, who had been staying at Bloomfield for the past two days: "The Yankees leave early this morning having appropriated to their use everything they could get their hands on. What is to become of us, if this continues? Oh Lord deliver us!"[423]

When the war finally came to an end, Kate's brother Philip married in Leesburg and created a new life for himself, having spent most of the war in prison. Kate and her mother presided over Bloomfield II, finally at peace after four turbulent years. Kate lived to be ninety years old. She died in 1924 and is buried at Union Cemetery in Leesburg. Her sister, Frances, lived until 1888 and was the wife of Reverend W.G. Hammond. She is buried next to her sister.

Cambridge, Maryland

The Eastern Shore of Maryland had allegiances to both the North and South during the Civil War. It was an area that had a long history of slavery on its plantations. It also had a number of Quaker settlements that condemned the evils of slavery. There were no separate areas that could primarily be called pro-Union or pro-Confederate. The allegiances of the residents were split within counties, within the towns and within families. Volunteers signed up and fought for both sides during the war.[424]

The allegiances of the seven women from Cambridge who signed Laura's album were most definitely for the cause of the South. Perhaps these allegiances are best expressed in one married woman's feelings about her husband, as printed in an Eastern Shore newspaper: "I pray that Philip may die in the front, and that they may burn me on the plantation before the Confederacy makes peace on any terms but their own."[425]

Located along the Chesapeake Bay, the Eastern Shore was inhabited by fishing tribes of the Algonquin Indians for fifteen hundred years before it was first visited by the Europeans in 1524. The area received the name "Eastern Shore, Md." from Captain John Smith in 1608 as he traveled north from Jamestown in search of fresh water.[426] Dorchester County, the largest county on the shore, dates back to 1668. Cambridge, the county seat, located on the Choptank River, was founded in 1684.

President Abraham Lincoln placed the state of Maryland under military control to prevent the legislature from passing an ordinance of secession in September 1861. About 4,500 Federal troops were also stationed in Salisbury in November of that year and swept south, capturing 175 militia and curtailing the efforts of smugglers to provide food, clothing, liquor, coffee, salt, boots, shoes, lead pencils, pipes, soap, carpenter tools and phosphorous to the South. Smuggling continued throughout the war, however, as the hundreds of waterways in the area provided perfect hiding places for those who had lived there for generations.[427] Locals easily eluded foreigners who had just arrived by land.

The cities of Cambridge and Salisbury, farther to the south, were occupied by Union troops throughout the war.

Seven women signed Laura's album. Like Laura, they were all Episcopalian and all associated with Christ Episcopal Church of the Great Choptank Parish in Dorchester County, Cambridge. Some of the seven women were descendants of the earliest and most prominent families in Dorchester County.

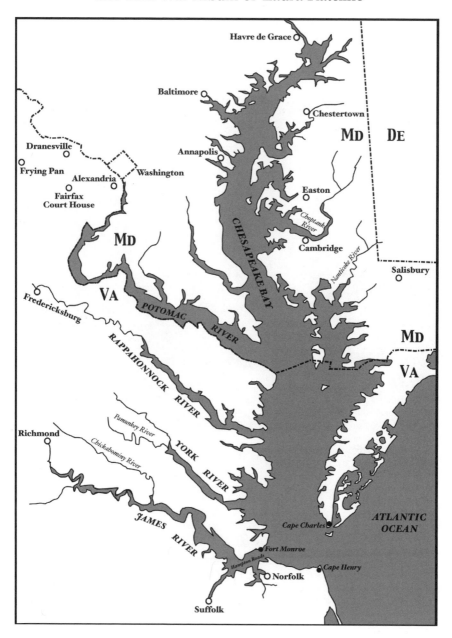

The Chesapeake Bay was the pathway from Cambridge, Maryland, on the Eastern Shore to Baltimore, Washington and Richmond. *Based on a map by Eric Mills in* Chesapeake Bay in the Civil War.

A boat hidden today along the Northeast Branch of Fishing Creek in Cambridge, Maryland.

Ella M. Anderson
Cambridge
Maryland

Ella M. (Mclean) Anderson was born in May 1846 and was fifteen years old in 1861. Her father, Thomas W. Anderson, was a merchant, the owner of a dry goods and grocery store in Cambridge. Her mother was Elizabeth K. Eccleston. At the age of twenty-five, Ella was married in Cambridge to Charles V. Bingley, a minister from Portsmouth, Virginia. She is listed in the 1900 census of Baltimore City. In 1920, she was listed as a widow in Baltimore.

The current Christ Episcopal Church in Cambridge, Maryland. Construction began in 1883, and the church was consecrated in 1892.

Kate Bayly
Cambridge,
Dorchester Co.
MD.

Kathleen "Kate" Ambrosia Bayly was born in 1845 and was sixteen years old in 1861. Her father, Alexander Hamilton Bayly, was a physician, surgeon and town commissioner in Cambridge. Her mother was Delia Byus Eccleston.

Kate was the granddaughter of Josiah Bayly, a lawyer in Dorchester County and attorney general of Maryland. Her brother, Alexander Hamilton Bayly Jr., was a Confederate soldier. Kate married a former Union soldier, Dr. John Oscar Skinner, at age twenty-eight in 1875 in Cambridge.[428] In 1901, she was listed in her brother's obituary as living in Chambersburg, Pennsylvania.

Delia Hayward
Cambridge
Maryland

Delia Bayly Hayward was born on August 14, 1845, and was sixteen years old in 1861. Her father was William Richard Hayward, a physician in Cambridge. Her mother was Eliza E. Eccleston. The Hayward family had lived in Cambridge since the late seventeenth century.[429]

Delia's brother, Charles Eccleston Hayward, served in the Confederate army. In 1868, Delia married CSA lieutenant colonel Clement Sulivane, then a lawyer, at Christ Church in Cambridge. She died on August 18, 1920, at the age of seventy-five. Both Delia and Clement are buried at Christ Church Cemetery.

It would be interesting to determine whether Clement Sulivane was stationed in Northern Virginia during the war. This would provide a possible reason for Delia to have traveled either to Laura's or Kate Carper's houses. Sulivane was born in Mississippi in 1838 but moved to Cambridge as a child.

The Sulivane house, 205 High Street, Cambridge, circa 1763.

In April 1861, Sulivane enlisted in the Tenth Mississippi Infantry, and upon learning of the organization of a Maryland regiment, he received a discharge and went to Richmond. By the time he arrived, the First Maryland Infantry had already been formed. On July 13, 1861, he enlisted in the Twenty-first Virginia Infantry in Richmond, and in October he was appointed as first lieutenant and an aide to the staff of his uncle, General Earl Van Dorn. After Van Dorn was shot and killed in May 1863 by the jealous husband of a woman who claimed that Van Dorn had conducted an affair with his wife, Sulivane became a lieutenant and member of the staff of Custis Lee, son of Robert E. Lee. He was later promoted to captain and assistant adjutant general in July 1864. He was captured at Saylor's Creek in April 1865 and was released in June at the end of the war. Throughout his service, there is no record of him having been located in Fairfax County.

The grave of Delia Bayly Sulivane and Clement Sulivane at Christ Church Cemetery, Cambridge, Maryland.

Willie G. Henry
Cambridge
Maryland

Williamina "Willie" Goldsborough Henry was born in 1846 and was fifteen years old in 1861. She was the daughter of Colonel Francis Jenkins Henry, CSA, and Williamina Goldsborough. She is a descendant of Reverend John Henry, born in Ireland in 1674, who immigrated to America in 1709 and eventually became the Presbyterian minister at Rehoboth Church in Somerset County on the Eastern Shore.[430]

Willie is also the great-granddaughter of Governor John Henry, who was a member of the Continental Congress from 1777 to 1778, a member of the United States Senate from 1789 to 1797 and the governor of Maryland from 1797 to 1798.[431] She is the great-granddaughter of Charles Goldsborough, governor of Maryland from 1818 to 1819.

Willie married Daniel Sulivane Muse, the older brother of Lizzie Muse. She died at the age of seventy-seven on September 21, 1923, and is buried at Christ Church Cemetery in the Henry plot.

Annie LeCompte
Cambridge
Maryland

Annie LeCompte was born in 1840 and was twenty-one years old in 1861. She was the daughter of Edward P. LeCompte and Emily White. She was a descendant of Antoine/Anthony LeCompte, who left his native France and was one of the first whites to settle along the Choptank River in 1659, ten years before Dorchester County was established.[432] LeCompte's Creek, a tributary of the Choptank River, was named for him.[433]

Annie never married and was listed in a census as a milliner living with her widowed mother and siblings. She died in 1894 at the age of fifty-four and is buried in an unmarked location at Christ Church Cemetery.

The grave of Williamina Henry at Christ Church Cemetery, Cambridge, Maryland.

Lizzie K. Muse
Cambridge
Md

Eliza "Lizzie" Kerr Muse was the daughter of William H. Muse, a physician, and Elizabeth A. Sulivane. She was born in 1849 and was twelve years old in 1861. Lizzie's younger sister married Willie G. Henry's younger brother. Lizzie was never married and lived until she was eighty-one years old. She died in 1930 and is buried at Christ Church Cemetery.

Annie Woodward
Cambridge,
Maryland

Annie Woodward was born about 1843 and was eighteen years old in 1861. She was the daughter of Benjamin Woodward and Emily L. Keene.

The Woodward family settled in Dorchester County in 1683, when John Woodward emigrated from England. John acquired a tract of land called Pawpaw Thicket on the Little Choptank River. This land was occupied by Woodwards for 170 years.[434]

In her book *An Introduction to Civil War Civilians*, author Juanita Leisch wrote, "The ties of blood were long."[435] It follows that the first place to look for a direct connection between Laura and the women of Cambridge is a family tie. There is one relationship that ties Laura directly to Cambridge.

Anna Maria Goldsborough was born in Dorchester County on November 15, 1796. It was there that she married William Henry Fitzhugh on January 11, 1814.[436] William lived on the Ravensworth Estate in Fairfax County. Ravensworth was "one of the largest and most historical land grant[s] in Fairfax County." Nearly twenty-two thousand acres were granted to William Fitzhugh in the late 1600s, and the mansion was built in the late 1700s in Annandale. William Henry Fitzhugh became the owner in 1809. A member of the Virginia Constitutional Convention, Fitzhugh was considered a possibility for Virginia's governorship before he met an early death in 1830.[437] His estate passed on to Anna Maria.

Anna Maria's parents were Governor Charles Goldsborough and Anna Maria Tilghman. After Anna Maria Tilghman Goldsborough's death, Charles married Sarah Yerbury. Williamina Goldsborough Henry of Cambridge, who signed the

The grave of Lizzie Kerr Muse at Christ Church Cemetery, Cambridge, Maryland.

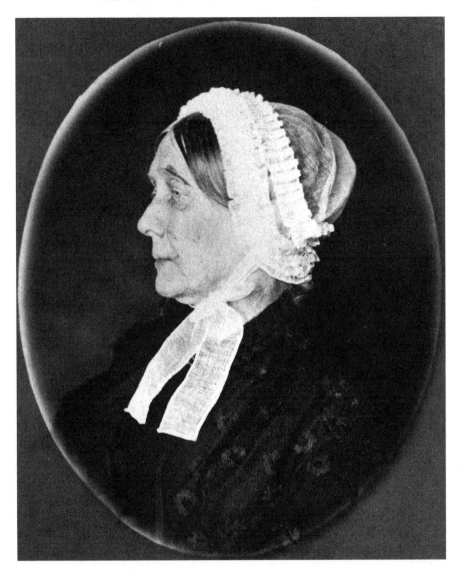

Mrs. William Henry Fitzhugh (Anna Maria Goldsborough). *Courtesy of the Virginia Historical Society.*

album, was a great-granddaughter of Sarah and Charles Goldsborough and a first cousin, once removed, of Anna Maria Goldsborough Fitzhugh.

Laura was a third cousin, twice removed,[438] of Anna Maria Goldsborough Fitzhugh's husband, William Henry Fitzhugh, through Laura's father's line, thus providing a family link between Cambridge and Fairfax County.

Anna Maria was quite wealthy and influential throughout the Civil War. She was the aunt of General Robert E. Lee, as her husband's niece, Mary

Anna Randolph Custis, was married to the South's most famous general. Brigadier General Fitzhugh Lee, who signed the album, was the godson of Anna Maria, providing another possible connection to Laura. Although the nature of the relationship between Laura and Anna Maria during the war remains undocumented, there is certainly a link between them that would have been very strong during the war.

Anna Maria was very much aware of her relations in Maryland during the war. In her deposition claim to the Southern Claims Commission in 1873 for damages due to losses to Union soldiers during the war, she tried to distance herself as much as she could from her Confederate relations in front of the Federal commissioners. She stated that she had stayed at Ravensworth throughout the entire war in order to protect the house, except for a few trips to her house in Alexandria. As for her Confederate relations, she recalled:

> *Some of the Fitzhughs were in the Confederate service and some were not. Some from Maryland were, but I had nothing to do with them for I would not have had one of them here if I could have prevented it. I had two nephews of the half blood, the ones of my sisters in the Confederate service who lost their lives in that service and a grievous thing it was to me, for they were fine, noble young men. Their names were Goldsborough.* [439]

Not only did the girls in Cambridge live near one another and attend church together, but there were also numerous family relationships in Cambridge, in addition to the Fairfax-Cambridge link between cousins Anna Maria Goldsborough Fitzhugh and Williamina Goldsborough Henry.

In the 1850 Dorchester County census, Ella M. Anderson is listed as living with her grandfather, Curtis Anderson, and his wife, Margaret. The Andersons are listed in the 1860 census right after the Woodwards, so they probably lived next door to each other.

Ella is also the great-granddaughter of Dr. Edward White. Annie LeCompte is a granddaughter of White, making them first cousins, once removed. Sarah Y. Goldsborough, the second wife of Governor Charles Goldsborough and at the time a sixty-two-year-old widow, was listed as living with Annie and her mother in the 1850 Dorchester County census, thus providing a connection to Williamina Goldsborough Henry.

Delia Bayly Hayward and Kate Bayly were the grandchildren of William W. Eccleston, Kate's mother's father, [440] and Sophia Richardson Eccleston, so they were first cousins.

Another possible link between Laura Ratcliffe, Kate Carper, William H.P. Berkeley and the seven women from Cambridge was a religious one.

The women of Cambridge and Laura Ratcliffe were Episcopalian. Kate Carper's father was Methodist.[441] Her brother Philip, however, attended Episcopal High School in Alexandria.[442] Her sister, Frances, made numerous entries in her journal on the subject of attending Zion Episcopal Church while at Coombe Cottage.[443] Although not stated, Kate most likely attended this church as well while attending Coombe Cottage. She was also likely an Episcopalian.

It was noted in the obituary of William Norris Berkeley, William H.P.'s father, that William Norris had been a lifelong member of the Trinity Methodist Episcopal Church.[444] Those who were "Southern in position, feelings, institutions, and interests" broke off from the Trinity M.E. Church in 1849 and formed the Washington Street Methodist Episcopal Church.[445] Therefore, the Episcopal church may have provided the connection between the signers on this page.

Anna Maria Goldsborough Fitzhugh was Episcopalian as well. It is highly possible that she attended Zion Episcopal Church in Fairfax Court House before the war, most likely the church that Laura attended prior to the war.

While the people who lived near Burke's Station and Annandale were physically closer to the county seat and routinely became communicants at Zion, circumstances brought the rectors of both Pohick and Zion to minister at Burke in the last quarter of the 19th century.[446]

It is likely that "the rectors of Zion in Fairfax Court House tended the scattered lambs of Burke before as well as after the Civil War."[447] Zion Church was constructed in 1842, but as it burned down in 1864, there are no records to indicate whether Laura and Anna Maria were members.[448]

As for why the seven women traveled from Cambridge to either Frying Pan and/or Dranesville at some point during the war, there are several premises. Perhaps they went as refugees to escape the Union occupation as troops moved into Cambridge in late 1861, or perhaps they brought supplies to the Northern Virginia area. They could have traveled there to visit their brothers or fathers in Confederate service or perhaps to attend school.

Their situations could have been similar to many other women during the war. Mrs. Cassius F. Lee of Alexandria fled the Union occupation there and moved to Canada with her family as a refugee. In a letter from August 1863, Mrs. Lee wrote something that may relate to the women of Cambridge, who were between twelve and twenty-one years old at the beginning of the war:

We consider it a great mercy that we were able to get our children in so pure
an atmosphere, for ours was perfectly poisonous. Our town being no longer
a safe home for any young girl.[449]

As for relatives of the Cambridge women in Confederate service,
Williamina Goldsborough Henry's father, Colonel Francis Jenkins Henry,
was listed as a Confederate soldier on his graveyard record, but his service
record is uncertain.[450]

As Maryland was not a part of the Confederate government, many men
traveled together in groups to other states and enrolled there.[451] There are
numerous possibilities listed for Francis Jenkins Henry in the *Compiled Service
Records of Confederate Soldiers* at the National Archives.

One F. Henry, age forty-six, enlisted in Company F, later Company H,
Thirty-sixth (Villepigue's) Georgia Infantry, on April 20, 1861, in Jackson,
Mississippi, for twelve months.[452] At the end of this term of service, the
designation of his company was changed to Company H, First Confederate
Infantry, Georgia Volunteers, where F. Henry was listed in the column of
names present. It was noted here that no later records were found.[453]

Francis J. Henry was listed as being forty-four years old in the 1860 census
in the town of Cambridge.[454] All of the records list Henry as a private, but
the records do not span the entire war, nor do they list a soldier's hometown,
making it difficult to pinpoint Henry's service and whether he was ever
stationed in Northern Virginia.

Kate Bayly's brother, Alexander Hamilton Bayly, was a Confederate
soldier, but his service records are conflicting. Different sources have him
enlisting very early in the war on April 26, 1861,[455] and later on January 23,
1862.[456] All records list him as a member of Peyton's Battery of Artillery,
which was formed at Orange Court House on March 20, 1862.[457]

Peyton's Battery was disbanded in October 1862 and reorganized
as Captain Fry's Company, Virginia Light Artillery (Orange Artillery).
Bayly was transferred to Peyton's Battery as a private, but he served as a
sergeant until October 9 and was then detailed to Danville, Virginia, as
a hospital steward by the secretary of war on October 20 for the balance
of the war.[458]

The reference to Bayly's enlistment on January 23, 1862, was in the
First Maryland Regiment.[459] Although he was not listed as a member, the
First Maryland Regiment was stationed in camps in Fairfax County in the
fall of 1861 through March 1862, including picket duty in Centreville,
Fairfax Court House, Fairfax Station, Chantilly, Burke Station, Munson's
Hill in Falls Church and Mason's Hill, two miles from Annandale,[460] under

Colonel J.E.B. Stuart.[461] If indeed he was a member, this tour of duty would have provided Butler with an opportunity to meet Laura and a connection to Cambridge.

While the troops were camped at Fairfax Station during the summer, it was not uncommon for female relatives to visit. Two sisters and their cousin from Baltimore were noted by one captain as visiting the regiment. "It was full of their brothers, their cousins and their beaux, and these beautiful young women in camp produced an effect on the mercurial Marylanders that can only be imagined." The young ladies were quartered in the field officer's tents, where they held court for several days.[462]

It is, therefore, possible that the women from Cambridge visited their relatives in Fairfax County at some point during the war. And if it was the First Maryland Regiment, they would have been in Fairfax County very early in the war, located very close to Laura at the time she received the album and at the time the Confederate army was in control of the area.

In any case, the women would have most likely traveled from Cambridge on the Chesapeake Bay to the Potomac River and disembarked near or at

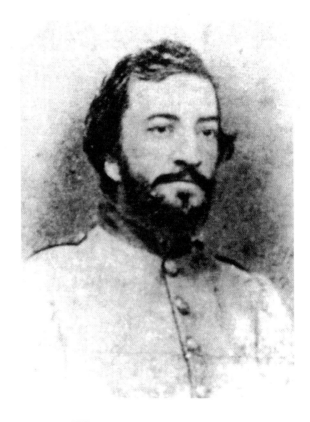

Alexander Hamilton Bayly.

Alexandria, where William Berkeley would have brought them to either Laura's or Kate's house. Whether Berkeley or some other male provided an escort on the trip from Cambridge is unknown.

Given the small size of the Ratcliffe residence in Frying Pan and the much larger size of Kate Carper's residence, Bloomfield II, in Dranesville, it seems more likely that the women from Cambridge stayed with Kate. Of course, they could have stayed with others in the area, perhaps the other local women who signed the album. The details, however, remain an unsolved mystery associated with the life of Laura Ratcliffe.

AFTER THE WAR

The following is a description of Laura in the postwar years:

At the end of the war, Laura was destitute, with a dilapidated house surrounded by weeds, her fences down, and the farm grown up in tall grass and briars. Her once productive farm lands had been trodden down by the enemy's cavalry and were growing up in brambles. Her mother had died. Her sister had married and gone away, leaving Laura and an invalid sister alone in the house.[463]

Laura's brother John enlisted in the Seventeenth Virginia Infantry on August 10, 1861, in Centreville.[464] Not surprisingly, he enlisted as a private in Company D under Captain William H. Dulany, who, according to the census of 1860, had lived in the Ratcliffe house. The Fairfax Rifles were organized as the Fairfax Rifle Rangers, volunteer militia, under Dulany at Fairfax Court House in December 1859[465] and were mustered into Confederate service on May 21, 1861.[466]

On the same day that Ratcliffe enlisted in Centreville, the Seventeenth marched to Fairfax Court House under General Longstreet.[467] Just over a month later, on September 24, it moved on to Falls Church. The Seventeenth moved back to Centreville in the fall of 1861 and spent an unpleasant winter there, until March 8, 1862, when it evacuated Fairfax County and marched ninety-five miles to near Orange Court House, arriving on the twenty-second.[468]

The Seventeenth only returned to Fairfax County one more time during the rest of the war. Fighting at Second Bull Run, it marched to Chantilly on September 1 but had no part in the battle. It seems likely that Laura had a chance to see her brother before the Seventeenth marched through Dranesville and halted at White's Ford on the third, before advancing north into Maryland, above Leesburg, on the sixth.[469]

Throughout the war, the Seventeenth Virginia saw action in twenty-two skirmishes and battles. On June 17, 1864, it moved into the trenches along the Howlett Line, between Petersburg and Richmond, in defense of Petersburg.[470] On August 13, a full one-third of the 226 men of the Seventeenth were listed as sick.[471]

By this time, the sick may have included John Ratcliffe, as he died on October 29, 1864, of chronic diarrhea at Chimborazo Hospital No. 1 in Richmond.[472] Of the seventy-six members of Company D present for duty on June 30, 1861, only four were present at the surrender at Appomattox on April 9, 1865.[473] Laura's brother did not return to help rebuild the Ratcliffe family after the war.

Immediately after the war, Laura's condition was no better than the rest of her neighbors in Fairfax County. "Probably no other county suffered to an equal extent."[474] Four years of occupation, first by the Confederate army and then by the Union army, had virtually stripped all the resources from the land, as well as the resident's possessions. Only those who stayed throughout the ordeal to protect their homes had their houses to start anew. And even then, not all of those who had stayed were able to keep their houses from being taken for use by the Union army.

The only solution was for farmers to work hard to attempt to cultivate whatever crops they could for the upcoming winter. Women used all of their talents to refurbish what was left to restore their homes. "Ladies once accustomed to leisurely living prepared meals over open fires and scrubbed family laundry."[475]

It wasn't until August 1865 that court was held at Fairfax Court House for the first time in three years. A local newspaper reporter noted that the area around the courthouse was beginning to be rebuilt: "Stores are being reopened, houses repaired, and fencing replaced. The day may come when Fairfax will rise from the ruins and call upon her friends to settle within her borders."[476]

In 1869, Laura's mother sold the 133 acres she owned near Burke Lake. On July 2 of that same year, her mother purchased the house Merrybrook and eighteen acres from Laura's sister Ann Marie Ratcliffe Coleman and Ann Marie's husband, Richard Coleman. Presumably, the Ratcliffe family moved there from the Smithson house.

The origins of the house date back to 1793, when it was a one-room cottage at the north end of the current structure that is no longer present. The earliest part of the current house dates back to 1820; it is the northernmost one-and-a-half-story wing of the house, including the dining room. A log-framed, two-story addition was built adjacent to this structure between 1867

John R. Ratcliffe's grave marker, Division G, Row J, Marker 112, at Oakwood
Cemetery, Richmond.

and 1873, most likely after Laura moved in with her mother and sister Cora.
In 1890, another two-story extension was added to the house. The final
addition to the house, the three southernmost bays, was built in 1948.

Laura's mother left all of her property to Laura and her sister Cora in her
will of October 31, 1873, stating:

Merrybrook.

I give and bequeath unto my two daughters, Cora L. Ratcliffe & Laura F. Ratcliffe, all my Real Estate of every description, real and personal, including my interest in the estate of my brother, the late Richard K. Lee of this County.

Cora passed away on September 22, 1880, leaving ownership of the house to Laura.

No doubt struggling to make ends meet, Laura married Milton Hanna on December 4, 1890, at the St. James Hotel in Washington, D.C., when she was fifty-four years old.[477] Milton Hanna was a wealthy neighbor, originally from New York, who was involved in raising cattle. In 1894, he "sold to Mr. M.G. Jerman eight head of cattle, of his own raising, that averaged 1,200 lbs. per head."[478] It was probably Milton who built the addition in 1890 for Laura and himself when he moved in after their marriage.

Maybe not so surprisingly considering her plight, Laura accepted this support from a Northerner. Mr. Hanna, "enriched by politics and mellowed by age," built Laura a two-story frame house that overlooked a small, wandering brook just west of Centreville Road and just south of Herndon. Laura and her sister lived there until her sister died. Following her sister's death, Laura accepted Milton's proposal of marriage. They named their

house Brookside.[479] Perhaps a marriage of convenience, there was indeed love involved, at least on Milton's part, as Laura was quite attractive. Laura, for her part, was very loyal.[480]

Although this marriage took Laura from destitution to wealth, the marriage lasted only seven years, as Milton was killed in an accident in May 1897. He left his two-hundred-acre property next to Merrybrook to Laura.

Laura was grief-stricken. She decided that no animal alive at the time that Milton died would be killed. There are stories of old horses wandering up to the front of the house and leaning up against the side of the veranda. She cared for her farm horses long after they outlived their service. No chickens were killed, and she took care of them herself.[481]

At Brookside, [Laura] looked after her large estate, supervising her renters, the crops and livestock, and spending much of her time on horseback as she rode from farm to farm. She dearly loved her horses and diligently cared for them, even after they were too old to ride or draw a plough. She loved the trees, and especially the dogwoods. She allow[ed the] dead to be cut down for firewood.

With her abundant resources, she devoted much of her interest to the needs of the poor and unfortunate. Though an Episcopalian in faith, she gave land near Frying Pan for the establishment of a Presbyterian church and also gave liberally to the Methodist church.[482]

Laura donated an acre of land from her property in 1906 for the establishment of a Presbyterian church, Beacon Hill, currently standing on the corner of Coppermine and Centreville Roads.

As the years passed by, Laura seldom mentioned her role as a spy and shunned publicity about her role as a provider for the Confederacy during the war. On September 10, 1910, ninety-six of Mosby's men held their sixteenth reunion at the Darlington Estate in Herndon. In an address by Representative C.C. Carlin, Laura's contributions were mentioned. Mr. Carlin "referred especially to the service rendered to Mosby by Miss Laura Ratcliffe, a venerable woman, who gave the guerilla leader valuable information as to the movements of Federal troops." The men's leader, John S. Mosby, did not attend.[483]

It is entirely possible that Laura did not leave her association with the Civil War totally behind her. Her 1855 Bible is signed "Laura Ratcliffe, Chantilly, VA." It is very likely that the she attended Christ Episcopal Church, located at the corner of today's Lee-Jackson Highway, Route 50, and Sullyfield Circle, the site of the current Oakton Baptist Church in Chantilly, about two miles south of Merrybrook.

Beacon Hill Church, Floris, Virginia.

Christ Episcopal Church was built in 1875. Philip DeCatesby Jones Lee, of Company B, Mosby's Rangers, donated the lumber for the construction of the church.[484] In addition to Lee,[485] there are two other members of Mosby's Rangers buried in the small graveyard next to the church—Albert Wrenn of Company A,[486] who died in 1910, and Ben Utterback of Company H,[487] who died in 1899. Laura's attendance at church would have no doubt prompted discussions between her and these veterans or at least remembrances of the war.

In 1914, when Laura was seventy-eight years old, she slipped on the flagstones outside her house as she went out to feed her chickens and apparently broke her hip. As the town doctor was male, modesty forbade Laura from allowing him to examine her. She lived the final nine years of her life in bed and died at her home on August 3, 1923. The exact nature of her injury was never known. There are many stories of people who came to visit her. She was still beautiful and was considered a local legend. She kept lots of cats that were free to run in and out of the house through a cat door.[488]

Laura still had servants on her dairy farm who took care of her. Local visitors remarked that she was always very gracious and wore little earrings.[489] She remained cheerful, keeping a lively interest in her community by reading local newspapers. She never sought publicity and spoke very little of her

A page from Laura Ratcliffe's 1855 Holy Bible. The text on the top and bottom pages is a funeral prayer. The text on the top page reads, "Out of the world of the weary, Out of a land very dreary, And into the rapture of rest, Father Ryan." Laura signed this page on the side "Laura Ratcliffe, Chantilly, VA." The text on the bottom page is similar: "Out of a world very dreary, Out of the land of the weary, And into the rapture of rest." Sanborn, Carter & Bazin published the Bible in Boston. *Courtesy of the City of Fairfax Historic Collections.*

activities for the cause of the Confederacy.[490] She is buried on a small hill on her property in a small family plot with her mother and husband.[491]

Her obituary in the *Fairfax Herald* read:

> *Mrs. Laura Hanna, widow of the late Milton Hanna, and one of the oldest and best known residents of the Herndon neighborhood, died Friday last after a long illness. Mrs. Hanna was 87 years of age and was a native of this county. Before her marriage, about a half century ago, she was Miss Laura Ratcliffe, and was related to many residents of the Fairfax neighborhood and elsewhere in the county. Her funeral took place Sunday afternoon and was attended by a number of her Fairfax relatives. Her body was laid at rest in the family burial ground near Herndon.*

Laura's will reads as follows:

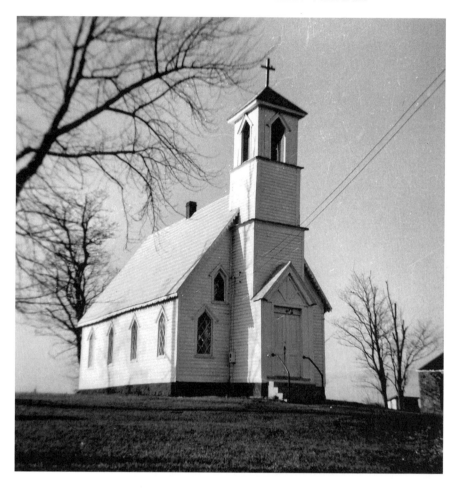

Chantilly Episcopal Church. The church was torn down in 1967. *Courtesy of the Fairfax County Public Library, Photographic Archives.*

I, Laura Ratcliffe Hanna of the County of Fairfax, State of Virginia, being of sound mind and memory, but knowing the uncertainty of life, do make publish and declare this to be my last will and testament, revoking all others made by me.

That is to say, I give to my cousin Nellie L. Nevitt the house and farm given me by my late husband, Milton Hanna. I wish her to live on the farm, and always keep it in the family if possible. I give the home I now occupy, given me by my Mother to my cousin Mamie C. Wiley hoping that she will make it her home and I especially wish that there be no public sale of my household effects. I give to my two cousins Mary Lee Bennett and Nellie Bennett my farm known as the Coleman farm containing 188 acres,

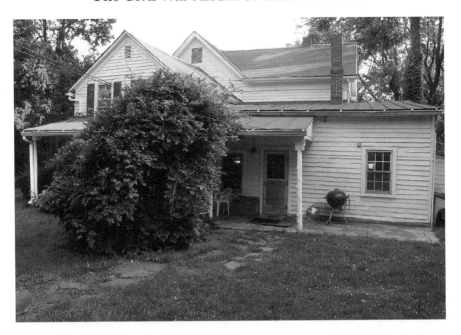

The steps at Merrybrook where Laura fell.

with the wish that they keep it within the family, never sell it to a stranger & I wish to have put up in my own graveyard a neat gray granite stone with the Names of Ratcliffe, Coleman and Hanna cut on it. After my funeral expenses are paid I wish what money I have in Mr. Keith's hands to be divided between the four cousins mentioned above, except what I may mention hereafter in this paper.

I hereby appoint my cousin Doddridge Nevitt Executor and request the court to permit him to qualify without giving security. I want it expressly understood that I do not owe any body, anything for services of any kind. I do not owe anything and shall not at my death for I always pay every thing that is done for me at the time it is done.

Witness my hand and Seal this 18th day of Sept 1920.
Laura Ratcliffe Hanna

Doddridge Nevitt was Laura's second cousin, age forty-eight, and lived at 1310 Vinton Avenue in Memphis, Tennessee, prior to his becoming her executer on August 15, 1923. He was a district sales manager of the National Biscuit Company at the time. Laura had asked Doddridge to be her executor while he was at her house in the spring of 1920, the last time Doddridge had seen Laura. At that time, she told Doddridge that she intended to leave her

Laura Ratcliffe's grave, Herndon, Virginia.

"home place" to her cousin Mamie and said that "it would make her a nice home...it was not large but it runs down the road." Mary Lee and Nellie Bennett are listed in Fairfax County in the 1920 Virginia census.

The three tracts of land that Laura owned, as mentioned in the will, were about 200 acres that her husband Milton owned; 188 acres known as the Coleman farm, where she was buried; and the 13.75 acres that she inherited from her mother, where she lived in the house named Brookside.

The money Laura mentioned in her will that "I have in Mr. Keith's hands" totaled $3,800 and was divided among her four cousins as requested.

Laura's property was appraised and sold at a public sale for $666.60 on September 20, except her household furniture, certain silverware and jewelry at her request. Doddridge put an ad in the *Fairfax Herald* on August 24 announcing the sale of "3 Horses, Harness, 9 Cows...and other articles of personal property." The sale was held on "Thursday, September 20, 1923 at Ten o'Clock, A.M., on the farm whereon the late Laura R. Hanna resided."[492] This amount and these personal items were turned over to Mamie C. Wiley, a second cousin of Laura. It is clear that there was not going to be any further attempt at farming or raising cattle, as the sale included all of her farming equipment, six cows and two horses.

Laura also had a total $2,951.20 in her checking and savings accounts in the National Bank of Herndon. Of this amount, $252.25 was paid to T.E. Reed and Sons in Herndon for her funeral expenses; $81.50 was paid to two workers for work performed on her farm; and $8.00 was paid to Robert Bush for digging her grave. The balance of $2,609.45 was paid to Doddridge Nevitt for his services as executor of Laura's will.

The rest of Laura's personal estate, $4,024.73 not mentioned in her will, was distributed to thirty-nine of her heirs or next of kin. This caused Doddridge a great deal of effort "by correspondence and took a great deal of time," as they "were pretty well scattered over the country." The "neat gray granite stone" was cut by T.A. Sullivan of Washington, D.C., at a cost of $275.00.

Miss Nellie Lee Nevitt held onto her property, previously belonging to Milton Hanna and given to her by Laura, until 1938, when she sold her 236 acres.[493]

Gladys Utterback, ninety-one years old in 1997, who took Tom Evans to Laura's Civil War house in 1991, remembered Laura Ratcliffe from when she was a young girl. She said that her father had managed a dairy farm and she lived on the farm as a child. She remembered taking water to Laura from the well and said that it was the coldest water she ever tasted. She also remembered Laura raising chickens and that Laura was a wealthy woman who managed a number of farms in the area.[494]

The cemetery where Laura is buried is located on property just south of Herndon on the ninety-four-acre office park known as Worldgate. Gladys said that she and her mother had been present when Laura was buried. She said that her mother took care of Laura in her later years, and her father oversaw Laura's business estate. "My mother used to go down and read the Bible to her. Ratcliffe was an invalid during her last years, the victim of a fall on an icy back porch." She said that Laura's husband (Hanna), mother (Ratcliffe) and sister (Coleman) are also buried at the cemetery site. There are no doubt other members of the Ratcliffe and Coleman families buried there as well.

In 1925, Mr. Utterback was noted as renting the home of Laura Ratcliffe to a Mr. John Lewis Carr[495] after purchasing the property on January 2 of the same year. The property passed on to Euan and Harriet Davis in 1948, and they renamed the property Merrybrook. In 1971, the Davises sold the house and four remaining acres of property to David and Winifred Meiselman.

Miss Mamie Wiley was elected a delegate to the United Daughters of the Confederacy Convention to be held in Clarendon by the Fairfax Chapter in 1928.[496] She died on June 7, 1953, "one of the oldest residents of Fairfax."[497]

So to whom did Laura pass the album and J.E.B. Stuart's watch chain with a gold dollar? It was to Mamie Wiley, whose descendants own the watch chain today. The album passed into the hands of a private collector.

The story of Laura and the album given to her by J.E.B. Stuart provides us with an interesting insight into the intersection of civilian and soldiers'

Mamie Wiley's grave, Fairfax Cemetery.

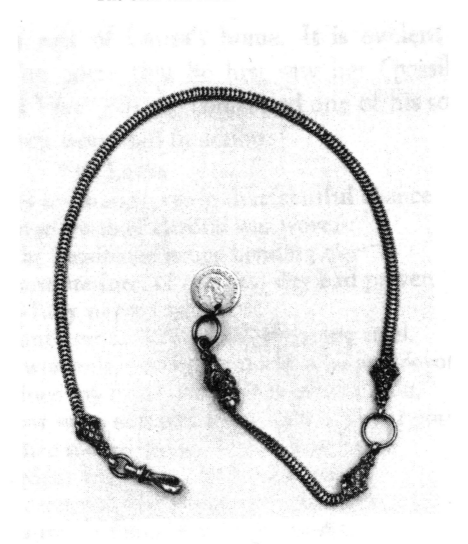

The watch chain and gold dollar given to Laura by J.E.B. Stuart.

lives during the Civil War. It is a story of their dependence on one another, as well as their daring, cunning and bravery to survive this terrible chapter in American history. It is a story based on a limited amount of evidence provided in a secret album, but whose full details we can only hint at and which will probably never be fully revealed.

The Laura Ratcliffe sign dedication November 4, 2007. *Left to right*: Jo Ann Killeen, Nancy Wiggington, Catherine DeLano, Don Ward, Jacque-Lynne Schulman, Ray Borden and Ken Fleming.

The legacy of Laura and her exploits during the war has been held onto by a small but dedicated number of people in the local Herndon area and members of local John Mosby and J.E.B. Stuart societies. She was recognized for those exploits at a ceremony conducted by the Laura Ratcliffe Chapter of the United Daughters of the Confederacy on November 4, 2007. A Virginia Historical Highway marker was unveiled next to Laura's grave site by chapter president Jacque-Lynne Schulman and members of the T. Clinton Hatcher, Camp #24, Sons of Confederate Veterans.

The group of fifty people was then invited to adjourn to Laura's postwar home at Merrybrook for refreshments by owners Win and David Meiselman and the Friends of Laura Ratcliffe. These groups and other interested parties strive to continue to preserve the legacy of one woman's covert but extraordinary service to her country and countrymen.

NOTES

INTRODUCTION

1. David B. Guralnik, ed. in chief, *Webster's New World Dictionary*, 2nd College Edition (New York: World Publishing Company, 1970).
2. Hugh C. Keen and Horace Mewborn, *43rd Battalion, Virginia Cavalry, Mosby's Command* (Lynchburg, VA: M.E. Howard, Inc., 1993), 26.
3. Major John Scott, *Partisan Life with Col. John S. Mosby* (New York: Harper & Brothers, 1867), viii.

THE RATCLIFFES AND FAIRFAX COURT HOUSE

4. Ross D. Netherton and Ruby Waldeck, *The Fairfax County Courthouse* (N.p.: Fairfax County Office of Comprehensive Planning, 1977), 3.
5. Ibid.
6. Fairfax Harrison, *Landmarks of Old Prince William*, Vols. I and II (N.p.: The Prince William County Historical Commission, 1987), 321.
7. Netherton and Waldeck, *Fairfax County Courthouse*, 5.
8. Ibid., 4.
9. Ibid., 7.
10. Ibid., 9.
11. Ibid., 14.
12. Edward Coleman Trexler Jr., *Endowed by the Creator, Families of Fairfax Court House, Virginia*, (Fairfax, VA: James River Valley Publishing, Fairfax, 2003), 10.
13. Ibid., 13.
14. Ibid., 14.
15. Ibid., 19.

16. City of Fairfax, Virginia, Archaeological Survey of the Ratcliffe Cemetery (44FX1174), Final Report, Prepared by the Louis Berger Group, Inc. (Fairfax, VA: Office of Historic Resources, May 2005), 63.

WOMEN OF THE CIVIL WAR

17. George Cary Eggleston, *A Rebel's Recollections* (Baton Rouge: Louisiana State University Press, 1996), 56.
18. Ibid., 63.
19. Ibid., 77.
20. Drew Gilpin Faust, *Mothers of Invention, Women of the Slaveholding South in the American Civil War* (New York: Vintage Books, 1997), 11.
21. Ibid., 22.
22. Ibid., 140.
23. Eggleston, *Recollections*, 78.
24. Ibid.
25. Ibid., 79.
26. Katherine M. Jones, *Heroines of Dixie* (New York: SMITHMARK Publishers, a division of U.S. Media Holdings, Inc., n.d.), v.
27. Ibid., vii.
28. Bell Irvin Wiley, *Confederate Women* (New York: Barnes and Noble Books, 1975), 144.
29. Ibid., 145.
30. Ibid., 146.
31. Ibid., 143.
32. Ibid., 147.
33. Ibid., 149.
34. Faust, *Mothers*, 196.
35. Ibid., 205.
36. Ibid., 223.
37. Ibid., 180.
38. Wiley, *Confederate Women*, 169.
39. Faust, *Mothers*, 236.
40. Ibid., 238.
41. Ibid., 249.
42. Ibid., 253.
43. Wiley, *Confederate Women*, 178.

GROWING UP

44. Brian Conley, *Genealogy* (Fairfax, VA: Virginia Room, Fairfax City Regional Library, n.d.).

45. Constance Ring, "Richard Ratcliffe, The Man, His Courthouse, and His Town," *Yearbook: The Historical Society of Fairfax County, Virginia* 25 (1995–96): 111.

46. Ibid., 122.

47. Cordelia Grantham Sansone, *Journey to Bloomfield, Lives and Letters of 19th Century Virginia Families* (Fairfax, VA: Fairfax Room, Fairfax City Regional Library, 2004), 212.

48. Nan Netherton, Ruth Preston Rose, David L. Meyer, Peggy Talbot Wagner and Mary Elizabeth Cawley DiVincenzo, *Fairfax, Virginia: A City Traveling Through Time* (Fairfax, VA: History of the City of Fairfax Round Table, 1977), 16.

49. *Fairfax Northern Virginia Sun*, December 2, 1980, 5.

50. Sansone, *Bloomfield*, 45.

51. Cordelia G. Sansone, "Coombe Cottage, First Girls Academy in Fairfax County, Va.," *Yearbook: The Historical Society of Fairfax County, Virginia* 16 (1980): 38.

52. Sansone, *Bloomfield*, 105.

53. Trexler, *Endowed*, 30.

54. Ibid., 32.

55. Jeanne Rust, "Portrait of Laura," *Virginia Fairfax County Spies* (Winter 1962–63): 34–35.

56. William Page Johnson II, *Brothers and Cousins: Confederate Soldiers and Sailors of Fairfax County, Virginia* (Athens, GA: Iberian Publishing Company, 1995), xx.

57. Fairfax County Land Records, Deed Book Z3, Fairfax County Courthouse, Fairfax, Virginia, p. 357.

58. Trexler, *Endowed*, 251.

59. Ibid., 247.

60. Ed Trexler Jr., e-mail to author, December 18, 2008.

61. Southern Claims Commission, Claim #21,739.

62. Susan Hellman, e-mail to author, August 20, 2007.

63. Susan Hellman, e-mail to author, January 17, 2007.

64. Margaret Peck, interview with author, January 6, 2007.

65. Fairfax County Deed Book E-4, p. 461.

66. Fairfax County Deed Book W-7, p. 80.

67. Fairfax County Deed Book X-3, p. 272.

68. Sansone, *Bloomfield*, 149–150.
69. Fairfax County Deed Book, E-4, p. 461.
70. Thomas Hutchinson, *Boyd's Washington and Georgetown Directory* (N.p.: 1862).
71. *Hutchinson's Washington and Georgetown Directory* (N.p.: Hutchinson & Brother, Publishers, 1863).
72. Fairfax County Deed Book E-4, p. 421.
73. Fairfax County Deed Book L-4, p. 519.
74. Library of Congress, Geography and Map Division, #493.
75. U.S. Corps of Topographical Engineers, http://www.topogs.org/b_michler.html.
76. Thomas J. Evans and James M. Moyer, *Mosby's Confederacy, A Guide to the Roads and Sites of Colonel John Singleton Mosby* (N.p.: White Mane Publishing, 1991), 43.
77. Tom Evans, e-mail to author, January 23, 2007.
78. There is an error in the Evans and Moyer book. On page forty-three, they state that the "Old Peck Home" is 2.3 miles north of Route 50 on Route 267, Centreville Road. They also state that Frying Pan Church is 1.5 miles farther north on Centreville Road. This is a total of 3.8 miles. The church is, in fact, only 3.3 miles north of Route 50 on Centreville Road, but it is 1.5 miles north of the location of the "Old Peck Home," as Evans and Moyer indicate. The author spoke to Tom Evans on January 16, 2008, to discuss this, and Tom agreed that since Frying Pan Church and Route 50 have not moved, there is an error on the mileage in his book, which is easily corrected here. The "Old Peck Home" is 1.8 miles north of Route 50 on Centreville Road and 1.5 miles south of Frying Pan Church.

LETTERS AND POEMS

79. Mrs. Arnold Greer, *Service Record, World War I and II, Herndon, Virginia* (N.p.: Herndon Post 91, American Legion, and Herndon Unit 91, American Legion Auxiliary, 1949), 103.
80. Emory M. Thomas, *Bold Dragoon, The Life of J.E.B. Stuart* (New York: Harper & Row, Publishers, 1986), 66–67.
81. Ibid., 83.
82. Ibid., 88.
83. Robert J. Trout, *They Followed the Plume, The Story of J.E.B. Stuart and His Staff* (Mechanicsburg, PA: Stackpole Books, 1993), 3.

84. Burke Davis, *JEB Stuart, The Last Cavalier* (Toronto, Canada: Clark, Irwin & Company, Ltd., 1957), 74.

85. Emory M. Thomas, *Bold Dragoon, The Life of J.E.B. Stuart* (New York: Vintage Books, A Division of Random House, May 1988), 90.

86. Ibid., 98–99.

87. *Official Records*, series I, vol. 5 [S# 5], December 20, 1861, Engagement at Dranesville, Virginia, No. 11, Reports of Brigadier General J.E.B. Stuart, CS Army.

88. Edward G. Longacre, *Lee's Cavalrymen, A History of the Mounted Forces of the Army of Northern Virginia* (Mechanicsburg, PA: Stackpole Books, 2002), 62.

89. Ibid., 63.

90. Oscar Arvle Kinchen, *Women Who Spied for the Blue and the Gray* (Philadelphia: Dorrance & Co., 1972), 59.

91. Keen and Mewborn, *43rd Battalion*, 38.

92. Thomas, *Dragoon*, 100.

93. Ibid., 103.

94. Edward G. Longacre, *A History of the Mounted Forces of the Army of Northern Virginia, 1861–1865* (Mechanicsburg, PA: Stackpole Books, 2002), 61.

95. Mark M. Boatner III, *The Civil War Dictionary* (New York: Vintage Books, 1988), 561.

96. Thomas Low, "My War, Letters to Laura," *Civil War Times Illustrated* (July/August 1992): 12.

97. E.H. Butler changed from a bookseller to a book publisher in 1842. *McElroy's Philadelphia Directory for 1843*, 6th edition.

98. Rust, "Portrait," 34.

99. Thomas, *Dragoon*, 103.

100. Ibid.

101. Larry J. Daniel, *Shiloh, The Battle That Changed the Civil War* (New York: Simon & Schuster, 1997), 227.

102. Ibid., 236.

103. Thomas, *Dragoon*, 112.

104. Ibid., 129.

105. Ibid., 139.

106. Ibid., 158.

107. Thomason, *Stuart*, 252.

108. Charles V. Mauro, *The Battle of Chantilly (Ox Hill), A Monumental Storm* (N.p.: Fairfax County History Commission, 2002), 42.

109. Longacre, *Lee's Cavalrymen*, 126.

110. R.E. Lee, general, letter to the Honorable George W. Randolph, secretary of war. Richmond, Virginia, September 3, 1862.

111. A.H. Chilton, AA general, letter to the Honorable G.W. Randolph, secretary of war, Richmond, Virginia, September 2, 1862.

112. Davis, *Cavalier*, 190.

113. Thomason, *Stuart*, 351.

114. Thomas, *Dragoon*, 199.

115. *Official Records*, series I, vol. 21 [S# 31], Nos. 1, 2 and 5.

116. Major John Scott, *Partisan Life with Col. John S. Mosby. By Major John Scott, with portraits and engravings on wood* (New York: Harper & Brothers, Publishers, Franklin Square, 1867), 20.

117. Keen and Mewborn, *43rd Battalion*, 6.

118. Davis, *Cavalier*, 74.

119. John W. Thomason Jr., *Jeb Stuart* (Lincoln: University of Nebraska Press, 1994), 128.

120. Thomas, *Dragoon*, 279–80.

121. W.W. Blackford, *War Years with JEB Stuart* (New York: Charles Scribner's Sons, 1945), 155–56.

122. *Union Provost Marshall File of Papers Relating to Southern Civilians, Confederate Papers Relating to Citizens or Business Firms*, National Archives and Records Administration.

123. Thomas P. Lowry, *Confederate Heroines, 120 Southern Women Convicted by Union Military Justice* (Baton Rouge: Louisiana State University Press, 2006), 180.

124. Ibid., 6.

125. Charles V. Mauro, *The Civil War in Fairfax County, Civilians and Soldiers* (Charleston, SC: The History Press, 2006), 11.

126. Mark Grimsley, *The Hard Hand of War, Union Military Policy Toward Southern Civilians, 1861–1865* (Cambridge, UK: Cambridge University Press, 1995), 86–88.

127. Frank Anderson Chappell, *Dear Sister: Civil War Letters to a Sister in Alabama* (Huntsville, AL: Branch Springs Publishing, 2002).

128. Ibid., 37.

129. Ibid., 184–85.

130. Ibid., 160.

THE J.E.B. STUART PAGE

131. Robert S. Gamble, *Sully* (Chantilly, VA: Sully Foundation, Limited, 1973), 105–08.

132. Eggleston, *Recollections*, 10.

133. Trout, *Plume*, 167.

134. Ibid., 168.

135. Ibid., 10.

136. Ibid., 13.

137. Ibid., 169.

138. Ibid., 174.

139. Ibid., 175.

140. Ibid., 174.

141. Ibid., 6.

142. Ibid., 10.

143. Sansone, *Bloomfield*, 150.

144. Trout, *Plume*, 107.

145. John Esten Cooke, *Wearing of the Gray, Being Personal Portraits, Scenes, and Adventures of the War* (Baton Rouge: Louisiana State University Press, 1997), 134.

146. Ibid., 135.

147. Sansone, *Bloomfield*, 152.

148. Cooke, *Gray*, 135.

149. Edward G. Longacre, *Lee's Cavalrymen, A History of the Mounted Forces of the Army of Northern Virginia, 1861–1865* (Mechanicsburg, PA: Stackpole Books, 2002), 31.

150. Sansone, *Bloomfield*, 171.

151. Trout, *Plume*, 18.

152. Ibid., 113.

153. Ibid., 114.

154. *Civil War News*, June 2002.

155. Keen and Mewborn, *43rd Battalion*, 2–3.

156. John S. Mosby, *Mosby's Memoirs* (Nashville, TN: J.S. Sanders & Company, 1995), 99.

157. Ibid., 100.

158. Kevin H. Siepel, *Rebel, The Life and Times of John Singleton Mosby* (New York: St. Martin's Press, 1983), 47.

159. Mosby, *Memoirs*, 105.

160. Trout, *Plume*, 317.

161. Scott, *Partisan Life*, 441.

162. Mosby, *Memoirs*, 143.

163. H. Beam Piper, *Rebel Raider*, reprinted by the Project Gutenberg EBook, September 6, 2006, from *True: The Man's Magazine* (December 1950): 2.

164. Keen and Mewborn, *43rd Battalion*, 6.

165. Ibid., 351.
166. Ibid., 431.
167. Scott, *Partisan Life*, 96–97.
168. Ibid., 106.
169. Virgil Carrington Jones, *Ranger Mosby* (Chapel Hill: University of North Carolina Press, 1944), 147.
170. Keen and Mewborn, *43rd Battalion*, 75.
171. Ibid., 77.
172. Ibid., 81.
173. Ibid., 82.
174. James J. Williamson, *Mosby's Rangers: A record of the Operations of the Forty-Third Battalion Virginia Cavalry from Its organization to the Surrender* (New York: Polhemus Press, 1982), 94.
175. Keen and Mewborn, *43rd Battalion*, 86.
176. Ibid.
177. Ibid., 431.
178. Waverly L. Berkley III, *The Berkleys of Berkley* (Fairfax, VA: History 4All, Inc., 2008), 79.
179. Ibid.
180. Ibid., preface.
181. Longacre, *Lee's Cavalrymen*, 260.

THE WILLIAM THOMAS CARTER PAGE

182. "Private William Thomas Carter," www.angelfire.com/tx/RandysTexas/page8.html.
183. Richard M. Coffman and Kurt D. Graham, *To Honor These Men, A History of the Phillips Georgia Legion Infantry Battalion* (Macon, GA: Mercer University Press, 2007).
184. Ibid., 296.
185. Ibid., 28.
186. Ibid., 70.
187. Ibid., 73.
188. Ibid., 85.
189. Mauro, *Chantilly*, 17.
190. Coffman and Graham, *Phillips Georgia Legion*, 87.
191. "Private William Thomas Carter," www.angelfire.com/tx/RandysTexas/page8.html.

THE JOHN SINGLETON MOSBY PAGE

192. Interview with Tom Evans, January 2, 2007, coauthor with James Moyer of *Mosby's Confederacy: A Guide to the Roads and Sites of Colonel John Singleton Mosby.*
193. Scott, *Partisan Life*, 24.
194. Keen and Mewborn, *43rd Battalion*, 8.
195. Ibid., 25.
196. Ibid., 26.
197. Captain Willard Glaziers, *Three Years in the Federal Cavalry* (New York: R.H. Ferguson & Company, Publishers, 1873), 148–49.
198. John Bakeless, *Spies of the Confederacy* (Mineola, NY: Dover Publications, 1970), 63.
199. Keen and Mewborn, *43rd Battalion*, 90.
200. Near the Marriott Hotel at the intersection of Centreville Road and the Dulles Toll Road; Evans and Moyer, *Mosby's Confederacy*, 44.
201. Jones, *Ranger Mosby*, 82.
202. Keen and Mewborn, *43rd Battalion*, 26.
203. Bakeless, *Spies*, 63.
204. Ibid.
205. Jones, *Ranger Mosby*, 82.
206. Keen and Mewborn, *43rd Battalion*, 26.
207. John Singleton Mosby, *Mosby's War Reminiscences and Stuart's Cavalry Campaigns* (New York: Pageant Book Company, 1958), 63–67.
208. The Thompson house was moved back from the intersection for the widening of West Ox Road.
209. Keen and Mewborn, *43rd Battalion*, 27.
210. Scott, *Partisan Life*, 53.
211. Virginia Historical Society, MSS 12: March 12, 1863, 1.
212. Keen and Mewborn, *43rd Battalion*, 51.
213. Ibid., 305.
214. Ibid., 95.
215. Ibid., 41.
216. Ibid., 404.
217. Ibid., 463.
218. Peter A. Brown, *Mosby's Fighting Parson, The Life and Time of Sam Chapman* (Westminster, MD: Willow Bend Books, 2001), 235–36.
219. Keen and Mewborn, *43rd Battalion*, 106.
220. Scott, *Partisan Life*, 184.
221. Williamson, *Mosby's Rangers*, 146.

222. Ibid., 327.
223. Ibid., 250.
224. Scott, *Partisan Life*, 472.
225. Keen and Mewborn, *43rd Battalion*, 273.
226. Ibid., 320.
227. The Fifth New York Camp was located on the northeast corner of today's Jermantown Road and Route 50; interview with Tom Evans, July 18, 2008.
228. Williamson, *Mosby's Rangers*, 33.
229. Keen and Mewborn, *43rd Battalion*, 320.
230. Wilbur F. Hinman, *Corporal Si Klegg And His Pard* (Cleveland, OH: Williams Publishing Company, 1997), 221, 108.
231. Scott, *Partisan Life*, 74.
232. Keen and Mewborn, *43rd Battalion*, 320.
233. Ibid., 86.
234. Williamson, *Mosby's Rangers*, 231.
235. Ibid., 232.
236. Keen and Mewborn, *43rd Battalion*, 268.
237. Ibid., 351.
238. Ibid., 65.
239 Williamson, *Mosby's Rangers*, 197.
240. Keen and Mewborn, *43rd Battalion*, 351.
241. Scott, *Partisan Life*, 303.
242. Keen and Mewborn, *43rd Battalion*, 240.
243. Ibid., 272.
244. Ibid., 351.
245. Ibid., 316.
246. Ibid., 84, 316.
247. Ibid., 86.
248. Ibid., 316.
249. Ibid.
250. Ibid., 304.
251. Ibid., 143.
252. Ibid., 321.
253 Williamson, *Mosby's Rangers*, 313.
254. Keen and Mewborn, *43rd Battalion*, 321.
255. Williamson, *Mosby's Rangers*, 107.
256. Keen and Mewborn, *43rd Battalion*, 364.
257. Ibid., 378.
258. *Fairfax Herald*, November 6, 1914, 3.

259. Brown, *Parson*, 146.

260. Mosby, *Memoirs*, 271.

261. Keen and Mewborn, *43rd Battalion*, 154.

262. Williamson, *Mosby's Rangers*, 232.

263. Keen and Mewborn, *43rd Battalion*, 376.

264. Ibid., 380.

THE FITZHUGH LEE PAGE

265. Edward G. Longacre, *Fitz Lee, A Military Biography of Major General Fitzhugh Lee, C.S.A.* (Cambridge, MA: Da Capo Press, 2005), 5.

266. Ibid., 12.

267. Ibid., 30.

268. Blackford, *War Years*, 47.

269. Longacre, *Fitz Lee*, 35.

270. Ibid., 36.

271. Thomas, *Dragoon*, 91.

272. Longacre, *Fitz Lee*, 68.

273. Ibid., 83.

274. Longacre, *Lee's Cavalrymen*, 127.

275. Thomas, *Dragoon*, 160.

276. Ibid.

277. Robert J. Driver Jr., *5th Virginia Cavalry* (Lynchburg, VA: H.E. Howard, Inc., 1997), 39.

278. Longacre, *Fitz Lee*, 94.

279. Longacre, *Lee's Cavalrymen*, 166.

280. Thomas, *Dragoon*, 199.

281. Longacre, *Fitz Lee*, 116.

282. Longacre, *Lee's Cavalrymen*, 243.

283. Ibid., 260.

284. Thomas, *Dragoon*, 292.

285. Longacre, *Fitz Lee*, 178.

286. Ibid., 185.

287. Ibid., 202.

288. Longacre, *Lee's Cavalrymen*, 33.

289. Longacre, *Fitz Lee*, 218.

290. John E. Divine, *35th Battalion Virginia Cavalry* (Lynchburg, VA: H.E. Howard, Inc., 1985), 2.

291. Frank M. Myers, *The Comanches: A History of White's Battalion, Virginia Cavalry, Laurel Brigade, Hampton Division, A.N.V., C.S.A.* (Baltimore, MD: Kelly, Piet & Co., 1987), 9.

292. Ibid., 18.

293. Ibid., intro.

294. Divine, *35th Battalion*, 2.

295. Ibid., 5.

296. Ibid., 10.

297. Ibid., 22.

298. General R.E. Lee, letter to Major General J.E.B. Stuart, commanding cavalry, headquarters, Army of Northern Virginia, September 9, 1863.

299. Myers, *Comanches*, 226.

300. Ibid., 229.

301. Ibid., 231.

302. Divine, *35th Battalion*, 42.

303. Ibid., 69.

304. Ibid., 72.

305. Ibid., 74.

306. Tom Evans, e-mail, November 1, 2006, from Spindle's obituary by his minister.

307. Driver, *5th Virginia Cavalry*, 249.

308. Longacre, *Lee's Cavalrymen*, 58.

309. Thomas, *Dragoon*, 91.

310. Driver, *5th Virginia Cavalry*, 28.

311. Longacre, *Lee's Cavalrymen*, 96.

312. Thomas, *Dragoon*, 154.

313. John J. Hennessy, *Return to Bull Run, The Campaign and Battle of Second Manassas* (New York: Simon and Schuster, 1993), 151.

314. Driver, *5th Virginia Cavalry*, 39.

315. Thomas, *Dragoon*, 191.

316. Longacre, *Lee's Cavalrymen*, 166.

317. Thomas, *Dragoon*, 262.

318. Longacre, *Lee's Cavalrymen*, 260.

319. Thomason, *Jeb Stuart*, 12.

320. Robert Driver Jr. and H.E. Howard, *2nd Virginia Cavalry* (Lynchburg, VA: H.E. Howard, Inc., 1995), 236.

321. Ibid., 283.

322. Ibid., 194.

323. Ibid., 268.

324. Ibid., 2.

325. Ibid., 6.
326. Ibid., 10.
327. Ibid., 11.
328. Ibid., 12.
329. Ibid., 14.
330. Ibid., 23.
331. Ibid., 25.
332. Ibid., 27.
333. Ibid., 28.
334. Ibid., 29.
335. Longacre, *Lee's Cavalrymen*, 66.
336. Driver and Howard, *2nd Virginia Cavalry*, 41.
337. Ibid., 194.
338. Ibid., 268.
339. Ibid., 283.
340. Ibid., 56.
341. Ibid., 236.
342. Ibid., 58.
343. Ibid., 59.
344. Ibid., 63.
345. Ibid., 67.
346. Ibid., 236.
347. Ibid., 268.
348. Ibid., 284.
349. Michael P. Musick, *6th Virginia Cavalry* (Lynchburg, VA: H.E. Howard, Inc., 1990), 106.
350. Ibid., 5.
351. Ibid., 2.
352. Ibid., 5.
353. Ibid., 8.
354 Ibid., 106.
355. Ibid., 16.
356. Ibid., 52.
357. Daniel D. Hartzler, *Marylanders in the Confederacy* (Silver Spring, MD: Family Line Publications, 1986), 221.
358. Ibid., 53.
359. *The Minutes of the 135th Session of the Baltimore Annual Conference of the Methodist Episcopal Church, South*, 1919, 70.
360. Daniel D. Hartzler, *A Band of Brothers, Photographic Epilogue to Marylanders on the Confederacy* (Westminster, MD: Willow Bend Books, 2005), 2005.

361. Divine, *35th Battalion*, 99.

362. *Baltimore Annual Conference*, 71.

363. Hartzler, *Marylanders in the Confederacy*, 2.

364. Ibid., 27.

365. Ibid., 36.

366. Divine, *35th Battalion*, 11.

367. Hartzler, *Marylanders in the Confederacy*, 31.

368. Stevan F. Meserve, *The Civil War in Loudoun County, Virginia: A History of Hard Times* (Charleston, SC: The History Press, 2008), 52.

369. Myers, *Comanches*, 231.

370. *Baltimore Annual Conference*, 71.

371. Robert J. Driver Jr. and Kevin C. Ruffner, *1st Battalion Virginia Infantry, 39th Battalion Virginia Cavalry, 24th Battalion Virginia Partisan Rangers* (Lynchburg, VA: H.E. Howard, Inc., 1996), 165.

372. Lewis Marshall Helm, *Black Horse Cavalry, Defend Our Beloved Country* (Fall Church, VA: Higher Education Publications, 2004), 2.

373. Ibid., 5.

374. Ibid., 8.

375. Ibid., 9.

376. Thomason, *Jeb Stuart*, 72.

377. Jubal A. Early, *The Memoirs of General Jubal A. Early* (New York: Konecky & Konecky, 1994), 4.

378. Driver and Ruffner, *24th Battalion*, 80.

379. Ibid., 82.

380. Ibid., 83.

381. Scott, *Partisan Life*, x.

382. Driver and Ruffner, *24th Battalion*, 165.

THE LOCAL WOMEN PAGE

383. Mrs. J.K. McWhorter, "Caring for the Soldiers in the Sixties," *Confederate Veteran* 29, no. 11–12 (November/December 1921): 409–11.

384. George Turberville McWhorter Jr., *William David McWhorter, MD (1838–1895)*, McWhorter Family Genealogy, http://members.tripod.com/~Bonestwo/index-5.html.

385. James A. Burgess, *Anderson, Cockrill, Moffett, Smith & Allied Families of Fauquier County, Virginia*, vol. 1, *Cockrill Families of Northern Virginia*, 1st edition (N.p.: Privately published, 2002), 473.

386. Ibid., 472–73.

387. Ibid.

388. Ibid.

389. Sansone, *Bloomfield*, 54.

390. Johnson, *Brothers and Cousins*, 31.

391. J. Berkley Monroe is listed on the Confederate Monument in Fairfax Cemetery.

392. Berkley, *The Berkleys*, 84.

393. *Fairfax Herald*, July 6, 1900, 3.

394. Berkley, *The Berkleys*, 85.

395. *Fairfax Herald*, June 15, 1917, 3.

396. Sansone, *Bloomfield*, 176.

397. Ibid., 169.

398. Ibid., 189.

399. Margaret Peck, a local resident who remembers the house, interview with the author, April 25, 2008. J.J. Coleman is listed in the same area on the *Surveys for Military Defenses, Map of North Eastern Virginia and Vicinity of Washington, Division Headquarters of General Irvin McDowell, Arlington, January 1 1862*. Coleman's Corner is also shown in the same area on the map of *Loudoun County, Commonwealth of Virginia*, surveyed and drawn by Eugene M. Scheel for the Loudoun Association of Realtors, Inc., 1990.

400. Patricia B. Duncan and Elizabeth R. Frain, *Loudoun County Marriages After 1850*, vol. 1, *1851–1880* (Westminster, MD: Willow Bend Books, 2000), 14.

401. 1880 Front Royal Township, Warren County, Virginia, Census.

402. The Staff and Volunteers of the Thomas Balch Library for History and Genealogy, *Loudoun County, Virginia, Cemeteries, A Preliminary Index* (Lovettsville, VA: Willow Bend Books, 1996), 20.

403. *Alexandria Gazette*, November 30, 1933, 7.

404. *Fairfax County Virginia Gravestones*, vol. 4, *Western Section, Centreville, Chantilly, Herndon, Reston and Surrounding Area* (Merrifield, VA: Fairfax Genealogical Society, Inc., 1997), HR–110, 111.

405. Sharon Hodges, genealogical research.

THE DRANESVILLE, VIRGINIA, AND CAMBRIDGE,
MARYLAND PAGE

406. Sansone, *Bloomfield*, 18.

407. Ibid., 23.

408. Ibid., 27.

409. Ibid., 38.

410. Ibid., 50.

411. Ibid., 105.

412. Ibid., 56.

413. Ibid., 76.

414. Ibid., 110.

415. Ibid., 166.

416. Ibid., 146.

417. Divine, *35ᵗʰ Battalion*, 86.

418. Richard Hammond, grandson of Kate Carper, interview with the author, December 2007.

419. Sansone, *Bloomfield*, 172.

420. Ibid., 148.

421. Ibid., 182.

422. Ibid., 187.

423. Ibid., 204.

424. Susan Cooke Soderberg, *A Guide to Civil War Sites in Maryland, Blue and Gray in a Border State* (Shippensburg, PA: White Mane Books, 1998), 171.

425. *Easton Journal*, July 26, 1864.

426. John R. Wennersten, *Maryland's Eastern Shore: A Journey in Time and Place* (Centreville, MD: Tidewater Publishers, 1992), 9.

427. Soderberg, *Guide*, 172.

428. James A. McAllister Jr., *Genealogical Notes, The Bayly Family* (N.p.: self published, 1975), 1–2.

429. Roger Webster, *The Hayward Family History* (N.p.: self published, 1980), 1.

430. Melanie Ayres Merryweather, *Genealogy of the Henry Family* (N.p.: self published, 1997), 1.

431. Ibid., 26.

432. Samuel Eaton LeCompte, *The LeComptes. A History of the Family of Monsieur Antoine LeCompte, From the First Settlement in Dorchester County in 1659* (N.p.: Dorchester Historical Society, n.d.), 1.

433. Ibid., 2.

434. Thomas Holliday Hicks, *The Hicks Family of The Eastern Shore of Maryland* (N.p.: self published, n.d.), section H, "Woodward," 1.

435. Juanita Leisch, *An Introduction to Civil War Civilians* (Gettysburg, PA: Thomas Publications, 1994), 5.

436. Marriage licenses for Dorchester County, Maryland 1781–1886.

437. Ray D'Amato, *History of Ravensworth*, www.ravensworthfarm.org/about/history.htm.

438. Through wills, land records and deeds dating back to William Fitzhugh, "the Immigrant," born January 9, 1651; died December 10, 1701, in Bedford, Stafford County, Virginia. William Fitzhugh, "the Immigrant," was Laura's fourth great-grandfather.

439. Anna Maria Fitzhugh, Southern Claims Commission, Claim #14013, January 3, 1873.

440. Church records.

441. Sansone, *Bloomfield*, 29.

442. Ibid., 36.

443. Ibid., 66, 73.

444. Berkley, *The Berkleys*, 82.

445. "A Brief History of Washington Street United Methodist Church," http://www.washingtonstreetchurch.com/history.html.

446. D'Anne Evans, *Burke Virginia* (Burke, VA: Church of the Good Shepherd, n.d.), 5.

447. Ibid., 4.

448. Parish Register of Zion Church, Truro Parish, Fairfax County, Virginia.

449. Letter from Annie E. Lee, East Hampton, Long Island, to Mrs. S.F. du Pont, August 5, 1863.

450. Graveyards Records of Christ Church, Cambridge, Maryland; e-mail from Melanie Merryweather, February 9, 2009.

451. Hartzler, *Marylanders in the Confederacy*, 2.

452. Compiled Service Records of Confederate Soldiers, Thirty-sixth (Villepigue's) Georgia Infantry, Microfilm Roll 266, National Archives and Records Administration, Washington, D.C.

453. Compiled Service Records of Confederate Soldiers, First Confederate Infantry, Microfilm Roll 258, National Archives and Records Administration, Washington, D.C.

454. Census Schedule 1, Free Inhabitants in the Town of Cambridge District No. 7 in the County of Dorchester, State of Maryland, August 29, 1860, 352.

455. Hartzler, *Band of Brothers*.

456. Elias Jones, *New Revised History of Dorchester County Maryland* (Cambridge, MD: Tidewater Publishers, 1966), 278.

457. Gregory J. Macaluso, *Morris, Orange, and King William Artillery* (N.p.: H.E. Howard, Inc., 1991), 14.

458. Compiled Service Records of Confederate Soldiers, Captain Fry's Company, Light Artillery (Orange Artillery), Microfilm Roll 324, National Archives and Records Administration, Washington, D.C.

459. John Drury, great-grandnephew of Alexander Hamilton Bayly, e-mail, February 4, 2009.

460. Robert J. Driver, *First & Second Maryland Infantry C.S.A* (Westminster, MD: Willow Bend Books, 2003), 38.

461. Driver, *Maryland Infantry*, 32.

462. Ibid., 35.

AFTER THE WAR

463. Oscar A. Kinchen, *Women Who Spied for the Blue and the Gray* (Philadelphia: Dorrance & Company, 1972), 122.

464. Lee A. Wallace Jr., *17th Virginia Infantry* (Lynchburg, VA: H.E. Howard, Inc., 1990), 133.

465. Ibid., 8.

466. Ibid., 14.

467. Ibid., 20.

468. Ibid., 27.

469. Ibid., 39.

470. Ibid., 64.

471. Ibid., 66.

472. Ibid., 133.

473. "History of the Seventeenth Virginia Infantry, CSA," http://www.fairfaxrifles.org/history.html.

474. Andrew M.D. Wolf, *Black Settlement in Fairfax County, Virginia During Reconstruction* (Preliminary draft, Fairfax County, Virginia, December 1975), 20.

475. Netherton et al., *Fairfax County*, 373.

476. *Gazette*, October 20, 1865.

477. *Fairfax Herald*, reprint of *News* of fifty-nine years ago, December 9, 1949, 2.

478. *Fairfax Herald*, April 20, 1894

479. Rust, "Portrait," 39. Win Meiselman, current owner of the house, states that there was an existing one-room structure that is the dining room in the current house. She says that Hanna rebuilt that part of the house and added an upstairs bedroom with an enclosed "Jefferson" staircase to conserve heat. He then built an additional room, with the ceiling made from the side of a barge, that is now the kitchen. There was also a separate building used as a summer kitchen due to the fire hazard. Interview with the author, July 15, 2000.

480. Meiselman, interview.
481. Ibid.
482. Kinchen, *Women Who Spied*, 124.
483. *Washington Post*, September 11, 1910, 10.
484. Margaret C. Peck, ed., *Voices of Chantilly, recollections and stories from 22 long-time residents* (N.p.: self published, 1996).
485. Keen and Mewborn, *43rd Battalion*, 341.
486. Ibid., 385.
487. Ibid., 377.
488. Meiselman, interview.
489. Ibid.
490. Rust, "Portrait," 39.
491. Laura Dalton, *Times*, September 30, 1985.
492. *Fairfax Herald*, August 24, 1923.
493. Ibid., February 25, 1938, 4.
494. Gladys Utterback, interview with author, January 10, 1997.
495. *Herndon News Observer*, February 26, 1925, 1.
496. *Fairfax Herald*, April 13, 1928.
497. Ibid., June 12, 1953.

INDEX

ABOUT THE AUTHOR

Mr. Mauro is the author and photographer of *The Civil War in Fairfax County: Civilians and Soldiers*; *Herndon: A Town and Its History*; and *Herndon: A History in Images*. He received the Nan Netherton Heritage Award for his historical research, writing and photography of *The Battle of Chantilly (Ox Hill), A Monumental Storm*. He is also the writer and co-producer of the independent film *The Battle of Chantilly (Ox Hill)*, based on his book.

Chuck is a member of the Civil War Preservation Trust, the National Center for Civil War Photography and the Louisiana Historical Association Memorial Hall Foundation, Inc. He is also a member of the Bull Run and Capital Hill Civil War Round Tables; the Stuart-Mosby Society; the Friends of Fort Ward; the Historic Centreville Society, Ltd.; Historic Fairfax City, Inc.; and the Historical Society of Fairfax County. Chuck is a member and past president of the Herndon Historical Society and the Manassas Warrenton Camera Club. He has won numerous prizes for his photography.

Mr. Mauro received his BA from the University of Maryland and an MA in business administration from Temple University. He is currently a manager at the Federal Aviation Administration (FAA).

He lives with his wife in Herndon, Virginia.

Please visit us at
www.historypress.net